The Crafted World
OF WHARTON ESHERICK

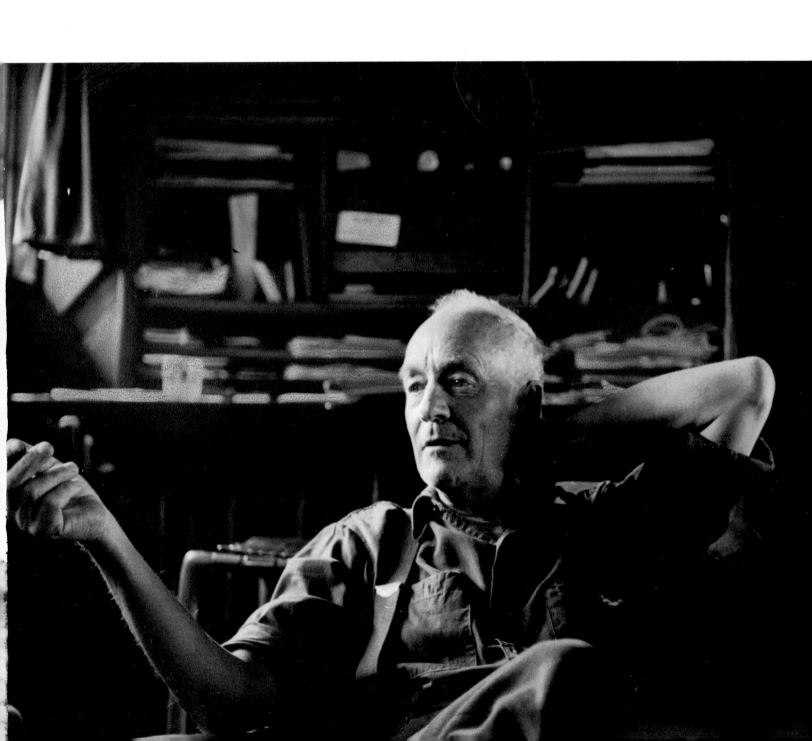

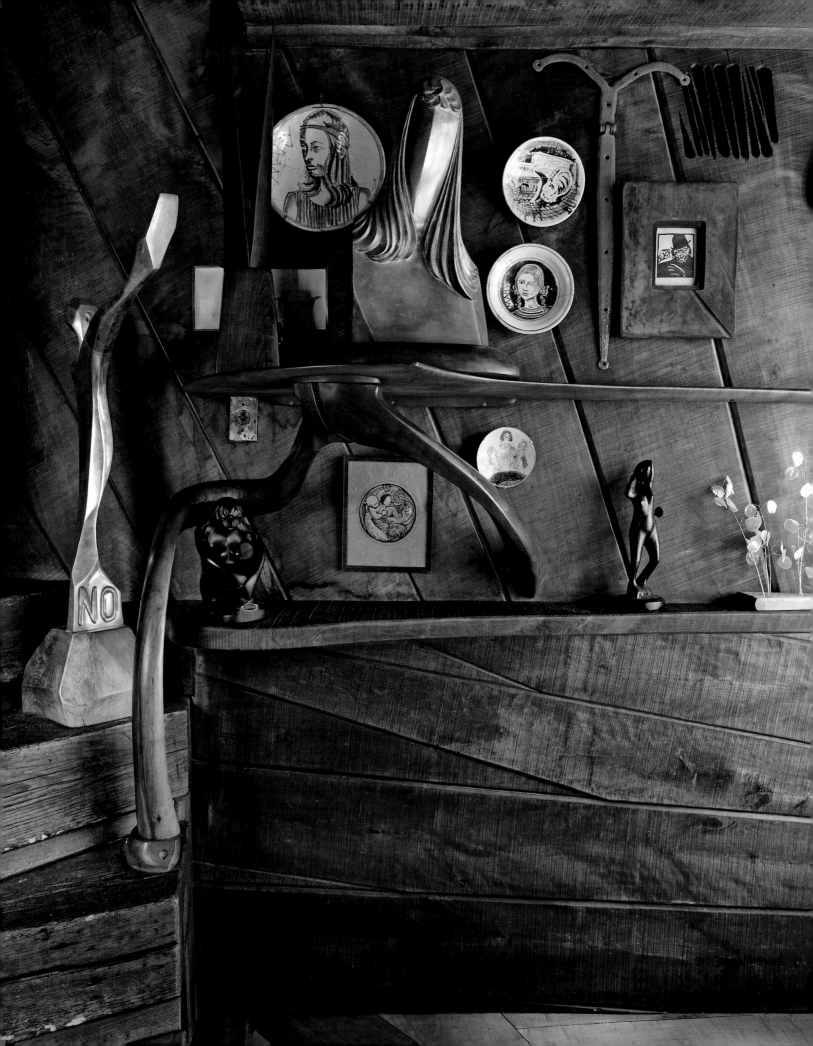

The Crafted World
OF WHARTON ESHERICK

SARAH ARCHER

COLIN FANNING

ANN GLASSCOCK

HOLLY GORE

EMILY ZILBER

Principal photography by

JOSHUA McHUGH

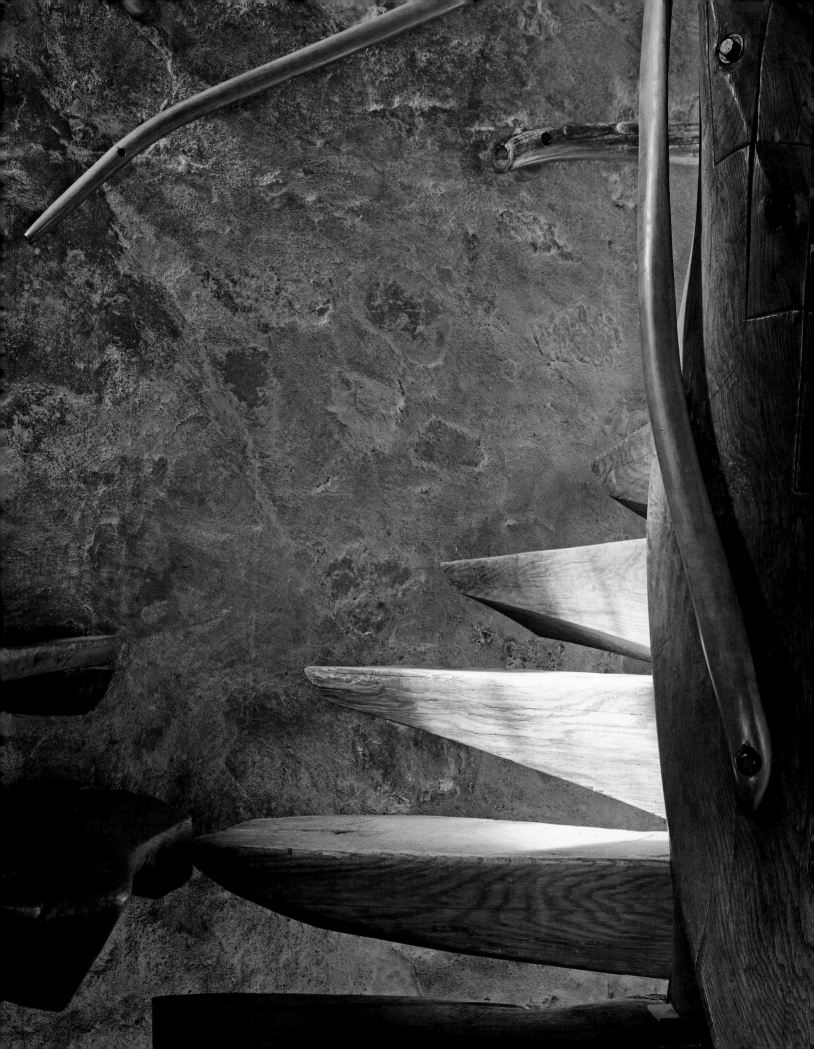

CONTENTS

16 DIRECTORS' FOREWORD
Julie Siglin and Thomas Padon

27 THE CRAFTED WORLD OF WHARTON ESHERICK
Holly Gore and Emily Zilber

45 THE RADIANT CURVE
Pattern and Dimension in the Work of Wharton Esherick
Sarah Archer

85 THE WAY THINGS GROW
Wharton Esherick and the Mechanics of Nature
Emily Zilber

123 BETWEEN WORLDS
Wharton Esherick's Rural and Urban Entanglements
Colin Fanning

157 THE ASSEMBLY LINE, THE DANCE CAMP, AND
WHARTON ESHERICK'S RHYTHMIC ART
Holly Gore

201 FOR ALL THE WORLD TO SEE
Presenting the Work of Wharton Esherick
Ann Glasscock

215 LIST OF EXHIBITED WORKS

219 SELECTED BIBLIOGRAPHY

221 CONTRIBUTORS

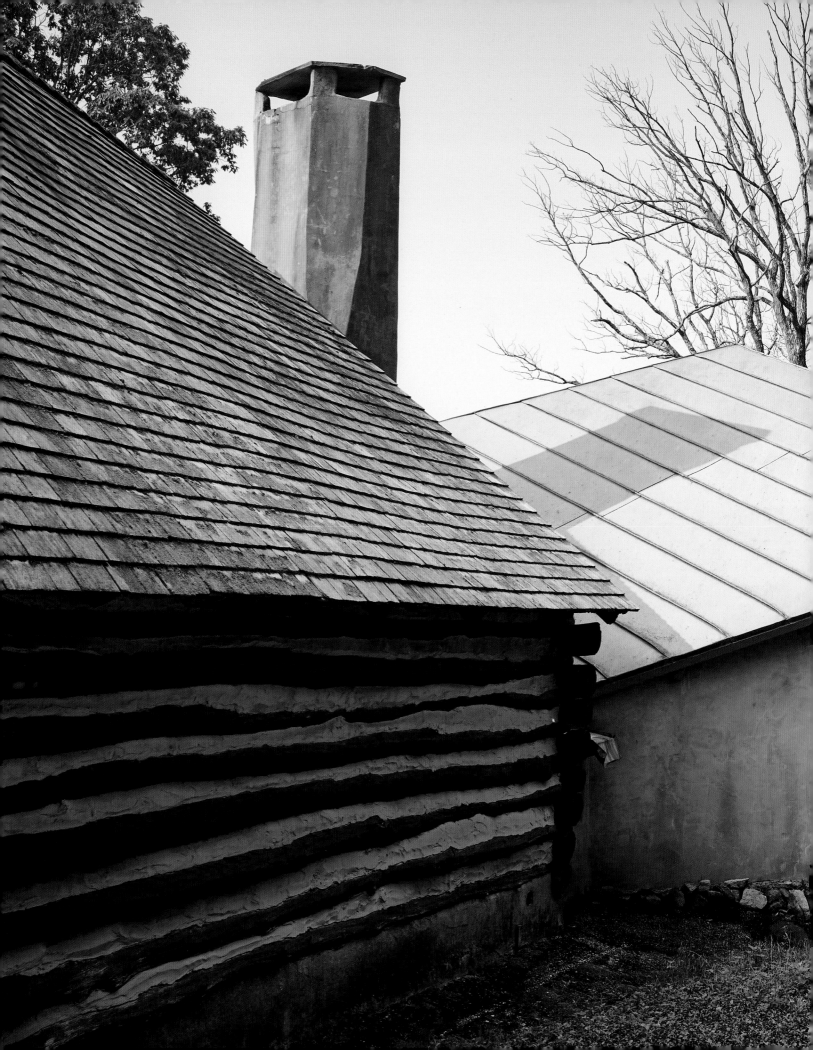

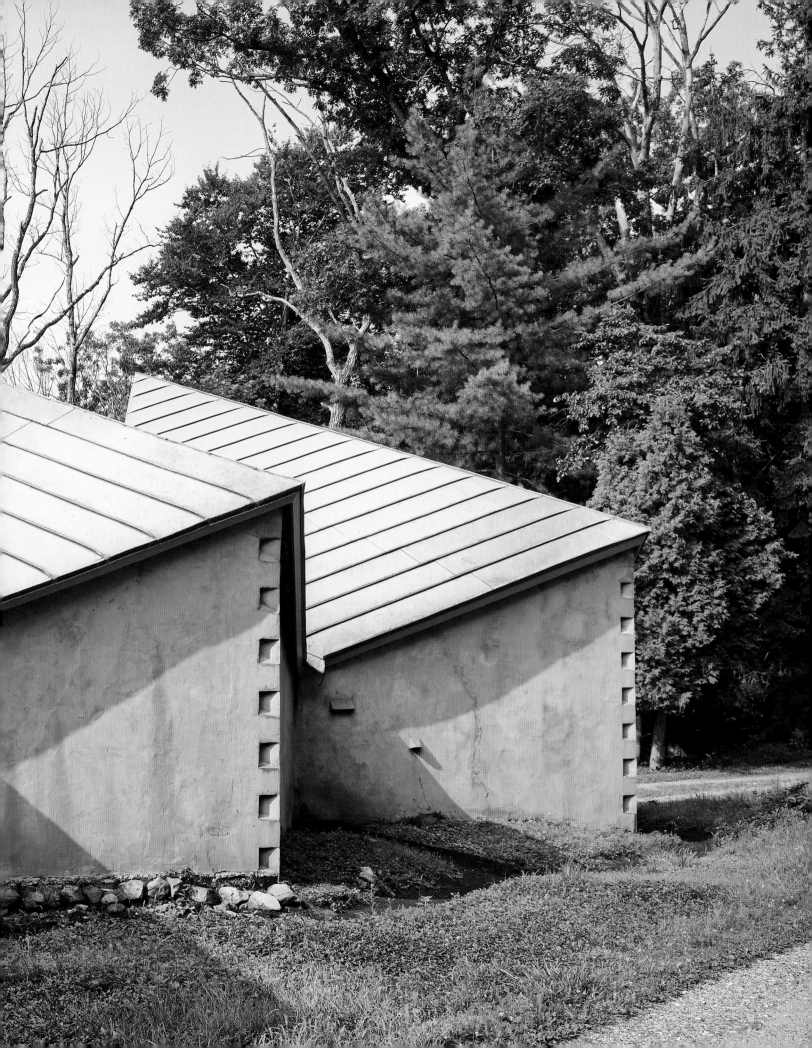

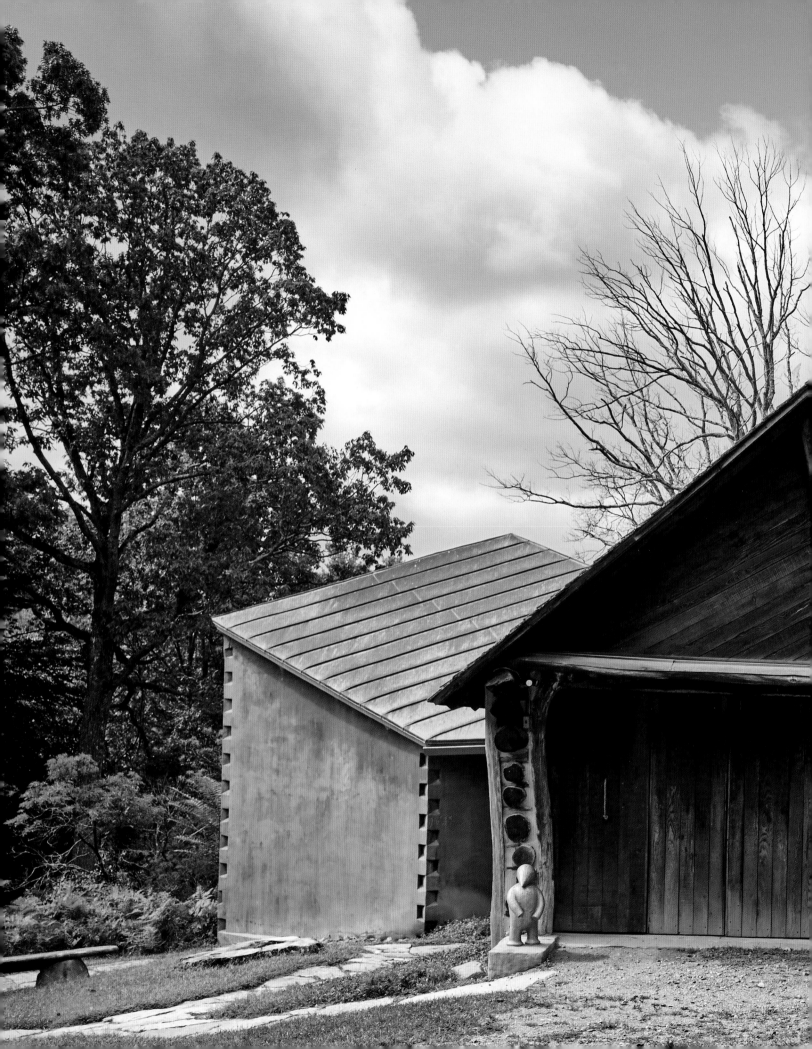

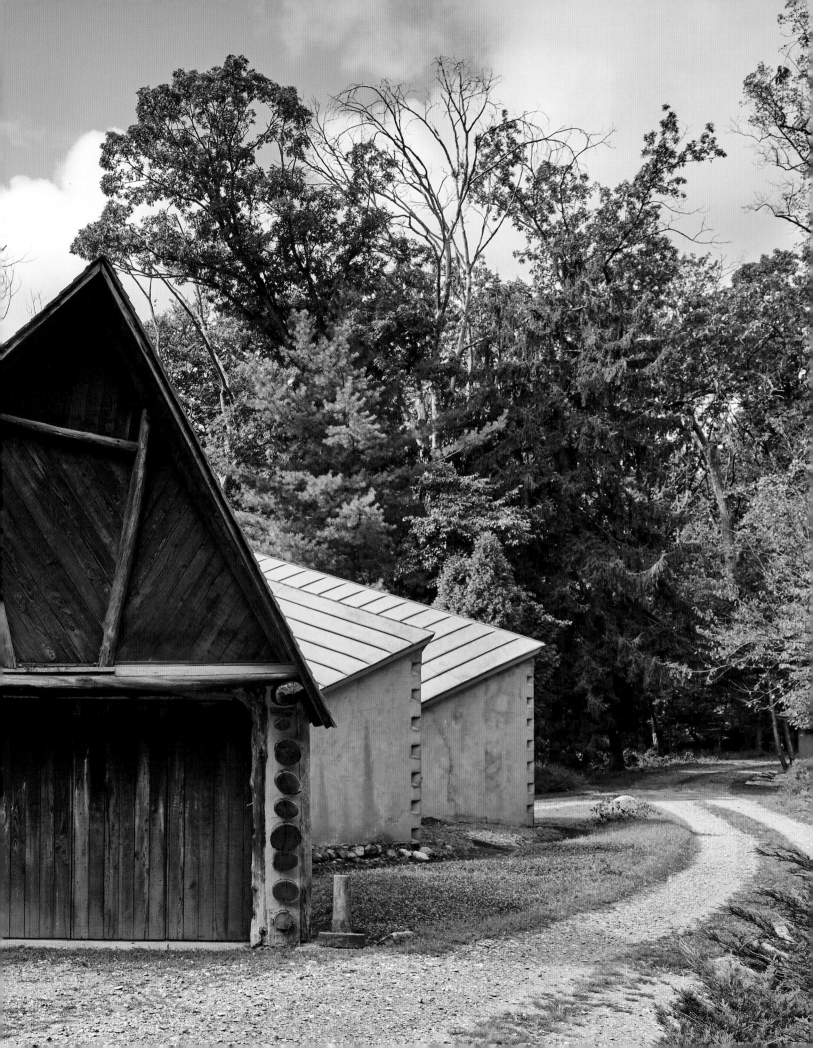

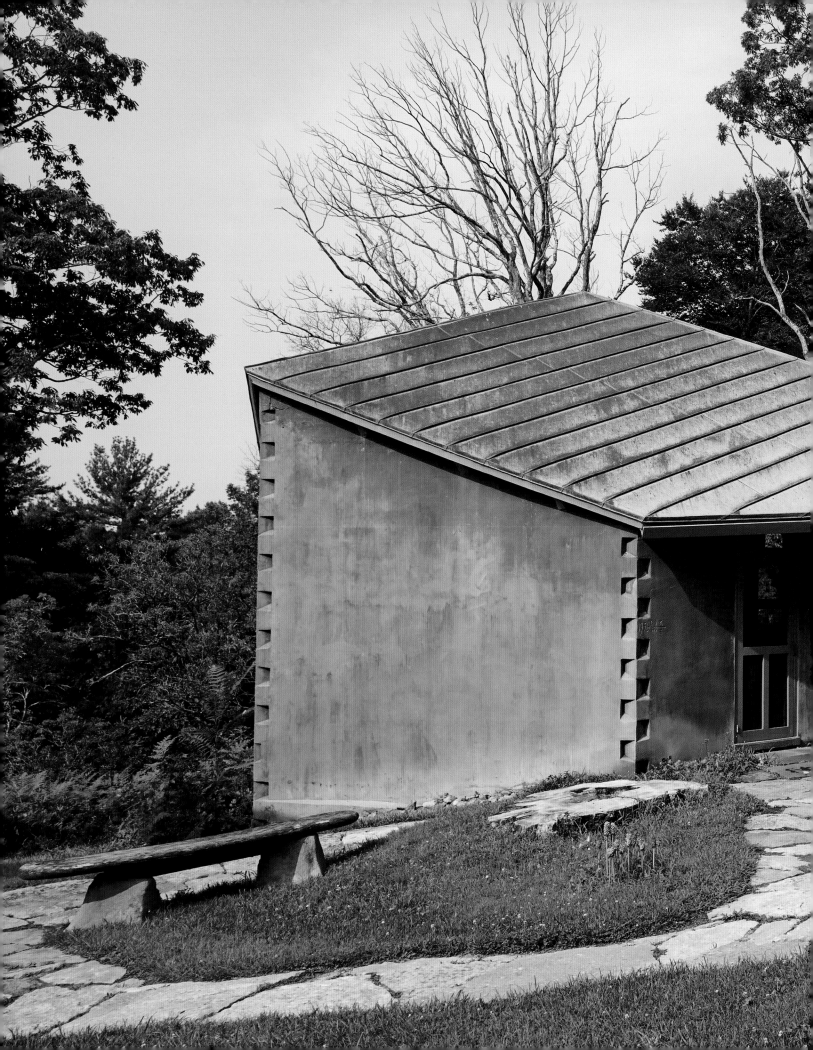

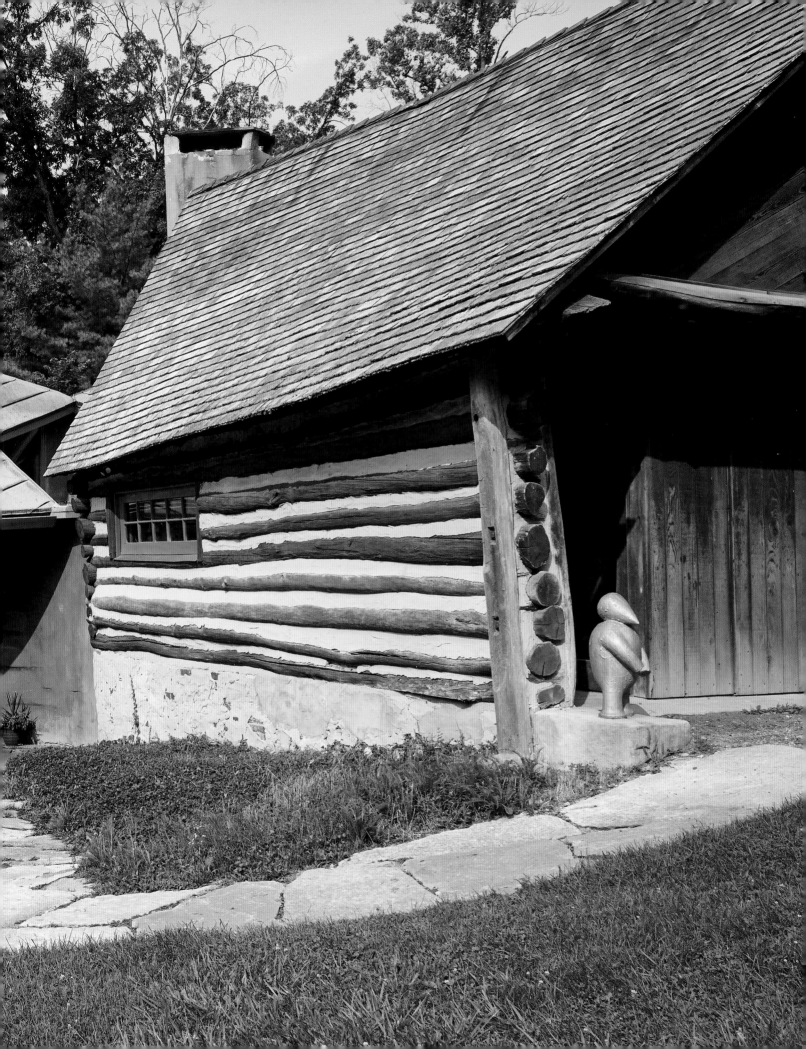

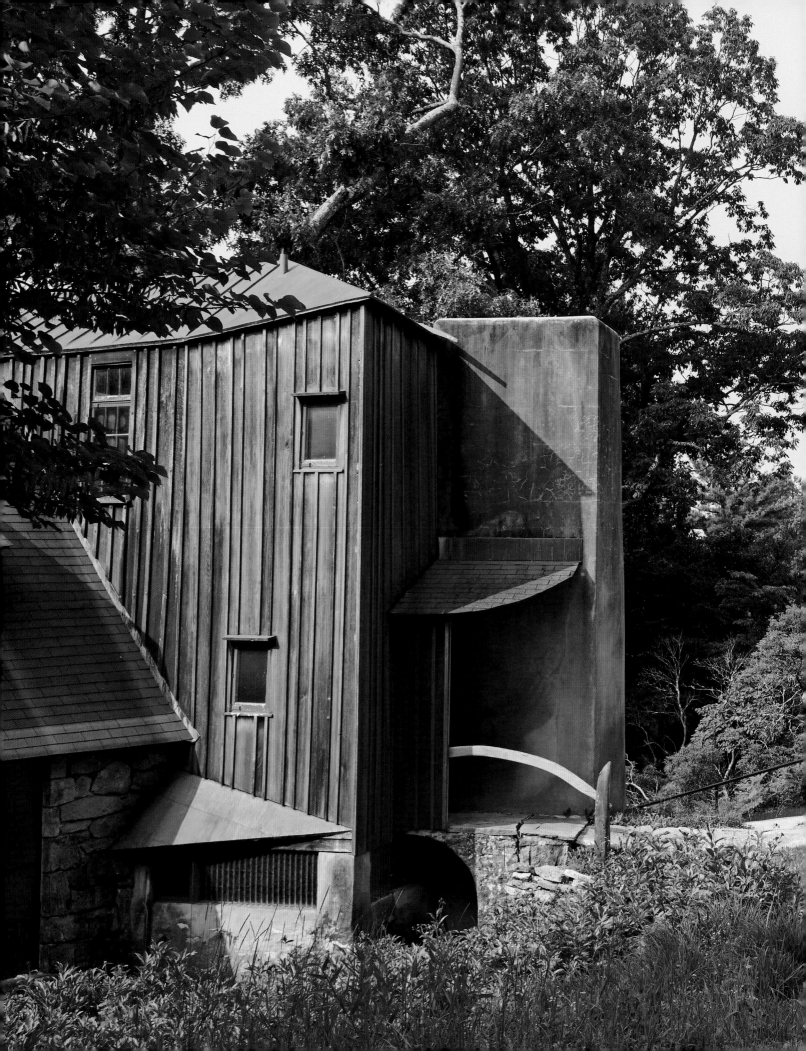

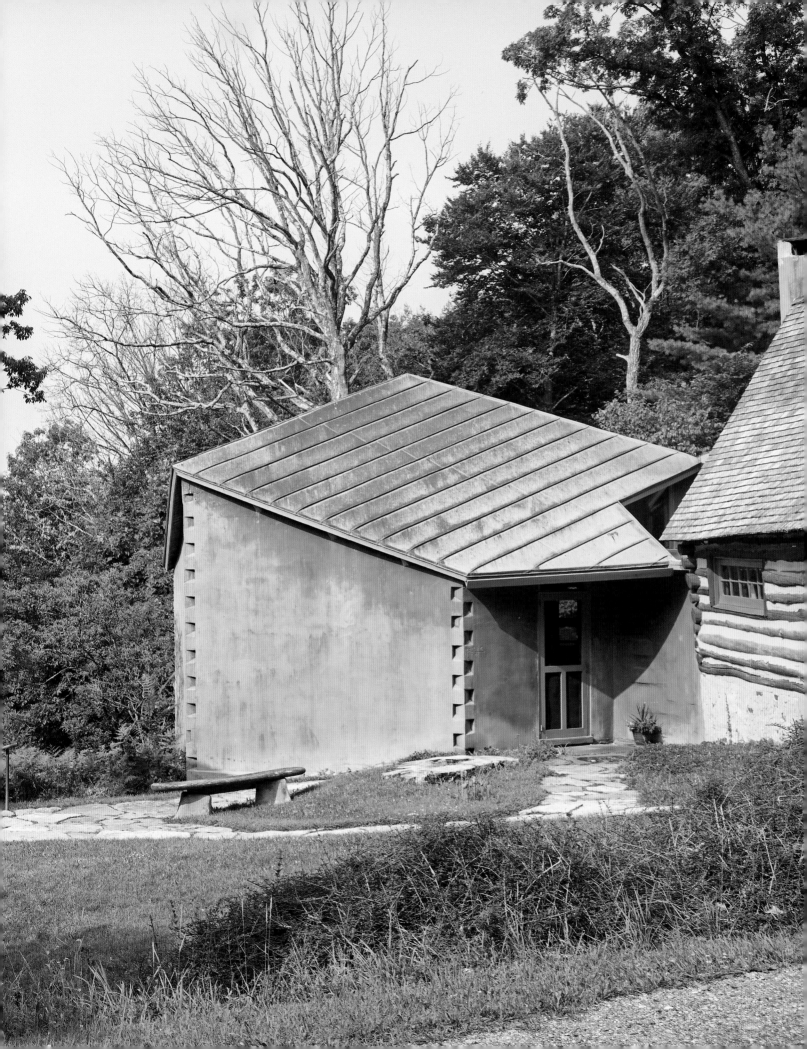

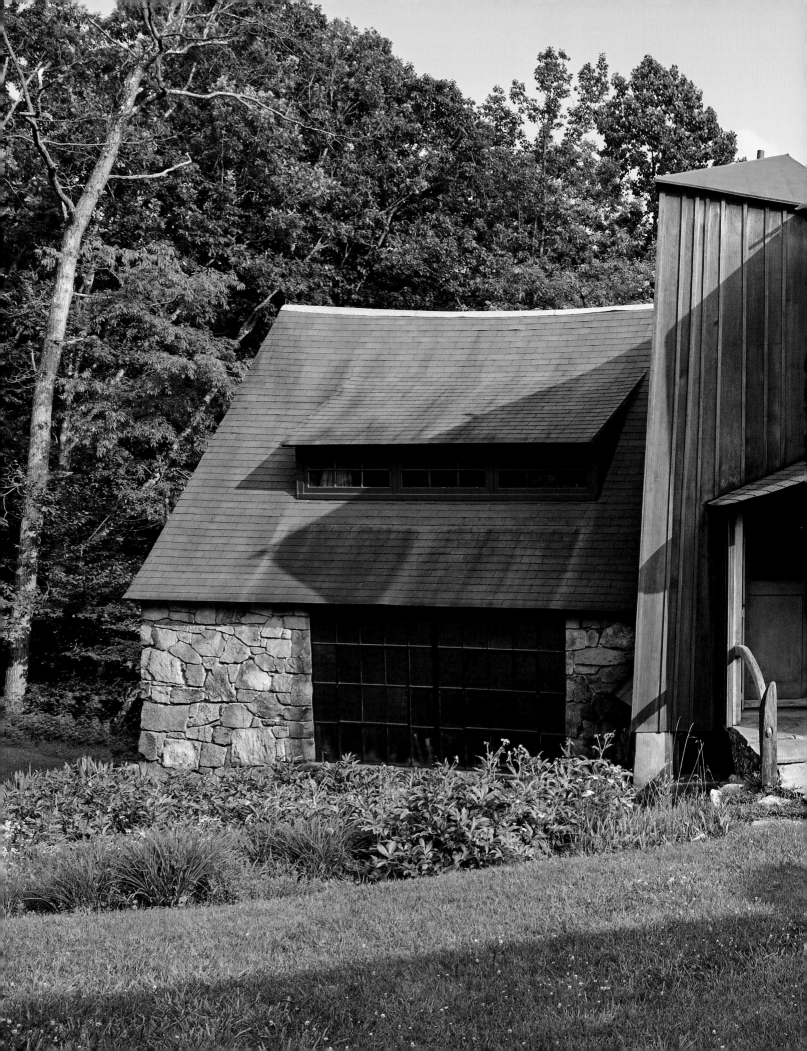

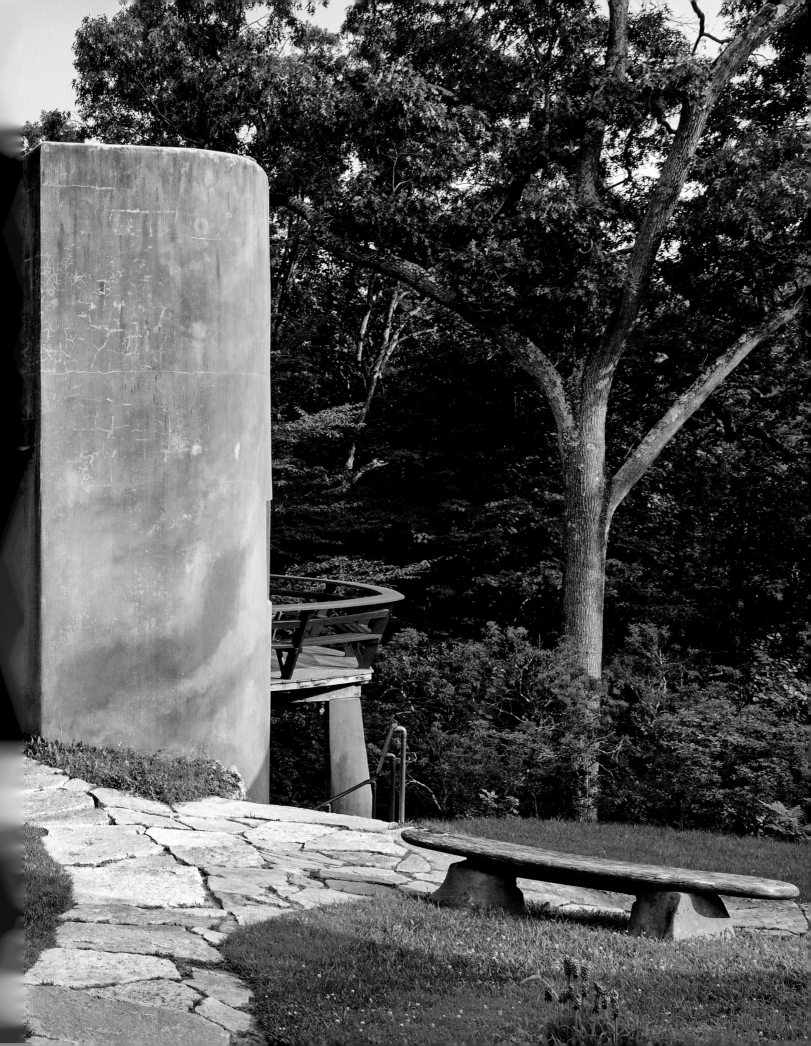

DIRECTORS' FOREWORD

▶ *THE CRAFTED WORLD OF WHARTON ESHERICK* takes you into the visionary landscape of one of the most innovative and influential artists of the twentieth century. A master craftsman and sculptor, Esherick created a world that blurred the boundaries between art and functionality and pushed the limits of wood and design. Through the pages of this publication, which features thematic essays and stunning new photography of Esherick's handcrafted home and Studio, we invite you to enter this world in a way that captures the magic of an on-site visit to the Wharton Esherick Museum (WEM).

While this exhibition was originally conceived as a small display of Esherick's woodblock prints from WEM's collection at the Brandywine Museum of Art, it quickly grew as the remarkable sweep of the artist's cross-disciplinary creative brilliance led to a more expansive examination. In a partnership forged over years of curators' visits to the Wharton Esherick home and Studio, conversations and deliberations, and marveling together over Esherick's work, Brandywine and WEM developed plans for this long-overdue reassessment of Esherick's contributions to American art, through WEM's rarely traveled collection. The exhibition and publication explore themes that are present in the home and Studio, with their rich array of artworks. They also connect Esherick's artistry to the broader intellectual and creative worlds of which he was an integral part. From sculptural furniture to breathtaking architectural spaces, each image in this publication tells a story of unwavering commitment to craftsmanship and artistic expression, as well as a deep connection to the medium of wood. Numerous moments of transformation are visible. Most striking, perhaps, is the overall evolution of Esherick's style, from early works characterized by prismatic shapes and intricate details to later organic and free-flowing designs.

Esherick's innovative approach to form and function has inspired generations of artists, designers, and makers. His career unfolded as conventional boundaries between

OPPOSITE Entrance
to the Studio kitchen
and dining room

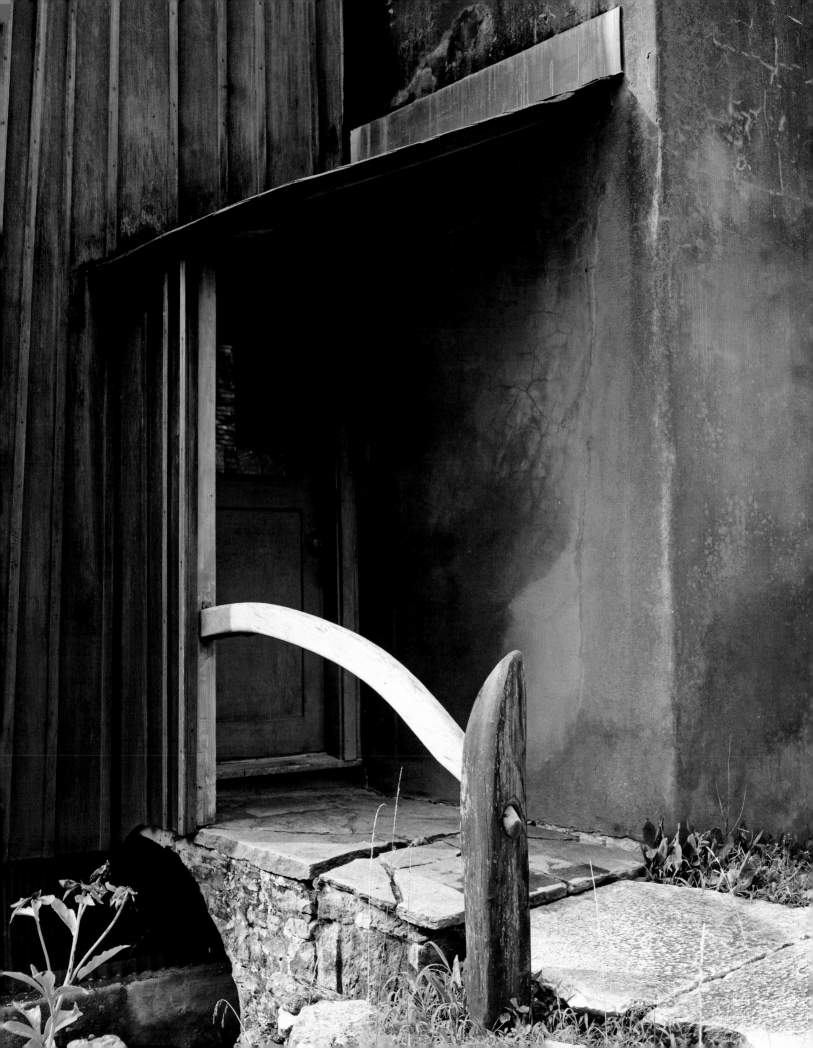

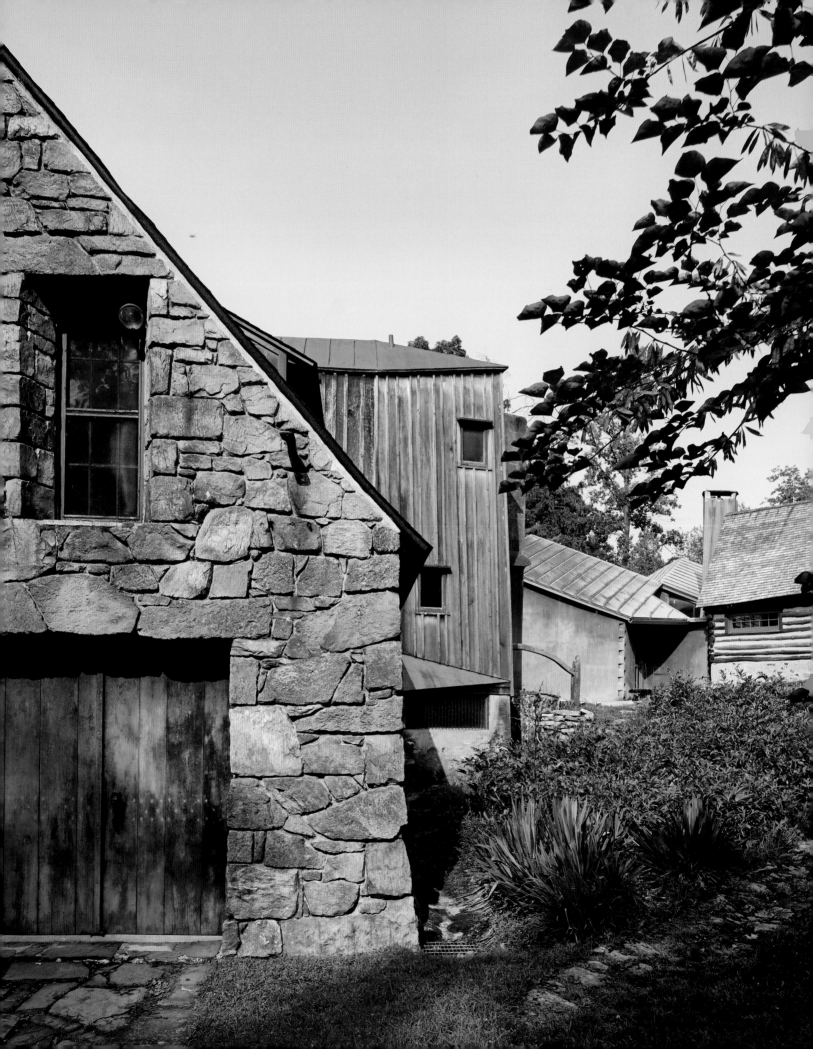

fine art and functional craftsmanship were being questioned. Esherick had rich answers to offer. His unique approach to blending form and function resulted in a body of work that challenges categorization. Because of his iconoclasm, Esherick's work resonates not only with enthusiasts of traditional woodworking, design, and "useful" craft, but also with those who see in his work the very essence of expressive creativity.

The spaces that Esherick created for himself, in which he lived and worked, offer evidence of one of his core beliefs: that our surroundings can and should reflect our individuality and enhance our lives in meaningful ways. Esherick saw the tactile nature of wood, carefully shaped by his own hands, as a principal means of fulfilling this goal. In his *Gesamtkunstwerk*—or "total work of art"—the warmth and intimacy of the spaces he created invite us to consider how the intimate objects of everyday life may be imbued with beauty, ritual, and comfort.

Emily Zilber, Director of Curatorial Affairs and Strategic Partnerships at WEM, and Amanda C. Burdan, Senior Curator at Brandywine, have been instrumental in bringing this project to fruition. We would also like to thank the Decorative Arts Trust and the Furthermore Foundation for their generous support of the catalog. We are delighted to share this extraordinary exhibition with audiences at the Chazen Museum of Art in Madison, Wisconsin, and the Taft Museum of Art in Cincinnati, Ohio. The staffs of these institutions share our enthusiasm for the project and have been wonderful partners in the process.

At WEM, we are grateful to our board of directors, staff, and volunteers for their passionate stewardship, to Mark Anderson for his expert guidance, and to our community of donors and members for their support. We would also like to acknowledge Julie Jensen Bryan and the Henry Luce Foundation for American Art for supporting projects that made this exhibition possible. Finally, our deepest thanks to Robyn Horn and the Windgate Foundation for their extraordinary investment in WEM's future.

At Brandywine, our remarkably generous board members, including in particular Cuyler H. Walker and DD Matz, encouraged this partnership between our two historic artists' homes and studios, leading to Brandywine's first-ever design-based exhibition. We also wish to acknowledge Virginia A. Logan, Brandywine's Frolic Weymouth Executive Director and CEO, for her unfailing support of the project.

JULIE SIGLIN
Executive Director
Wharton Esherick Museum

THOMAS PADON
The James H. Duff Director
Brandywine Museum of Art

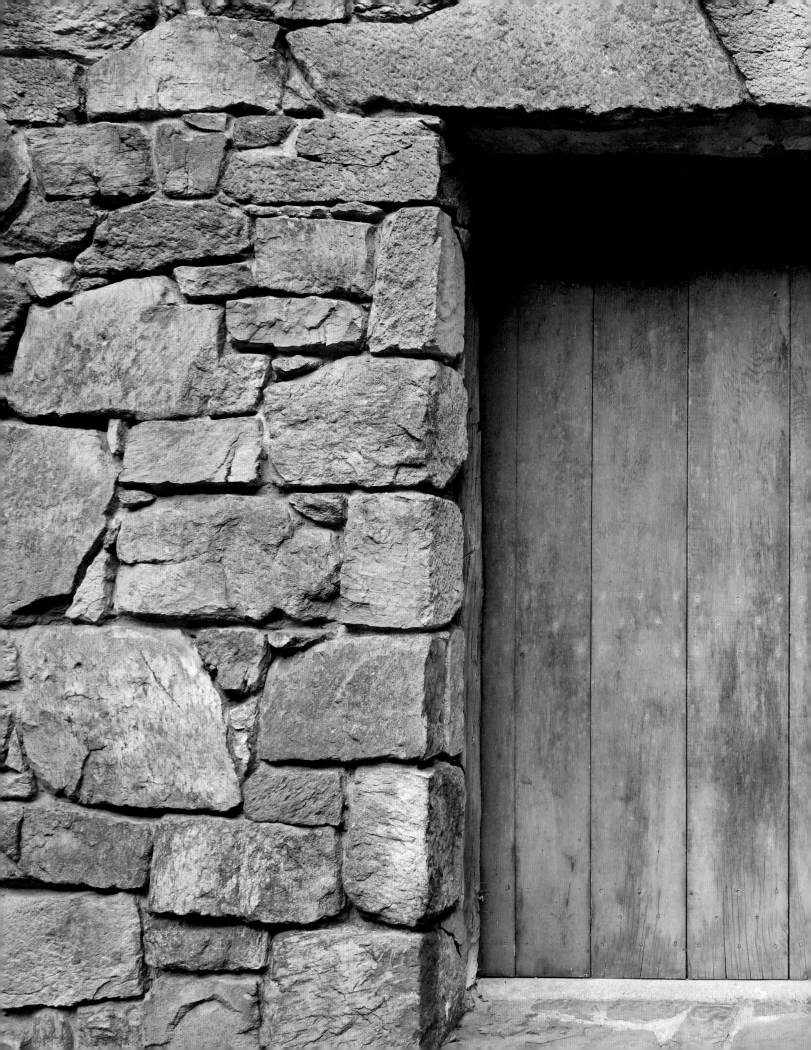

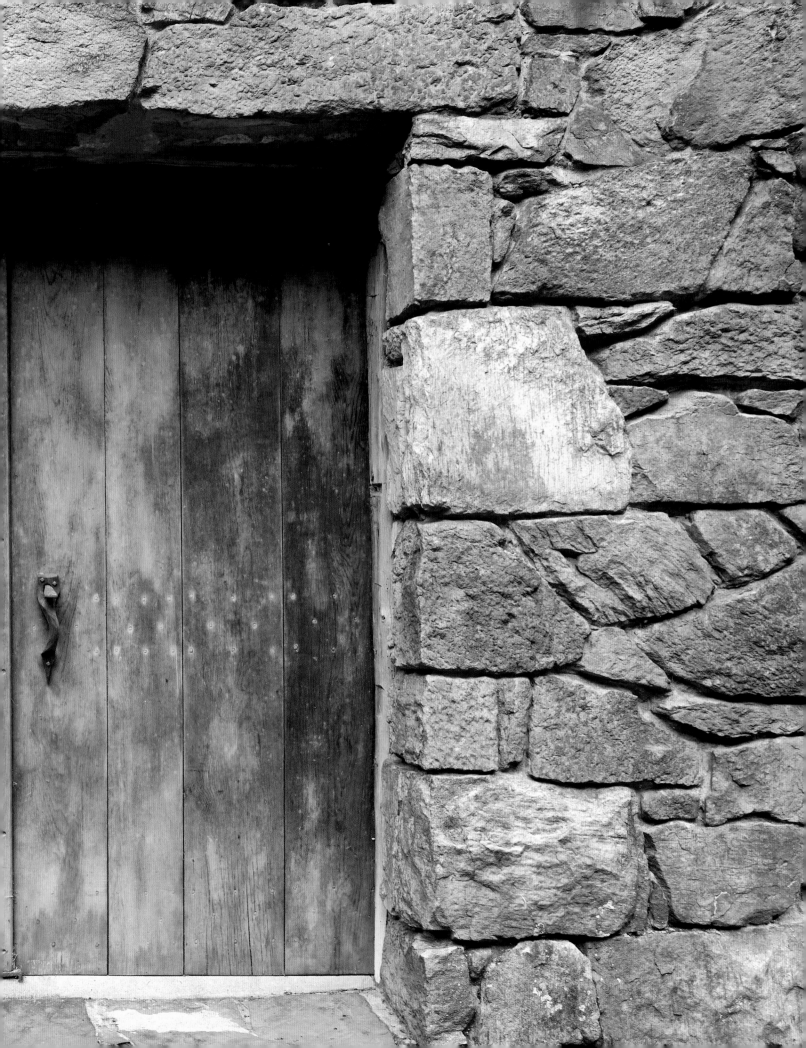

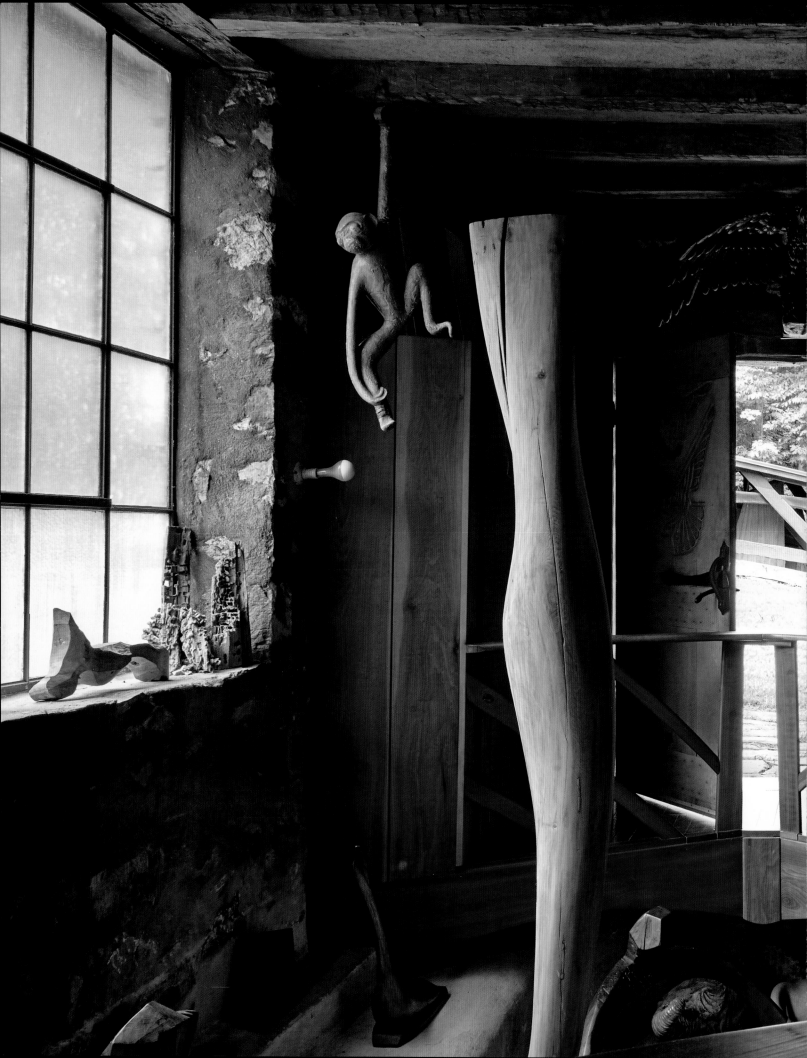

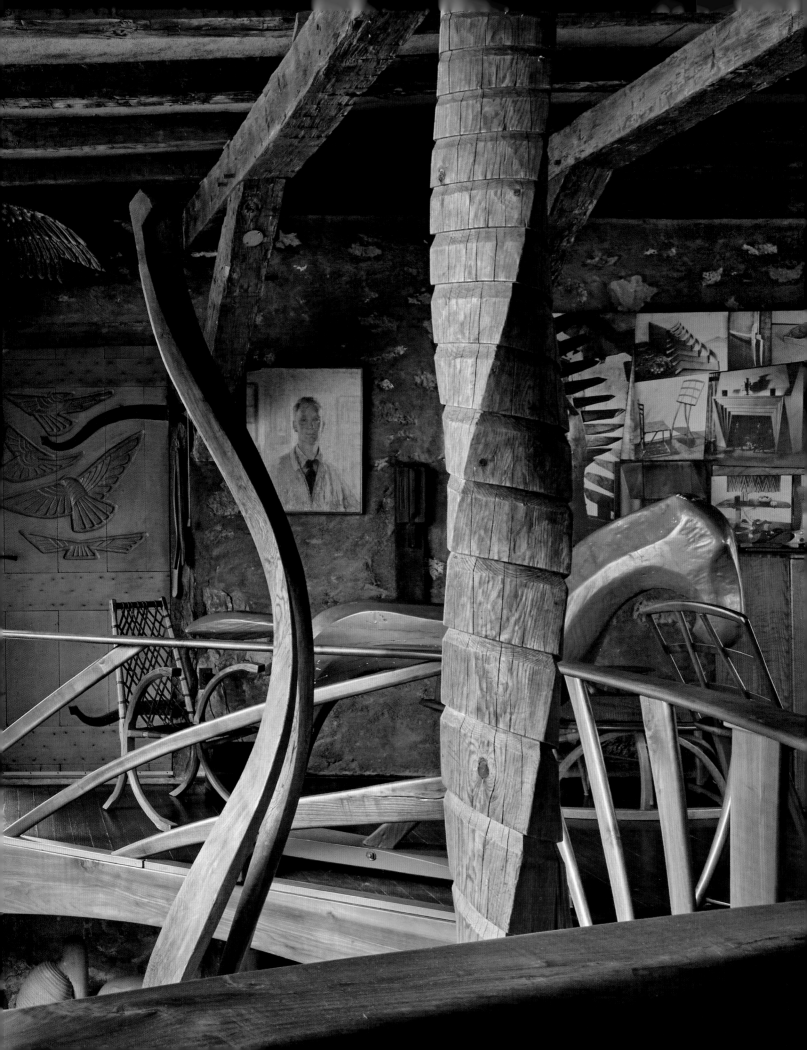

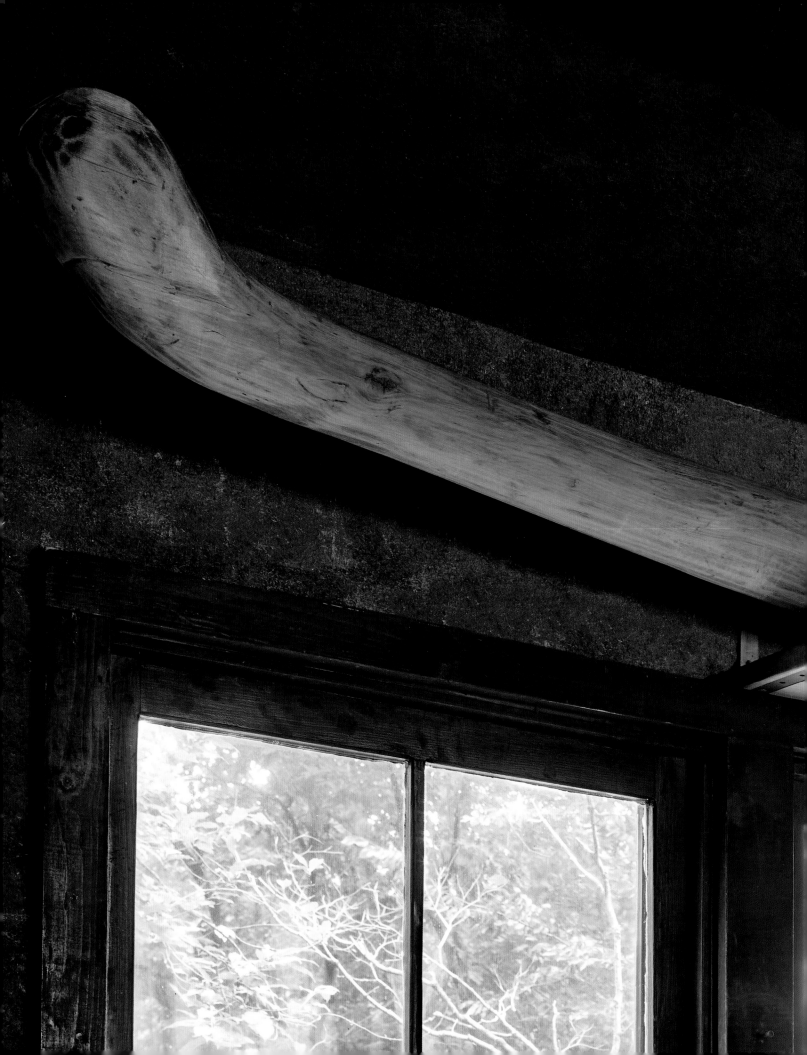

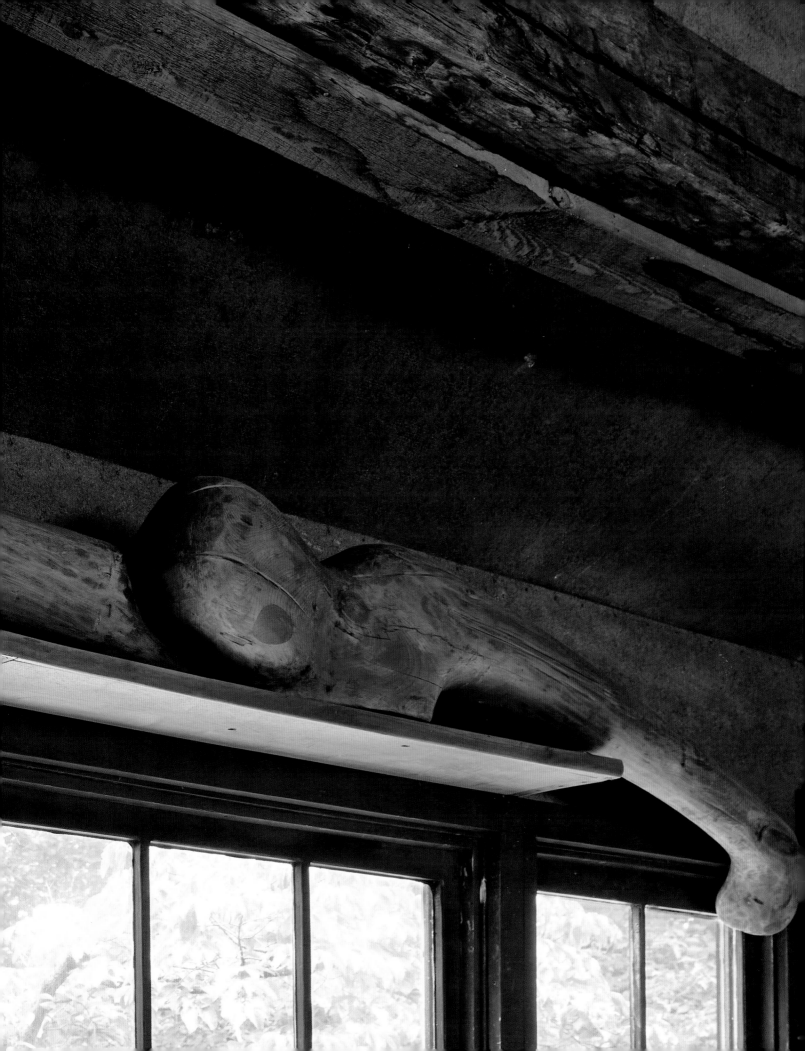

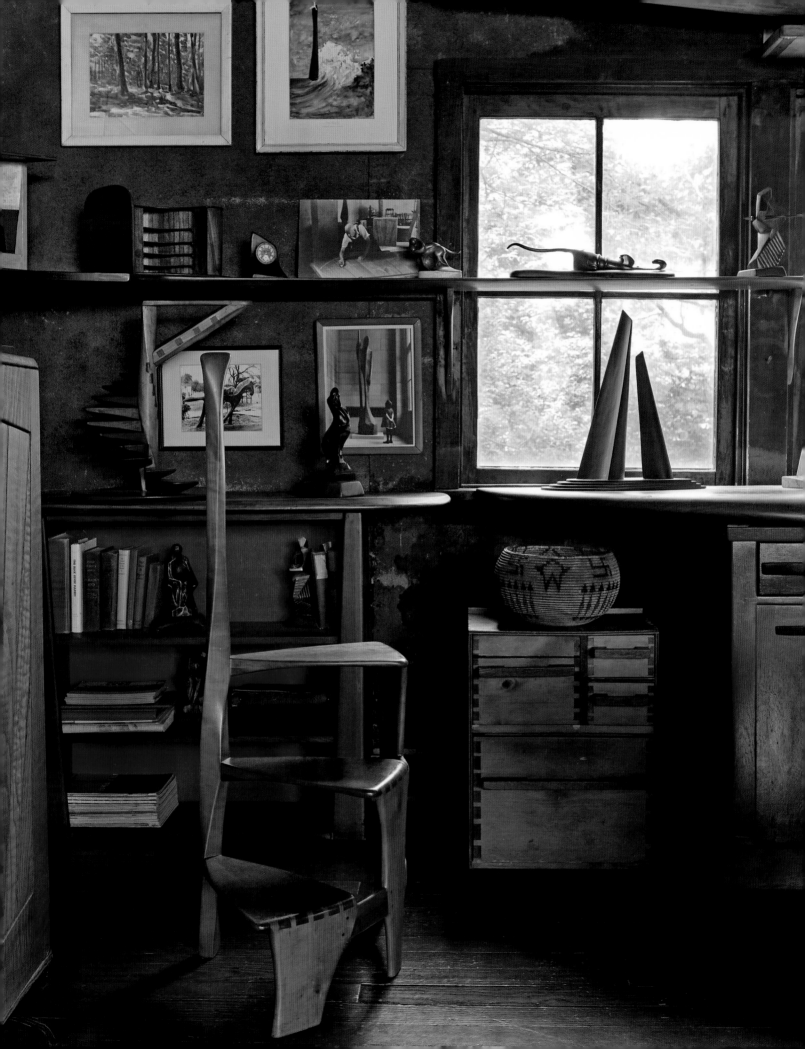

THE CRAFTED WORLD
OF WHARTON ESHERICK

HOLLY GORE AND EMILY ZILBER

► **BUILT INTO THE STEEP SOUTH-FACING SLOPE** of Valley Forge Mountain in Pennsylvania, the Wharton Esherick Studio is a total work of art. The handcrafted building was the home, workspace, and forty-year project of Wharton Esherick (1887–1970), an artistic polymath best known for his Modernist furniture and sculpture. The architect Anne Tyng, a frequent visitor to the Studio in the mid-1950s, remembered it as a place where art was integrated with everyday life. There, art dwelt in the smooth workings of a carved wood door latch; it resided in Esherick's movements in opening the door when he welcomed her in for dinner; and it slid along the sculpted contours of the serving bowls that he set on the table. "Even the food," Tyng recollected, "worked with all the forms he'd done."[1]

Self-expression is at the heart of the Esherick Studio. From its walls and roofline to tiny details of light pulls and drawer dividers, the building beckons visitors to share in the artist's humanity: his life stories, intellectual appetites, sense of humor, love of barns and sailboats, and understanding of sculpture as something far more expansive than a category of rarefied, nonfunctional objects. Esherick broke ground on the Studio in 1926, declaring his identity as a rural artist with a building of locally sourced sandstone that was modeled on a Pennsylvania bank barn. In subsequent decades, he made a series of sculptural additions to transform this workspace into a home and gallery. The last of these was in 1966, a curved concrete and stucco add-on he called his "silo." Painted with the colors of fall foliage, the silo reflects Esherick's deeply rooted dedication to living close to nature, as well as the season of his own life at the time of its construction. For most of the years that Esherick lived in the Studio, he did so alone. Still, the building is a sociable space, hospitable to visitors in its communicativeness.

This kind of unfettered self-expression was far from Esherick's birthright. Born in 1887, he grew up as one of seven children in a wealthy West Philadelphia family, with parents who envisioned a more conventional upper-class lifestyle for their son. Nonetheless, he

OPPOSITE Furniture, sculpture, models, and other artworks in the Main Gallery of the Studio

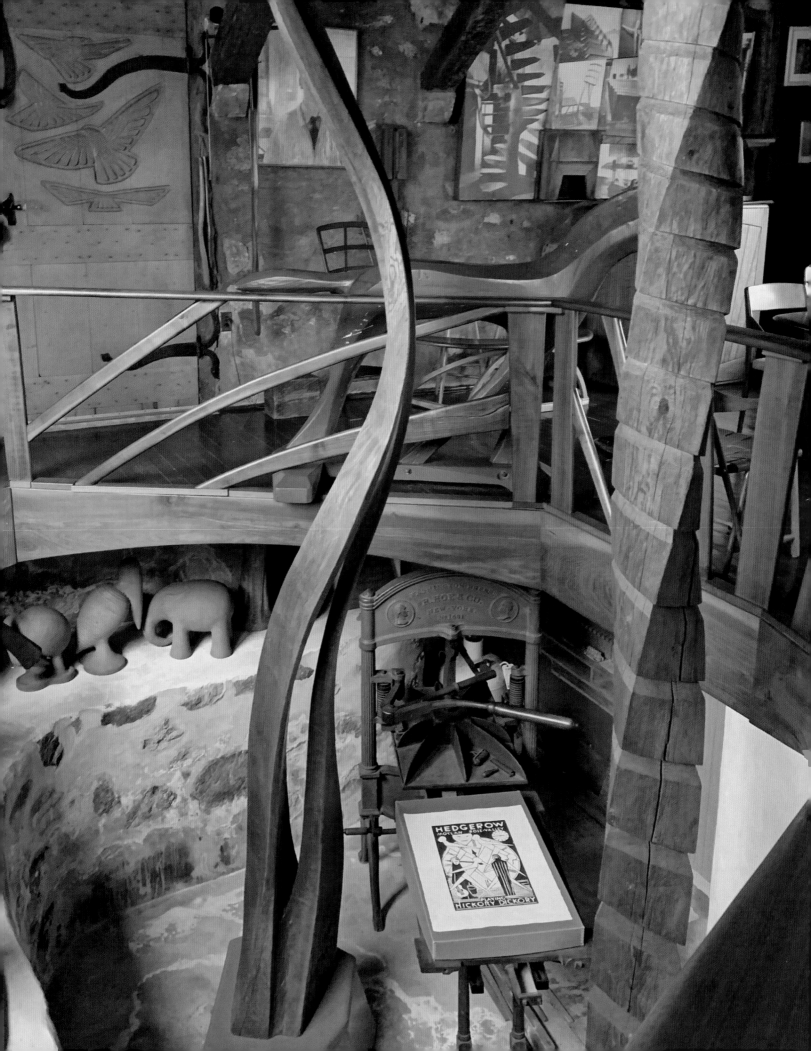

was determined to be an artist, studying woodworking and metalsmithing at Philadelphia's Central Manual Training High School and drawing and printmaking at the Pennsylvania Museum and School of Industrial Art (now the University of the Arts). In 1908 Esherick entered the painting program at the Pennsylvania Academy of the Fine Arts (PAFA), where he had the opportunity to learn from significant American Impressionists including Thomas Anshutz, Cecilia Beaux, William Merritt Chase, and Edward Redfield. Still, Esherick yearned for more freedom to experiment stylistically than PAFA afforded him. He left six weeks shy of completing the two-year nondegree program in 1910. For the next several years, he worked as a commercial illustrator, although not a terribly successful one.

In 1912 Wharton Esherick married Leticia (Letty) Nofer, who came from a similar background and held similarly unconventional views. The pair settled in an 1830s farmhouse on Valley Forge Mountain, twenty-five miles west of Philadelphia. They named their new home Sunekrest (pronounced "sunny crest"), for its hillside location and southern exposure. There, the young couple embarked on an experiment in homesteading. They planted enormous gardens to feed the family, which grew to include three children, raised animals for meat, and kept bees. Letty had a peony farm and taught dance. Wharton abandoned commercial illustration to devote himself to painting. For more than a decade he attempted to make a living from sales of his Impressionist-style canvases. In all, the Eshericks cultivated a nature-based, creative lifestyle that was a far cry from their elite roots.

The winter of 1919–20 marked a turning point in Wharton Esherick's career. Letty's interest in contemporary theories of education brought the family to Fairhope, Alabama, the site of an artists' colony and a cutting-edge progressive school led by the reformer Marietta Johnson, who gave Esherick a set of woodworking tools. In Fairhope, he began carving wooden frames with designs that reflected the subject of the paintings they surrounded, as well as woodblocks for printmaking; he would eventually carve more than four hundred blocks. He also began working with three-dimensional forms during this time. After he returned to Pennsylvania, he began carving designs into preexisting furniture and creating original works of sculpture that stylistically bridged Arts and Crafts and Modernist ideas.

By the mid-1920s Esherick was making his own furniture. Although he never formally trained in the craft, his construction abilities grew under the guidance of his friend and neighbor John Schmidt, a skilled cabinetmaker trained through a rigorous apprenticeship in his native Hungary. Esherick gradually transitioned away from work that prioritized the pictorial in favor of a focus on form and material. Influenced by artistic currents of German expressionism and geometric abstraction, as well as holistic philosophical movements like Rudolf Steiner's Anthroposophy, he began to create works that blurred the distinction between furniture and sculpture.

This pushing of boundaries and drive toward experimentation incubated in small, alternative communities where Esherick's work found acclaim, such as the avant-garde Hedgerow Theatre, a repertory company situated in the Arts and Crafts community of Rose Valley, Pennsylvania, for which he designed everything from stage sets and posters to furniture and architectural features. Indeed, Esherick began to think of himself primarily as an artist who could bring his distinct aesthetic vision to any medium and in any dimension,

OPPOSITE The Sculpture Well in the Main Gallery holds large works as well as a printing press

and found himself in need of a studio space befitting this ambition. In 1926, with the labors of a community of skilled craft and trade workers, and a financial gift from his grandmother to purchase a seven-acre parcel of land adjoining the homestead, Esherick was able to create a workspace that supported his expansive interests.

Esherick's daily walk from Sunekrest to the Studio was on a path through the woods. This short, steep trail marked his transition from life at the family farmhouse to his growing engagement with wood in the building that gradually became his full-time home. Once he reached the door of his Studio, with its hand-carved handle and its blue paint that reflected the surrounding sky, he had arrived at a space of new possibilities (despite still being close enough to Sunekrest to see it on the hillside below him). The original 1926 entry to the Studio was a vestibule opening onto a cavernous, stone-walled room framed with salvaged timbers. Sunlight filtered through a north-facing factory window. This was the main workspace until the 1950s, when Esherick converted it into a gallery, excavating the earth floor to create a terraced well for exhibiting his monumental sculptures. He frequently invited friends and supporters into the space to be immersed in his creative vision for architecture: buildings and interiors that were sculptural at the same time as they honored the craft of construction. These same ideals manifest on a smaller scale throughout the furniture in the room. Many of the works on view—desks, chairs, stools, cabinets, and benches—combine traditional furniture joinery with Modernist sculptural form.

This was Esherick's signature approach to design, for which he is credited as a formative innovator of American studio furniture, the mid-century movement in which individual practitioners, many of them with formal academic training, created furniture objects as singular works of art. For this postwar generation of artists who married artistic vision with craft materials and skills, Esherick was a prescient figure who offered a meaningful model as they shaped their own careers. For example, although Esherick never taught formally, the artist Wendell Castle called Esherick his "reluctant teacher," one who imparted lessons about how "furniture can actually be art—not just be like art, or something related to art—it can be art."[2]

Esherick's Studio has been preserved as it was at the end of the artist's life, allowing contemporary visitors to take the same journey through the space as Esherick's friends and colleagues. From the main level, a spiral staircase winds upward, branching and dividing left and right to connect the main gallery to domestic spaces above. The staircase left leads to the dining room and kitchen. Though these spaces are tight, they have a light feel, with windows giving a long view over the Great Valley to a horizon three miles south. In this and other details—odd-angle built-ins, glossy polyurethane-finished woodwork, raised lips on the edges of countertop and shelves, a ceiling lamp shaped like a tiller, and the efficient use of space—the dining room and kitchen recall Esherick's lifelong love of sailing. Helene Koerting Fischer, an early major patron, told him that a room he furnished for her made her feel like she was on a sailboat. He wrote back: "Sailboat means summer, sky, blue sky, light clouds. Really, I was not after but a mood. Did I get it?"[3] Ever the expressive artist, Esherick strove to convey more than the physical attributes of boats, evoking the experience of being on the water.

OPPOSITE Sculptural staircases lead from the Main Gallery to the bedroom (*right*) and dining room and kitchen (*left*)

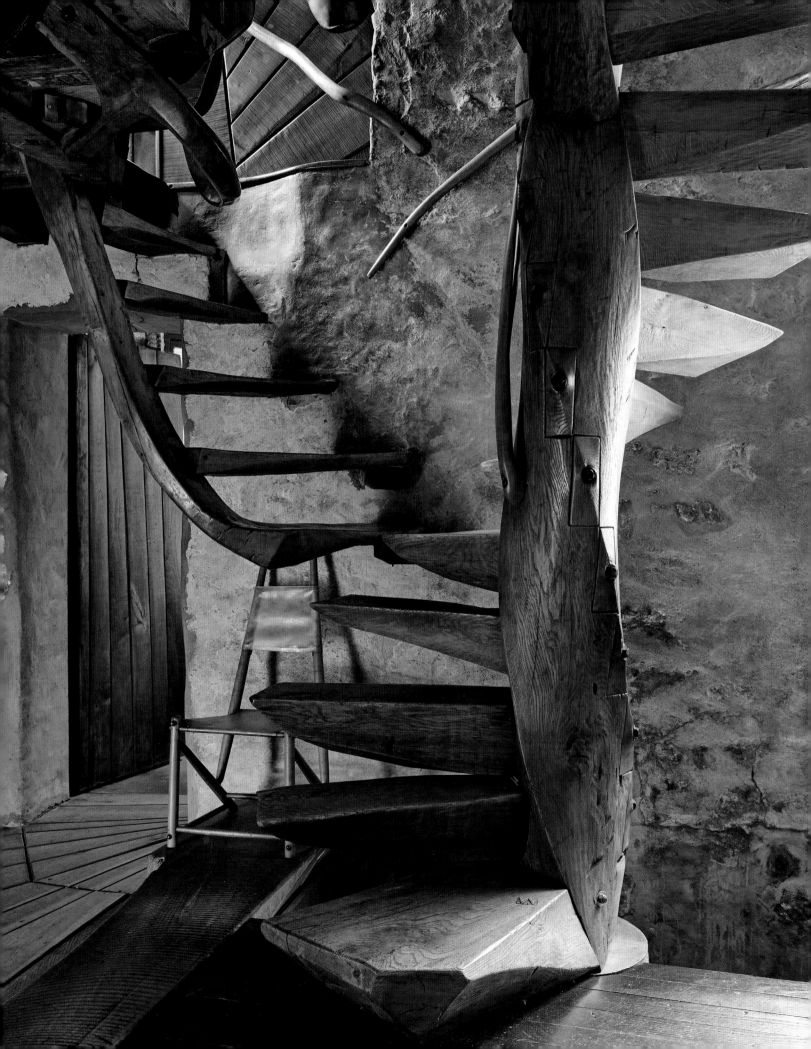

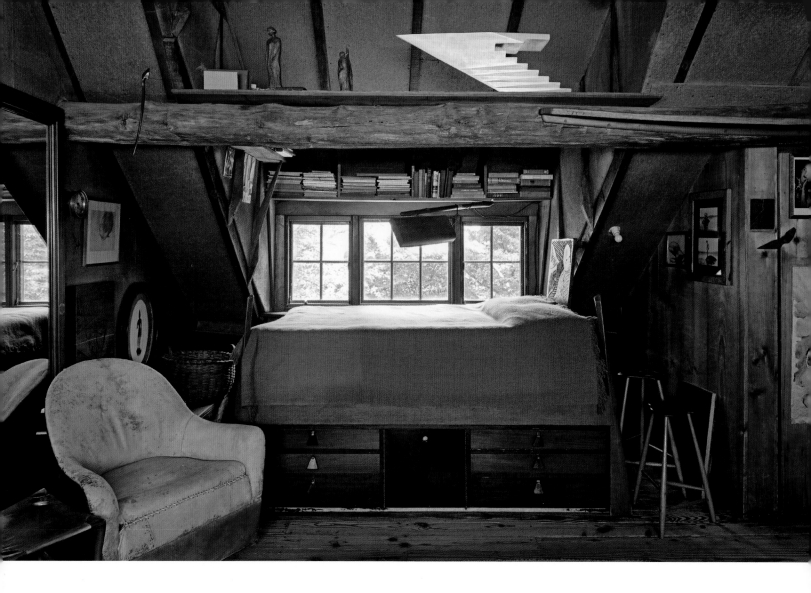

Intimacy is the tenor of Esherick's bedroom, accessed through a trapdoor opening atop the right branch of the staircase. The artist filled this cozy loft with personal objects including books, clippings, family photographs, and artworks by friends. This was a private space, though some guests were invited to ascend through the hatch where, in a wry touch, he had tacked a clipping with the words "at last man has reached the top of the world." The bedroom decor hearkens back to Esherick's early fascination with dynamic, jutting forms. The ceiling, pieced together from fiberboard insulation, is a composition of prismatic shapes. These angular forms carry through in the lines of the two-poster captain's bed. Anne Tyng admired the way that Esherick placed the bed within a dormer, setting the mattress level with the windowsill.[4] She created a similar setup when she renovated her Philadelphia townhouse, with a sleeping nook overlooking the city rooftops, as Esherick overlooked farms in the valley.

While the home and Studio are perhaps the most personal record of Esherick's creative shifts from the 1920s to the 1960s, he also found great public acclaim from significant commission and exhibition opportunities. Between 1935 and 1938, he designed a suite of interiors for the home of Pennsylvania State Supreme Court Justice Curtis Bok, including

ABOVE The artist's bed, next to a window overlooking the valley below

NOTES

1 Anne Tyng, oral history
 interviews with Mansfield
 Bascom, Ruth Bascom, and
 Susan Hinkel, June 1987. Oral
 History Archive, Wharton
 Esherick Museum.

2 Quoted in "Wharton
 to Wendell" (2021),
 whartonesherickmuseum.org/
 wharton-to-wendell/.

3 Wharton Esherick to Helene
 Koerting Fischer, Jan. 19, 1940.
 Wharton Esherick Family
 Papers, Wharton Esherick
 Museum.

4 Anne Tyng, oral history.

a fireplace now in the collection of the Philadelphia Museum of Art. The Pennsylvania Hill House, built for the America at Home pavilion in the second season of the New York World's Fair in 1940, positioned Esherick's Studio and its contents as part of the "World of Tomorrow." Twenty years later, he was given the first single-artist retrospective at the newly established Museum of Contemporary Crafts (now the Museum of Arts and Design) in New York City (1958–59), affirming his place as a foundational figure of both the studio craft and the modern design movements. Esherick continued creating new work until his death in 1970, at the age of 83, including some of the most celebrated and collected forms of his career, such as the sculptural and elegant *Library Ladder*, first designed for a client in 1966 (see p. 170).

Today, Esherick's work can be found in countless museums around the globe, and his creative legacy continues to influence not just furniture makers or those working with wood but artists across disciplines. Many of these artists have located their inspiration in Esherick's Studio and the surrounding site. For example, in 2018 the painter Becky Suss depicted the space as both inclusive in its welcome and fundamentally idiosyncratic in a series of evocative images. Since that time, Esherick's life and work have allowed numerous artists-in-residence at the Studio site to find themselves through his story. Despite his outsize impact and continued relevance, few publications address his legacy through the overarching themes that shaped his complex and pathbreaking artistic life. This publication aspires to a comprehensive representation of how Esherick approached life, art, and the integration of the two.

The essays that follow invite readers into the artist's space and mind simultaneously. While Esherick is often discussed in terms of biomorphism, Sarah Archer explores the ways that patterns drawn from living organisms served as a bridge between his work in two and three dimensions. Esherick's escape to the country figures into two essays: Colin Fanning explores his rural existence in relationship with his deep ties to urban clients, artistic movements, and artistic colleagues, while Emily Zilber looks at the mechanics, forms, and philosophies of the natural world that influenced the artist's work. Holly Gore connects Esherick's study of the human body and exposure to avant-garde dance communities with the rhythms that appear throughout his practice. Finally, Ann Glasscock addresses how Esherick shared the work of the Studio with broader audiences through significant exhibitions in his later decades. The evocative new photography of the Studio is the skillful work of Joshua McHugh. His atmospheric images capture the transformative quality of a visit to this special space, which the Wharton Esherick Museum has facilitated for thousands of visitors since 1972. ▼

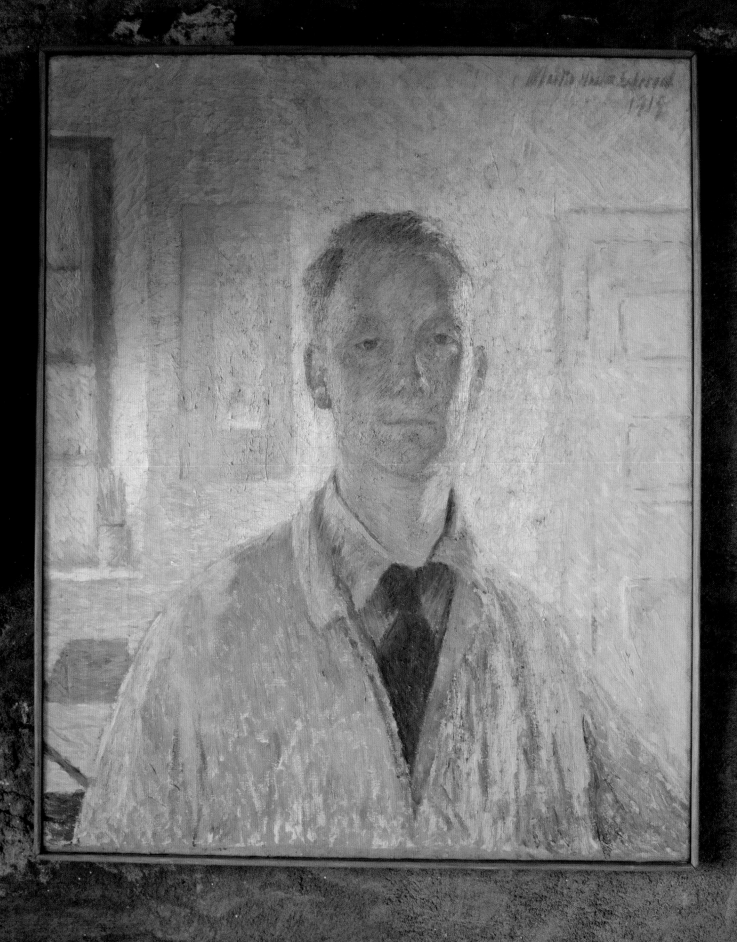

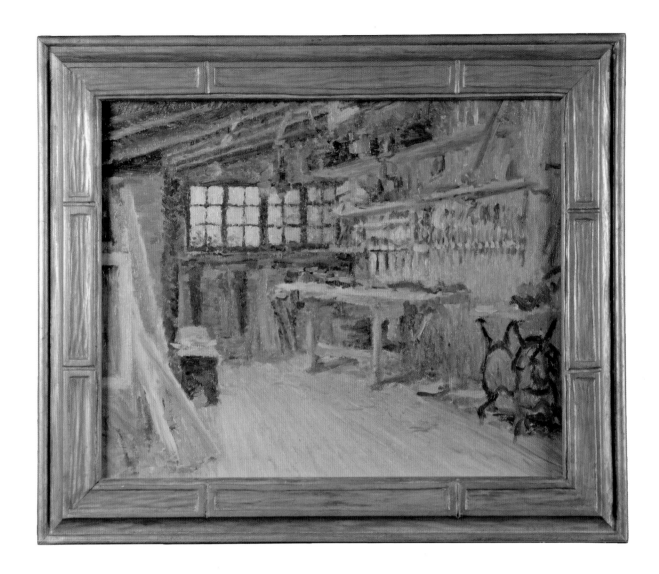

Self-Portrait, 1919
Oil on canvas
31 × 26 in.

ESHERICK DEPICTS HIMSELF in a traditional painter's smock, the uniform of students and faculty at the Pennsylvania Academy of the Fine Arts, with brushes resting on the windowsill behind him. While this painting showcases his deft handling of some of the primary elements of American Impressionism, including soft colors, expressive brushstrokes, and captured light, Esherick's unique voice was still being formed. This canvas was completed shortly before his life-altering trip to Fairhope, Alabama, and seven years before he began to build his hilltop Studio to accommodate his transition toward three-dimensional work.

Woodcarver's Shop, 1922
Oil on canvas, carved wood frame with metallic paint
20½ × 24¾ in.

PAINTED JUST THREE YEARS after Esherick's self-portrait, *Woodcarver's Shop* reflects significant changes in his creative life after he was given carving tools by the educational reformer Marietta Johnson at her School for Organic Education in Fairhope. After returning home, Esherick began converting a harness shed on his property into a woodcarving shop, depicted here in its original hand-carved frame. By the summer of 1922, his first major woodblock printing project—illustrations for *Rhymes of Early Jungle Folk*, a children's book on evolution by the American socialist author Mary Marcy—was well underway.

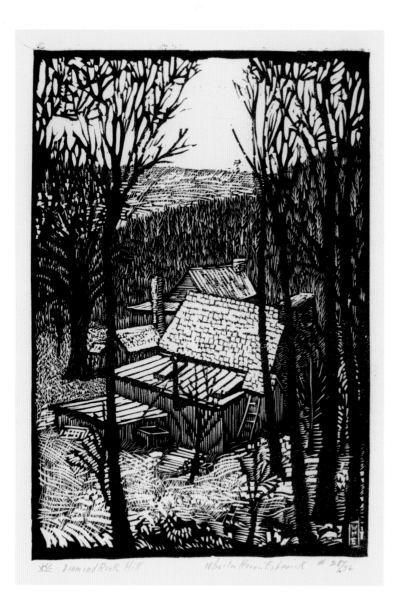

Diamond Rock Hill

LEFT

Diamond Rock Hill, 1923
Woodblock print
9 × 6 ½ in.

PRODUCED THREE YEARS before construction
began on the Studio, this print shows the view from
the site looking down onto Sunekrest, the artist's
family home. In the evenings, Esherick would walk
to the top of the hill and watch the sunset over the
valley. His desire to maintain the rural landscape
around his property as the surrounding area was
being built up may have led him to this site for
the Studio. Diamond Rock Hill, named for a large
outcrop of rock studded with quartz crystals,
almost became a quarry before Esherick acquired
the land.

OPPOSITE

Consuelo Kanaga (1894–1978)
Wharton at His Studio Entrance, ca. 1927
Photograph
5 × 4 in.

THIS PHOTOGRAPH OF Esherick at the entrance
to his hillside Studio shortly after its first phase
of construction was completed was taken by his
client and friend Consuelo Kanaga. The naturalistic
framing of the image reflects her affiliation with
Group f/64, a California collective whose members
included Ansel Adams, Imogen Cunningham, and
Edward Weston. They were committed to recording
life "as it is" through documentation and framing
techniques that departed from the Pictorialist
standards of photographic composition. Kanaga
took numerous photographs of Esherick, as well as
of his family, Studio, and artwork, over the course of
their friendship.

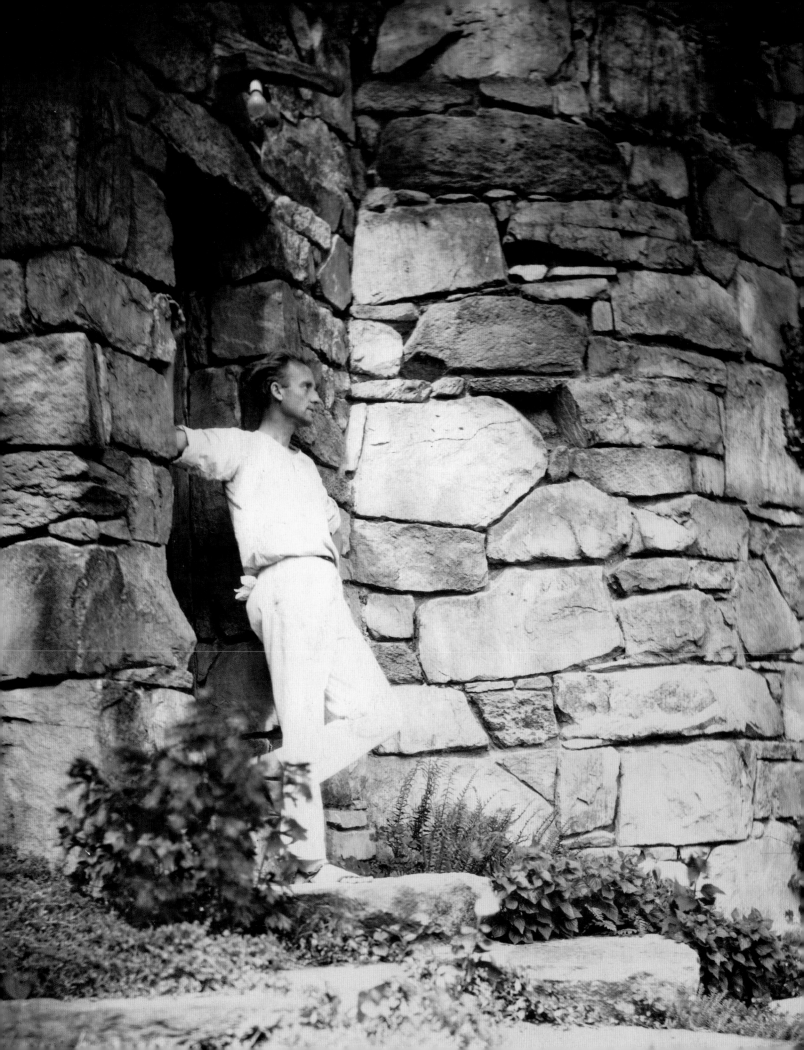

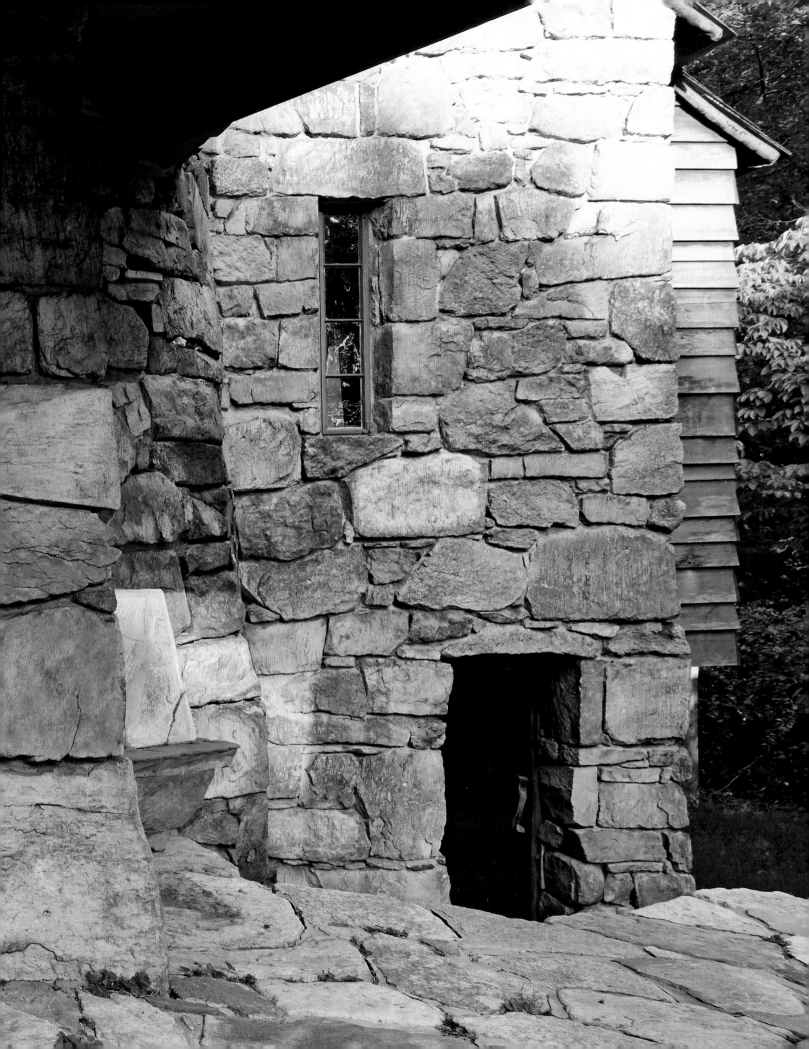

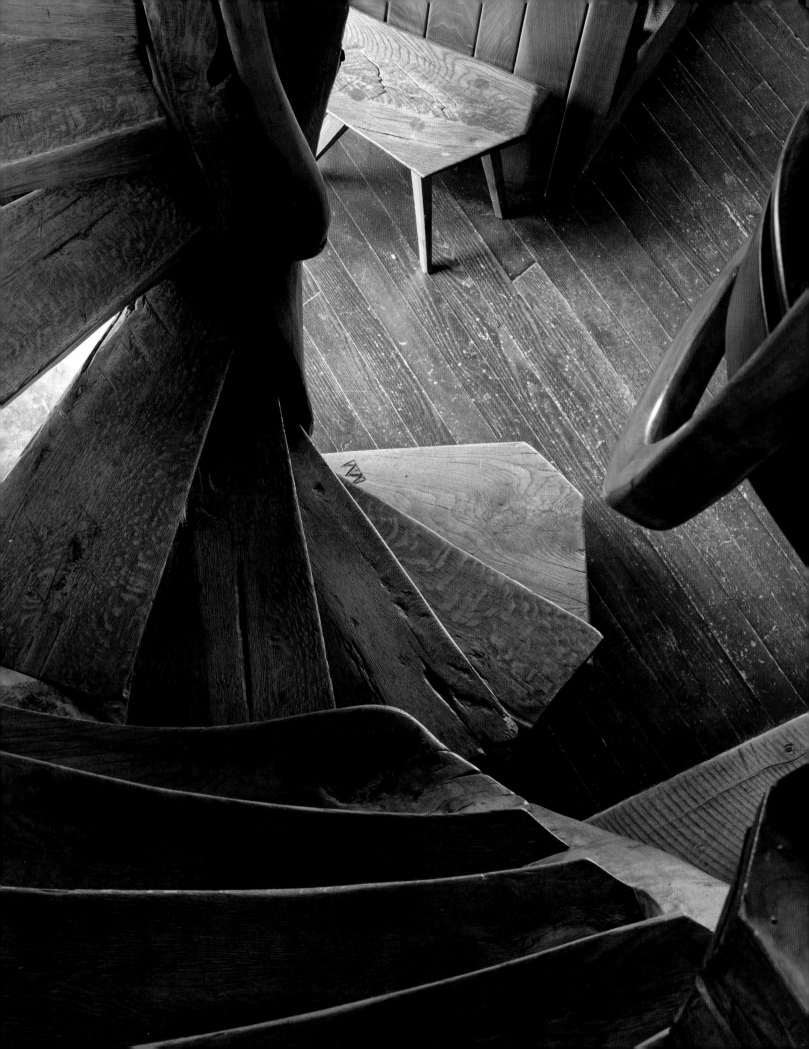

THE RADIANT CURVE

Pattern and Dimension in the Work of Wharton Esherick

SARAH ARCHER

► **THE ENGLISH WORD** *pattern* is rooted in an archaic meaning of the French word *patron*, connoting a plan, a model, or the original outline for a series of copies. It suggests an artistic practice built on order and design rather than happenstance or luck. A naturally occurring pattern can be discerned in the world by a keen observer, but an artist's pattern is a clear, abstract form made real through intention and material mastery.

Pattern may not be the first thing that comes to mind when considering the legacy of Wharton Esherick. The initial association with his work might be something handcrafted and curved, worn smooth by time and affection. His landmarked home and Studio and its primary structure are full of unexpected bends and arcs. If the Studio is indeed as Esherick described it, "an autobiography in three dimensions," those dimensions seem soft and yielding rather than strict and rectilinear. The interior welcomes visitors with subtly rounded banquettes and a spiral staircase that has been described as an example of "rustic cubism."[1] Nothing seems to line up straight.

As he began to gain wide recognition in the postwar era, Esherick's identity as a quirky master of the idiosyncratic, hand-hewn detail became part of his public persona. In the March 1951 issue of *House Beautiful*, the magazine's news editor Mary Roche wrote admiringly of Esherick's work and home Studio in a piece called "A New Feeling for Materials" that celebrates Esherick's artistic practice and offers readers a glimpse inside his home, where the "floor pattern is created by random shapes of contrasting wood," and a "sculpted door latch . . . proves that the strictly functional can also be fine art."[2] Perhaps haunted by visions of a postwar America studded with Levittown tract houses and candy-colored home appliances, Roche romanticizes Esherick's naturalism in woodwork, writing in an exoticist analogy all too characteristic of the era that he "collects wood as an Indian Prince might collect gems." She perhaps saw no contradiction in describing the process by which Esherick chose his floorboards as "random," then asserting that his handcrafted door latch functions

OPPOSITE The view down the spiral staircase

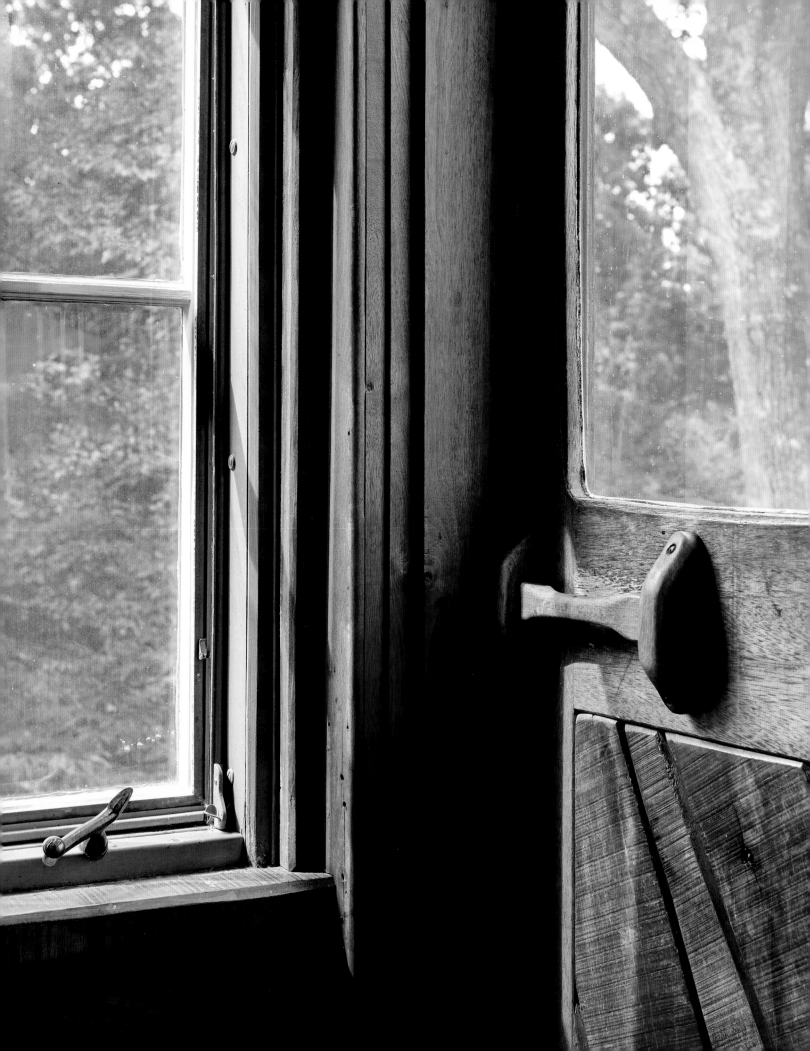

beautifully by design.[3] Indeed, the boldly mixed curves and sharp angles in the design of the floors—which Esherick fashioned from scraps of apple and walnut wood obtained from a local woodcutter—exist in harmony, even suggesting an abstract human figure.

In 1958–59 Esherick's work was the subject of a solo exhibition at the Museum of Contemporary Crafts in New York City (now the Museum of Arts and Design). It was the first monographic exhibition devoted to the work of any artist at the young institution. In the catalog essay, the museum's assistant director, Robert A. Laurer, suggests that Esherick had an ineffable artistic relationship with specific pieces of wood: "With his feeling for the inherent beauty of [the] color, grain and texture of wood, much of Esherick's inspiration has sprung from the special character of wood itself. The uniqueness of a certain piece of wood demands, inevitably, to be released in a certain form."[4]

Like Roche's characterization in *House Beautiful*, Laurer's description positions Esherick as an artist who stumbles upon the favorable traits found in his materials, gently guiding nature rather than muscling it into shape. In an era of pervasive consumer culture, social conservatism, and conformity, there must have been something enchanting about Esherick's idiosyncratic aesthetics, his process, and perhaps the bucolic setting of his home and Studio that lent his career an air of whimsy. Whether he accepted it or not, Esherick did nothing to dispel this characterization.[5]

OPPOSITE A hand-carved latch secures the door to the back deck from the dining room

FIG. 1. RIGHT Viktor Schreckengost (1906–2008), *The New Yorker (Jazz) Bowl*, 1931. Earthenware with incised and slip decoration, 12 × 16½ × 16½ in. High Museum of Art, Atlanta. Purchase in honor of Kathi Pierce Rhodes, President of the Members Guild, 1993–1994, with funds from the Decorative Arts Acquisition Endowment, 1993.13

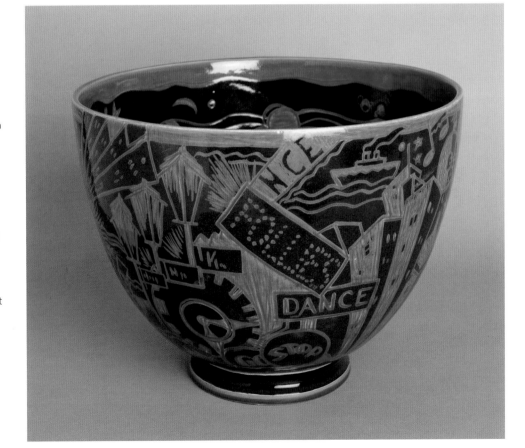

With all of this in mind, Esherick's body of work from the 1920s and 1930s—the period during which he shifted his practice from printmaking to building frames, and finally to making furniture—offers a rather bracing visual surprise. Across different mediums, much of Esherick's work from this period is bold, muscular, and energetic, incorporating the acute angles and sleek edges associated with Art Deco. Esherick's 1937 print *The Concert Meister* (see p. 145) depicts a scene reminiscent in both subject matter and style of Viktor Schreckengost's *The New Yorker (Jazz) Bowl* (fig. 1): a capacity audience in a concert hall sits in rapt attention as an orchestra plays, and viewers are perched on the balcony with fellow concertgoers watching the performance from an angle. Each element—the stage, the orchestra seats, and the mezzanines—is curved, evoking the feeling of sitting in a tightly packed hall and watching intently as something astonishing unfolds on the stage.

In his iconic *Fireplace and Doorway* for the Curtis and Nellie Lee Bok House (1935–38) there is scarcely a curve to be found: severely angled wood ornament evokes the look of tightly pleated fabric (fig. 2). Even the andirons are triangular (fig. 3). One way the later shift in Esherick's style—from taut and precise to soft and curvaceous—might be explained is as a leap from two dimensions into three. A *Fireplace Wall model* from 1953, which shares exact form and proportions with its life-size counterpart, is covered with lines drawn in colored pencil on the model's surface indicating where the lean, triangular panels will be placed (see p. 74). They are an exuberant series of marks made a little roughly, as though intended to convey the dynamic spirit of the work rather than to telegraph specific instructions.

Having initially embarked on a career as a printmaker and painter, Esherick came to woodworking through the somewhat unusual channel of making picture frames for his prints and paintings. Rather than designed to be all-purpose or interchangeable, his frames were custom-made for each work, and in some instances he added surface decoration that echoed the content of the work of art they surrounded. One such work is his own *Moonlight on Alabama Pines* (see p. 61), which he painted in 1919–20 while living in Fairhope, Alabama.[6] The painting itself is almost Impressionist in style, with clouds of blues, greens, and warm grays forming a hazy landscape of lush trees. The frame is decorated with carved pine needles and cones, their forms accurately rendered and easy to recognize, not Impressionist at all, and not—as in the world of the painting—arrayed as they would be found in nature, but lined up neatly in a rectangular pattern that frames the painting's content both literally and thematically.

During the 1920s Esherick was painting less, continuing to draw, making woodcuts, and eventually starting to build furniture. A significant early example in a style reminiscent of Arts and Crafts furniture is his 1927 *Drop Leaf Desk* (see p. 105), which has spent most of its life in Esherick's Studio holding prints and materials for printmaking. The desk captures a moment of transition in the artist's thinking about form, pattern, and surface; the desk's surface carving of raised vegetal patterns is reminiscent of the surface of a woodcut used for making prints.[7] In working with wood to make his desired impressions in ink on paper, Esherick had to become intimately familiar with the depth and contours of carved wood,

FIG. 2. OPPOSITE TOP Wharton Esherick, *Fireplace and Doorway*, 1935–38. From the library of the Curtis and Nellie Lee Bok House, Gulph Mills, Pennsylvania. White oak, stone, copper; fireplace and doorway: 8 ft. 6 in. × 16 ft. × 60 in. Philadelphia Museum of Art. Acquired through the generosity of W. B. Dixon Stroud, with additional funds for preservation and installation provided by Dr. and Mrs. Allen Goldman, Marion Boulton Stroud, and the Women's Committee of the Philadelphia Museum of Art, 1989, 1989-1-2

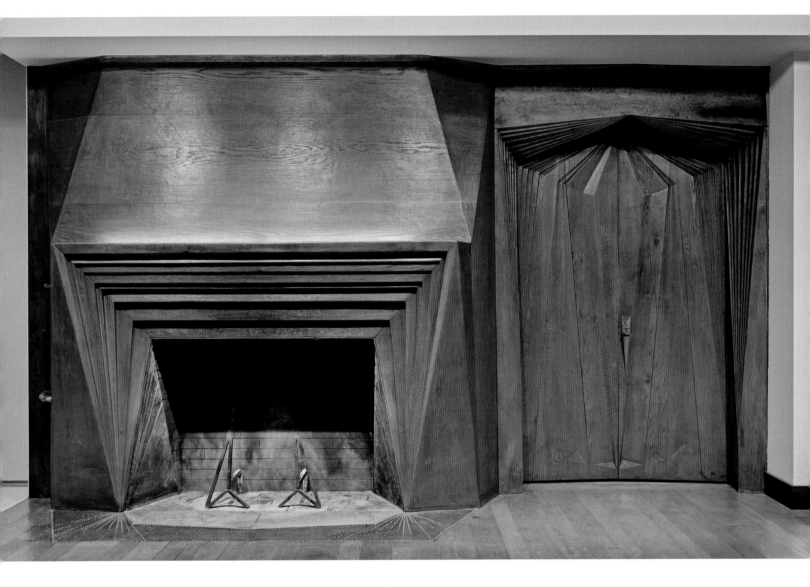

FIG. 3. RIGHT Wharton
Esherick, *Pair of Andirons*,
ca. 1936–37. Iron, 16 × 10 × 15 in.
Philadelphia Museum of Art.
Gift of Rachel Bok Goldman and
Allen S. Goldman, M.D., 2006

FOLLOWING PAGES A panel
the artist prepared in 1954 for
an exhibition at the New York
Architectural League displays
photographs of major projects
and models

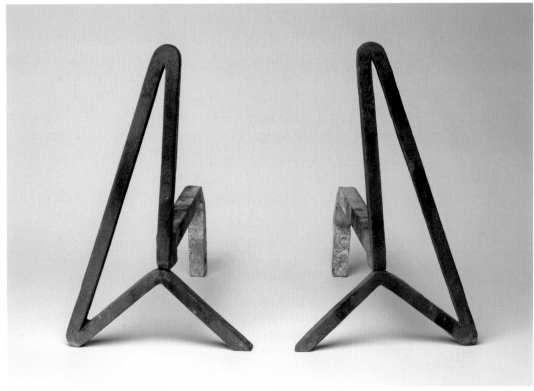

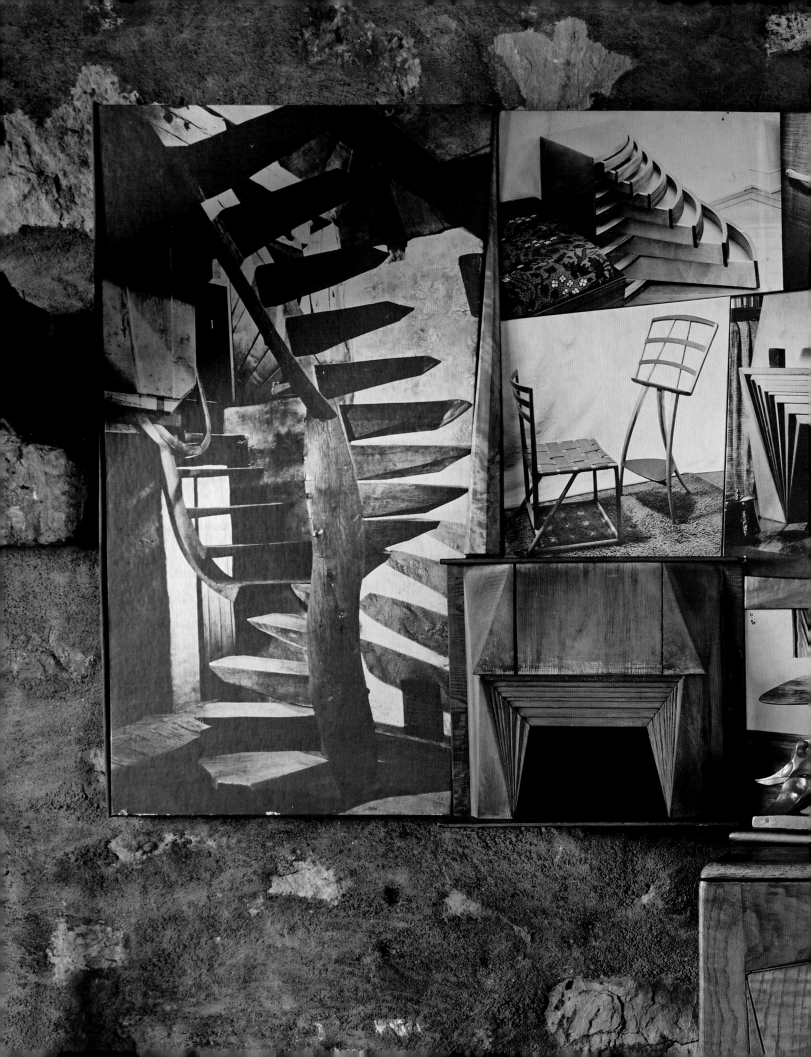

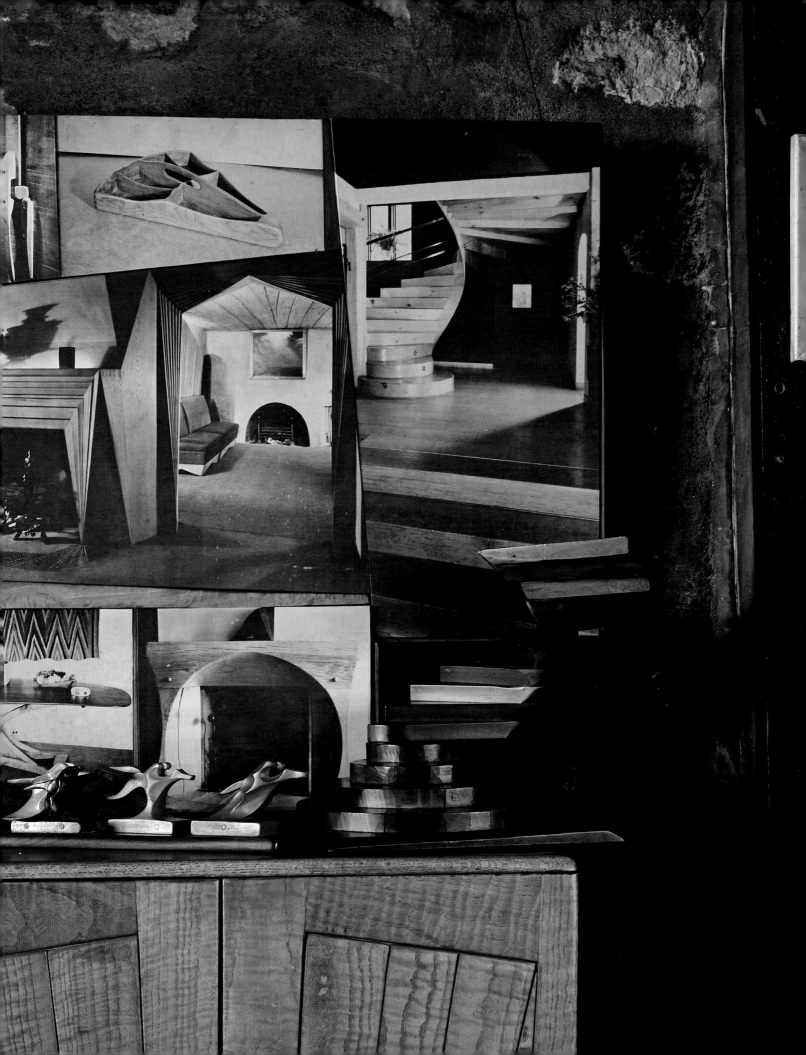

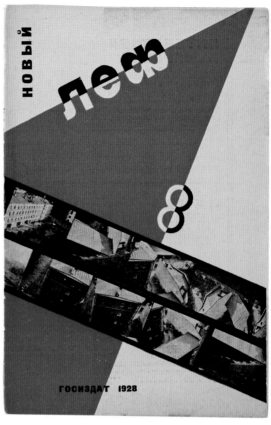

and he must have paid close attention to the vibrant threshold where two dimensions become three.

If Esherick's work from the 1920s and 1930s appears strikingly different from his later furniture, home, and Studio, it may be because it's easy to miss an important clue about the patterns, both visible and invisible, that shaped his work. In his later works, Esherick's love of curves is obvious, and it came to define his legacy. Earlier on, his fascination with shapes—including curves—was already evident. Though his country lifestyle in the postwar era might not suggest it, in the prewar decades Esherick frequented museums and galleries in Philadelphia and New York, and was an admirer of artists like Constantin Brancusi, Pablo Picasso, and Henri Matisse. He was keenly interested in the revolutionary art and politics emerging from Europe, and these topics were of vital importance to him and his circle of friends.[8] Though immersed in Arts and Crafts aesthetics, Esherick was also fascinated by German Expressionism, the Bauhaus movement, and Scandinavian design.[9]

Consider his 1924 woodcut print *The Hammersmen*, an illustration for an edition of Walt Whitman's *Song of the Broad-Axe*: three blacksmiths are gathered around an anvil with their tools, their powerful blows causing sparks to fly in all directions (see p. 140). To depict this scene, Esherick carved decisive, thick lines that radiate out from the center of the action, tapering to fine points as though dissolving in the night air. At the center—not

FIG. 4. ABOVE LEFT Aleksandr Rodchenko (1891–1956), *Untitled*, 1919. Linoleum block print, sheet: 8 × 5 in. Museum of Modern Art, New York. Gift of Nikita D. Lobanov, 264.1974

FIG. 5. ABOVE RIGHT Aleksandr Rodchenko (1891–1956), cover for the journal *Novyi LEF*, vol. 8, 1928. Letterpress, 8⅞ × 5⅞ in. Museum of Modern Art, New York. Jan Tschichold Collection, Gift of Philip Johnson, 573.1977.a-b

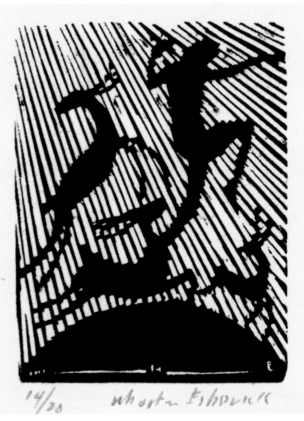

depicted, but evident through visual clues—is the subject of the composition: a sphere, from which energy extends in all directions.

Though there is no evidence they ever met, Esherick seems to have found a kindred spirit in the Soviet Constructivist designer Aleksandr Rodchenko, whose two-dimensional works revel in geometric play. Rodchenko's untitled 1919 linoleum block print offers an abstract counterpoint to *The Hammersmen*: there are no human protagonists, just shapes, and a circle at the center is surrounded by a spiral of fine lines to indicate motion (fig. 4). His 1928 cover for the arts journal *Novyi LEF* features a triangular block of red that could stand in for a bullhorn, or a road seen in perspective (fig. 5). It could also be an abstract shape designed to jolt viewers into rethinking the nature of what they see.

The taut geometric contours of Art Deco design similarly used hard edges to cast light on rounded subjects. Jean-Théodore Dupas's wall relief *Chariot of Aurora* from 1935, designed for the Grand Salon of the French ocean liner *Normandie*, depicts the arrival of Aurora, Greek goddess of the dawn, heralding the break of day (fig. 6). At the center, a sun-like compass offers a nod to modern navigational technology, while bold lines radiate out in every direction, with characters from Greek mythology animating the perimeter. There is no reason to imagine that Esherick's 1924 print *Upon the Hills* depicts specific characters from folklore or mythology, but there is a distinct consonance between the composition of this work and that of Dupas's wall relief. In Esherick's print, three deer and a human figure

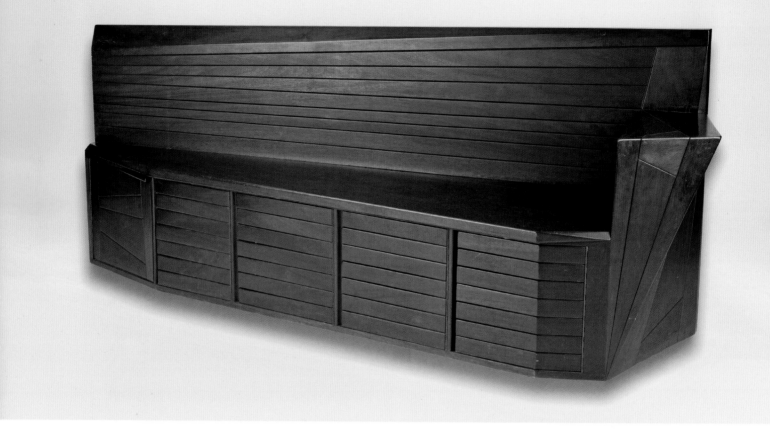

leap forward across a round hill as the sun's rays stretch across the field, lighting their way and offering us a clue about where the sun sits in the sky (fig. 7).

Esherick brought this elemental quality to a *Three-Legged Stool* he designed for Sunekrest (see p. 110), which was originally situated in dialogue with a hearth made from hand-hammered copper with a design of the sunrise. The sun is referred to in the house's name, and he incorporated sun imagery throughout the designed elements of the property. The elements of the stool are shaped almost like a crystal or a raw gemstone, with clear edges and facets but no strict geometric guidelines. The surface of the seat is carved with lines that radiate out from the tops of each of the legs. Viewed alongside the hearth with its sunrise motif, the stool's design seems to evoke rays of light.

When Esherick began making furniture, he sought guidance from his neighbor John Schmidt, an accomplished, Hungarian-born cabinetmaker who had trained in Europe.[10] The first transformative commission Esherick received, before he embarked on projects for the Curtis and Nellie Lee Bok House, was several pieces of furniture for the home of the Philadelphia businesswoman Helene Koerting Fischer. His work for Mrs. Fischer is sophisticated and striking, almost evocative of a film noir movie set. His 1931 *Corner Desk*, notable as a prime example of the influence of German Expressionism on Esherick's work, is richly detailed with varied angles, again, as though faceted like a gemstone (see p. 130). His padauk wood *Table Lamp* of 1932 is similarly geometric and angular, and may indeed function better as a sculpture than as a light source (see p. 73).

FIG. 8. Wharton Esherick, *Bench*, for the Helene Koerting Fischer home, 1938. Padauk, 38¼ × 94½ × 26¼ in. The Art Institute of Chicago. Through prior purchase of the George F. Harding Collection, 2011.229

But it is Esherick's 1938 *Bench* for the Fischer home that shows a connection between his geometric work and the curving, organic forms for which he is better known today (fig. 8). The bench was made from padauk wood, like the table lamp. Nearly eight feet long, it was designed for the front hall in the Fischer home, and includes storage space for the family's record collection. In the bench's form and surface design, two patterns are clearly evident. Like one of his 1920s woodcut prints, the back of the bench sports carved lines that radiate at a subtle angle from the shorter left side to the taller right side of the piece. The drawers supporting the seat form a series of parallel lines visible from the front, but the seat's footprint isn't straight: like the carved lines above, it radiates outward to become wider and thus offer more storage underneath. There are triangles, of course, but there is also a circle in the implied movement of the bench around the axis of its narrowest point. In one of his most beloved works, the 1931 print *The Lane*, which depicts the Fischer family home, Esherick does something similar with perspective (see p. 71). Gazing down an allée of snow-covered trees, the viewer perceives the faint image of a house and is drawn into the landscape and toward the home.

It is not a stretch to connect the Fischer bench with the movement and dimension of one of Esherick's most iconic works, his *Library Ladder* (see p. 170). If the ladder were sliced in half vertically, its elements would appear angular, like one of Esherick's 1920s woodcut prints. It is emblematic of the range and narrative arc of his artistic career, which evolved from painting, to making woodcuts, to carving frames, to building sculptural furniture and functional sculptures—at each step turning his vision from the flat territory of prints and drawings into the rustic realism of the three-dimensional world. ▼

NOTES

1 Paul D. Eisenhauer and Lynne Farrington, eds. *Wharton Esherick and the Birth of the American Modern* (Atglen, PA: Schiffer Publishing, 2010), 10–11.

2 Mary Roche, "A New Feeling for Materials," *House Beautiful*, March 1951, pp. 116–19; 117.

3 For more on *House Beautiful* under the editorship of Elizabeth Gordon in the 1940s and 1950s, and Gordon's interest in East Asian craft and design, see Monica Penick, *Tastemaker: Elizabeth Gordon, House Beautiful, and the Postwar American Home* (New Haven: Yale University Press, 2017).

4 Robert A. Laurer, *The Furniture and Sculpture of Wharton Esherick* (New York: Museum of Contemporary Crafts of the American Craftsmen's Council, 1958), n.p.

5 See Roberta A. Mayer and Mark Sfirri, "Early Expressions of Anthroposophical Design in America: The Influence of Rudolf Steiner and Fritz Westhoff on Wharton Esherick," *Journal of Modern Craft* 2, no. 3 (Nov. 2009): 299–323; 301.

6 Laura Heemer, "Fairhope Days" (2018), whartonesherickmuseum.org/fairhope-days/.

7 Mayer and Sfirri, "Early Expressions," 311.

8 Eisenhauer and Farrington, *Wharton Esherick and the Birth of the American Modern*, 10–11.

9 Mayer and Sfirri, "Early Expressions," 301.

10 Mayer and Sfirri, "Early Expressions," 301.

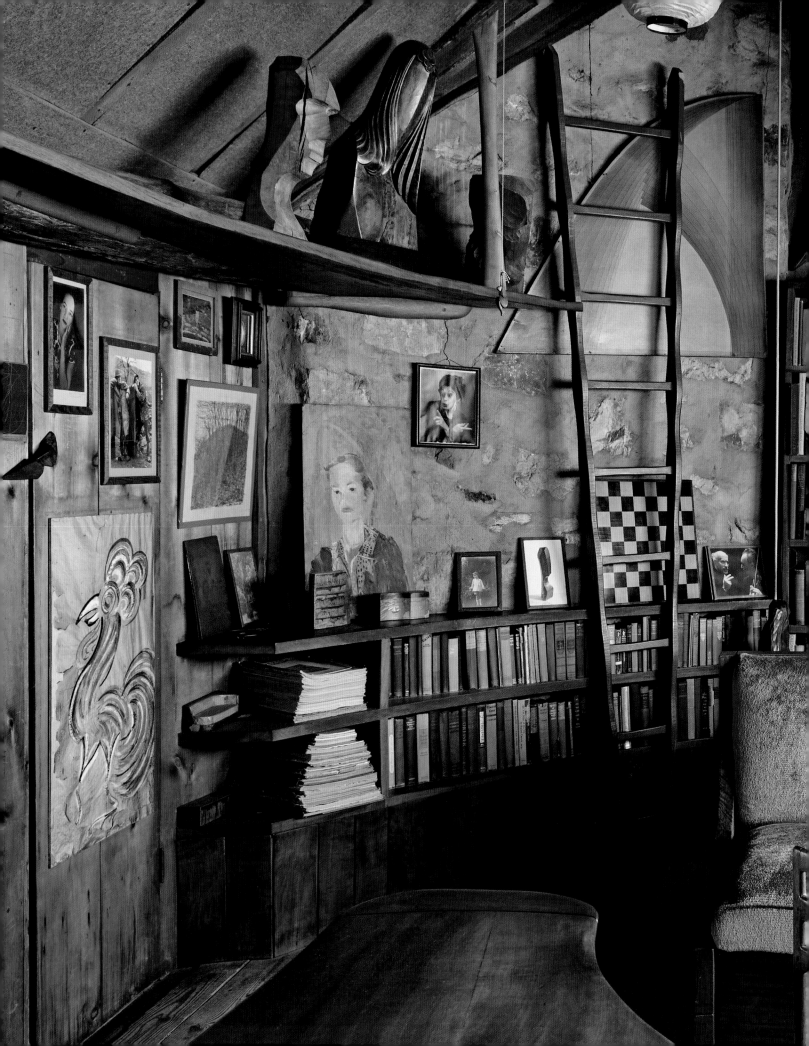

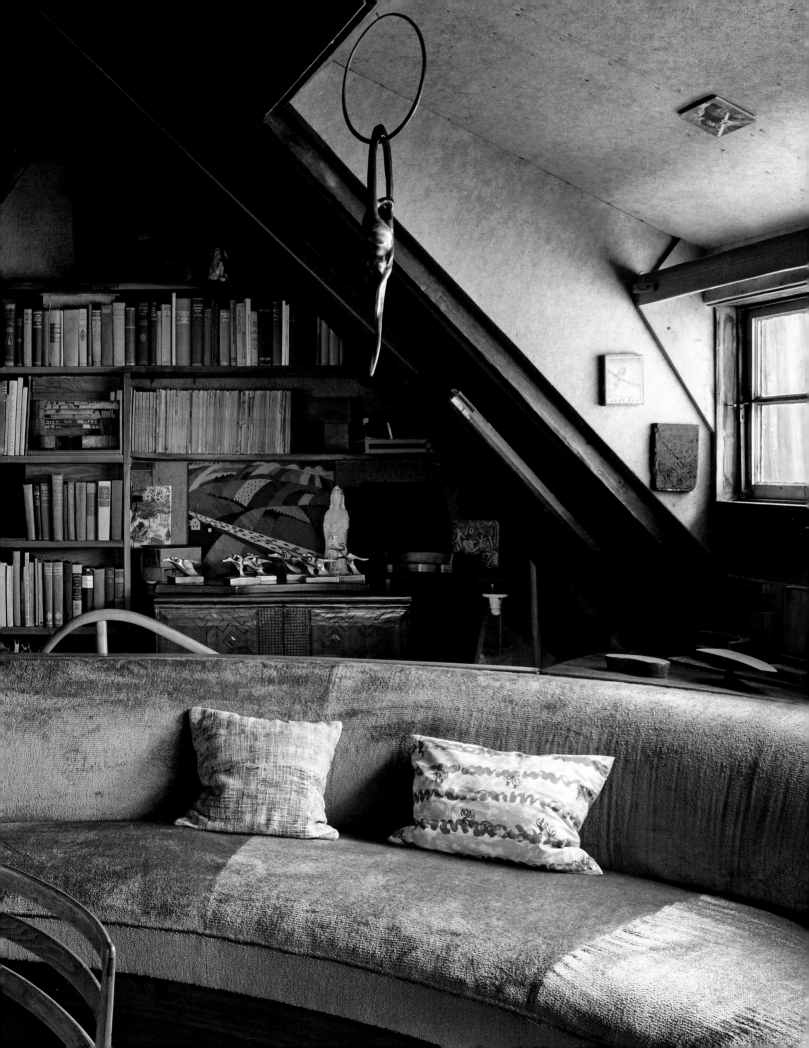

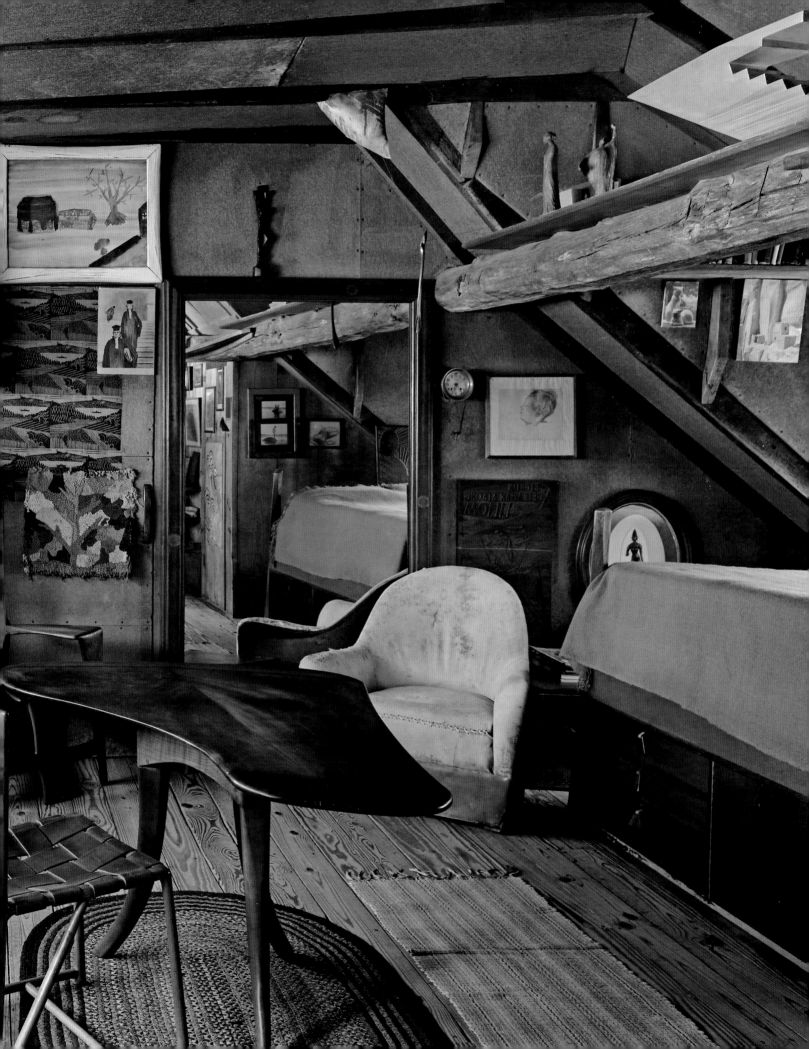

Alabama Pine,
from the *Alabama Trees* series, 1929
Woodblock print
9¾ × 6⅜ in.

Moonlight on Alabama Pines, 1919–20
Oil on canvas, carved wood frame
with metallic paint
23½ × 17½ in.

MOONLIGHT ON ALABAMA PINES, created during Esherick's first trip to Fairhope, is bordered by one of Esherick's earliest carved frames. The image is a representational depiction of an evocative forest scene, rendered by an Impressionistic hand, while the frame zooms in on bundles of pine needles to create a pattern abstracted by nature.

Completed a decade later, the print *Alabama Pine* calls back to the painting and its frame, with clusters of needles on branches sprouting from a slender trunk. While the subject matter of Esherick's paintings and prints often reflected each other, *Alabama Pine* shows the artist moving toward greater abstraction.

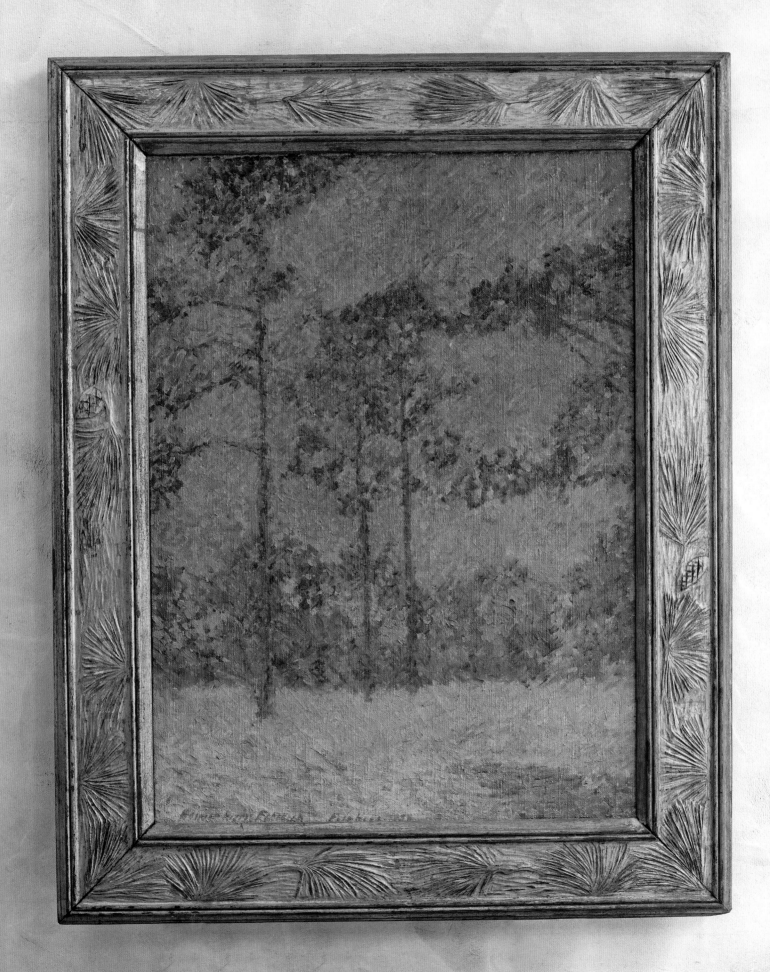

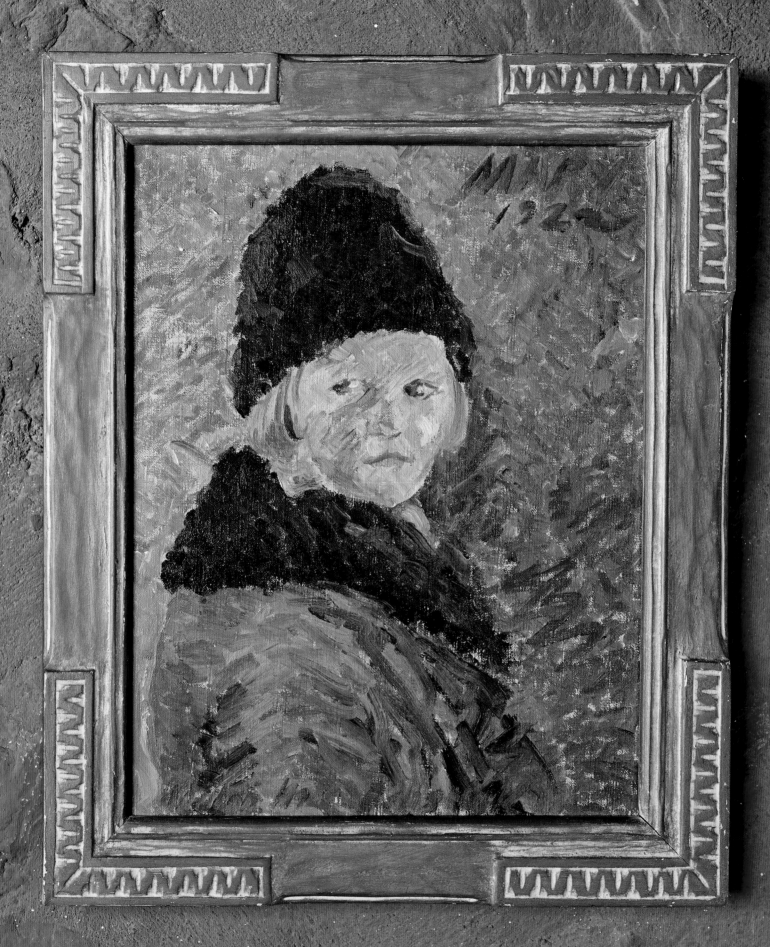

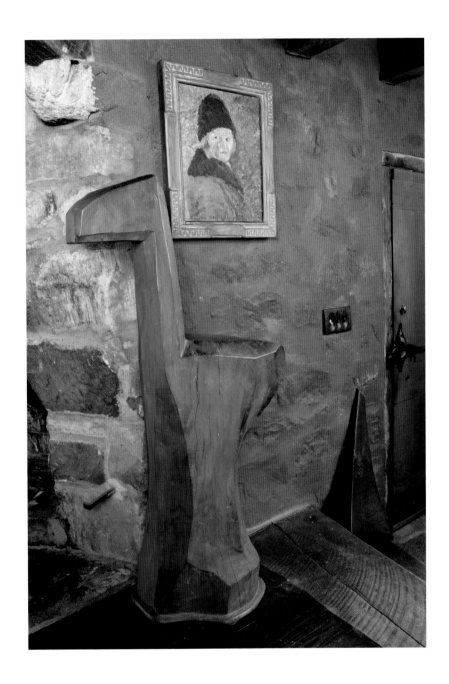

Mary, 1922
Oil on canvas,
carved wood frame
with metallic paint
24½ × 20½ in.

IN THIS PORTRAIT OF the artist's then six-year-old daughter Mary, both the painting and the frame's carving are less representational than they were in *Moonlight on Alabama Pines*. Esherick renders Mary's face and garments with larger and more distinct brushstrokes, and the frame no longer reflects the painting's contents. Instead, an incised zigzag pattern surrounds each corner, drawing the viewer to Mary's gaze.

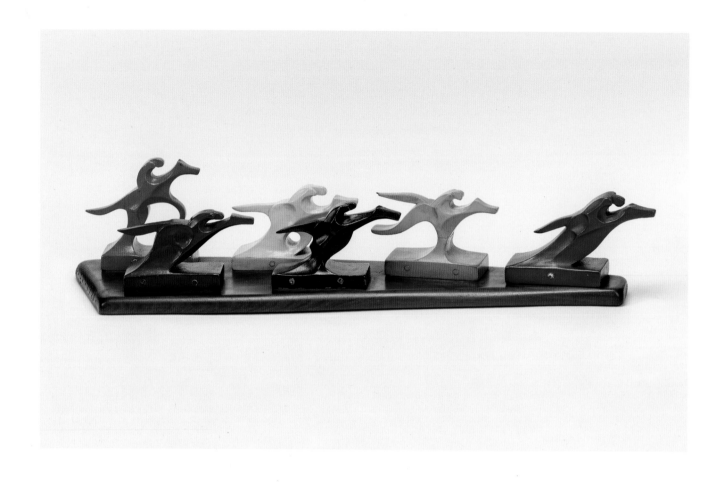

The Race, 1925
Painted wood on walnut base
6¾ × 30¾ × 8½ in.

SMALL SCULPTURES LIKE THIS were among the first three-dimensional objects made by Esherick after his initial experiments in woodcarving for picture frames and printing blocks. *The Race* is a version of a horse-racing game owned by his children. Esherick has transformed the static original figures to evoke speed and movement. The figure of horse and rider is repeated six times, rendered using sharp angles and slight variations in pose. Esherick creates narrative tension by mounting the variously colored figures in racing configuration on a piece of wood that narrows to emphasize the leader's position.

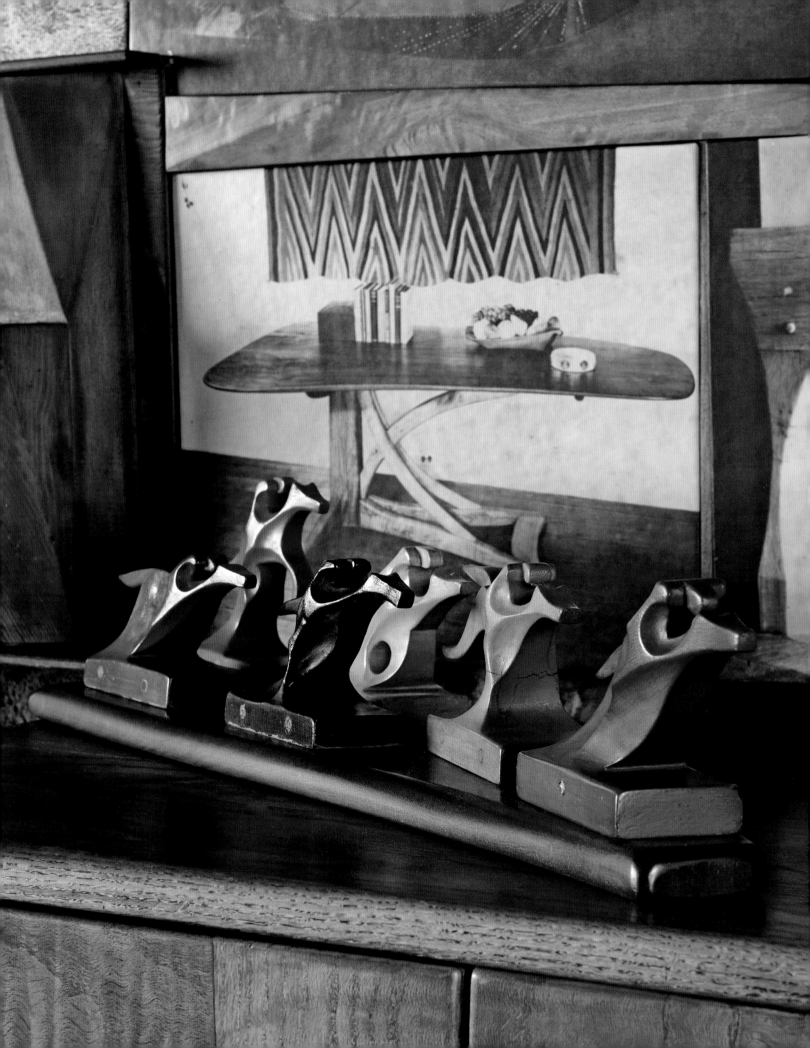

Speed, 1932
Cast aluminum
6 × 33½ × 12 in.

SPEED WAS MADE AS A STAGE PROP for the Hedgerow Theatre's production of a play titled *The Ship*. It represents an abstracted model of an aircraft carrier, a recent development in naval warfare. Esherick stacked flattened rectangles at an offset angle to create a design that conveys urgency and forward movement.

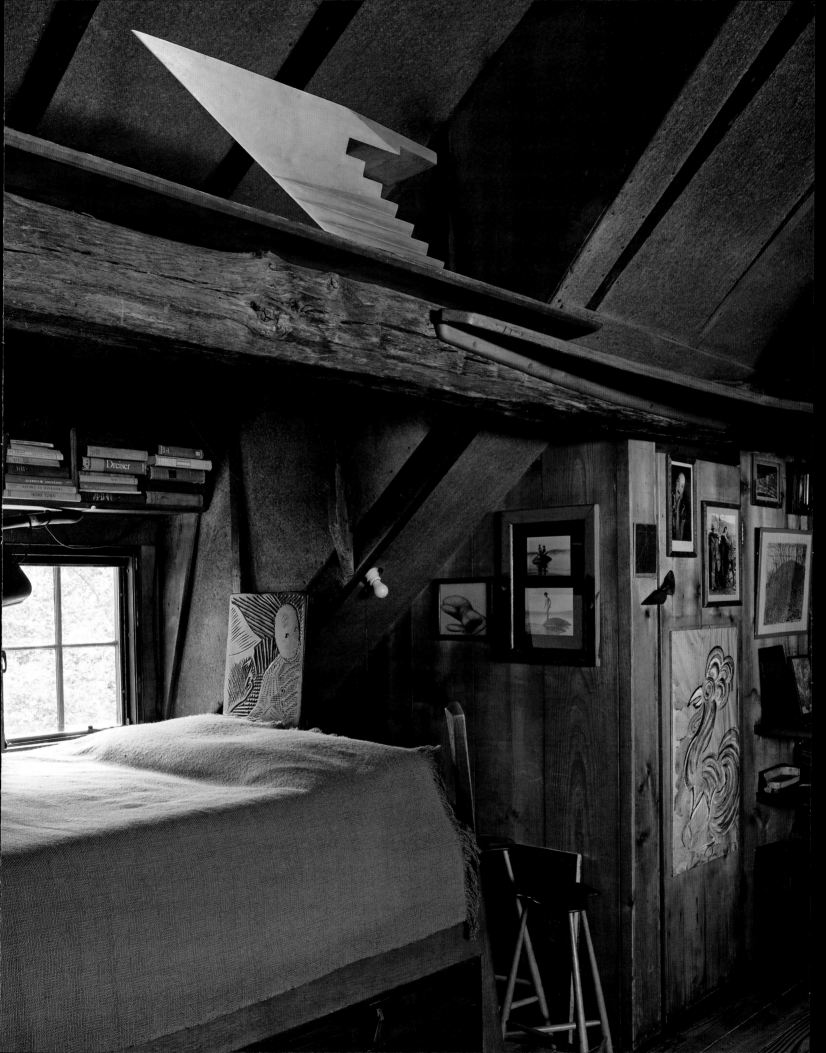

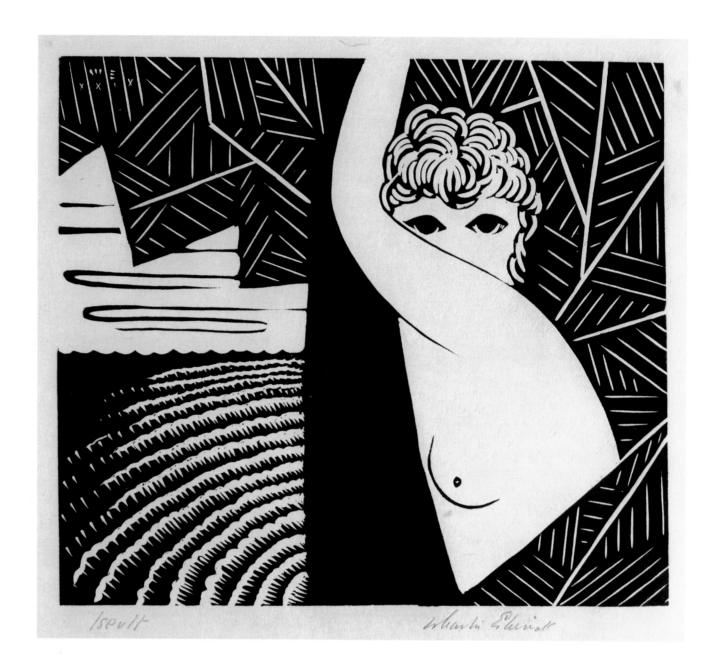

Iseult

ABOVE
Iseult, 1930

OPPOSITE
Silence—Death—Shadows,
1930

Illustrations for Amory Hare,
Tristram and Iseult
(Centaur Press, 1930)
Woodblock prints
7 × 8 in.; 6⅛ × 5 in.

HAROLD MASON FOUNDED Philadelphia's Centaur Book Shop to
serve as a cultural salon and private club, where the city's literary
elite could gather over cocktails and conversation about avant-
garde or controversial books. Esherick deftly uses juxtapositions of
patterns to define space in these images drawn from a theatrical
reimagining of the medieval chivalric romance. Radiating, swirling,
and branching lines are set against the patternless skin of Tristram
and Iseult, evoking the dizzying nature of their romance.

Tristan and Iseult Charles Shaw 1931
"Silence — Death — Shadow

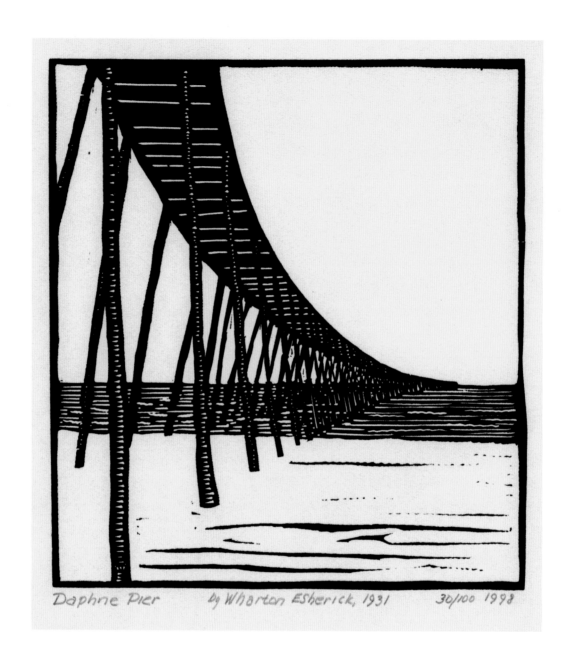

Daphne Pier by Wharton Esherick, 1931 30/100 1998

Daphne Pier, 1931
Woodblock print
6½ × 6¼ in.

DAPHNE, A TOWN ABOUT ten miles north of Fairhope, was home to both O'Neal Pottery and Peter McAdam, a ceramic artist who became Esherick's collaborator during his trips to Alabama. Like Fairhope, Daphne sits on Mobile Bay. Here, Esherick uses pattern and large areas of negative space to depict a wooden pier, high above the sand, arcing toward the horizon.

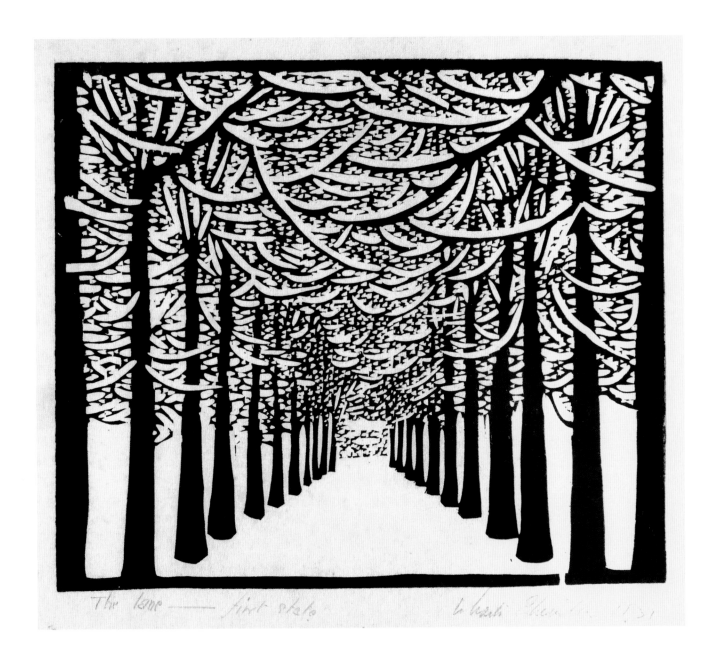

The Lane, 1931
Woodblock print
7¾ × 9¼ in.

THIS IMAGE CENTERS ON a tree-lined drive, whose pattern of tree trunks and swagged branches covered with snow leads to a house in the distance. Esherick's important patron Helene Koerting Fischer and her husband lived at the end of this path in Philadelphia's Chestnut Hill neighborhood, in a home filled with works by the artist.

Table Lamp, 1932
Padauk
30½ × 5¾ × 5½ in.

ESHERICK OFTEN INTEGRATED lighting into his work as a design element. In this expressionistic lamp, four tapering wood elements create a sense of rhythm around the bare lightbulb inside. Strong beams of light emerge from the spaces between the parts of the unconventional "shade."

BELOW
Fireplace Wall model, 1953
Mixed media
11½ × 20 × 3½ in.

OPPOSITE
Wall Cabinet model, 1954
Wood and paper
10 × 14¾ × 5¾ in.

ESHERICK OFTEN CREATED MODELS as a way to think through form and materials. They allowed him to work through a client's needs and desires during the commission process, and to discuss construction with his collaborators. Scaled-down models like these show how Esherick used patterns in interior contexts. The directional lines of the *Fireplace Wall model* illustrate for the client how the structure of the surround will evoke the energy and light of the fire within. The parallel lines of the *Wall Cabinet model* showcase the subtle variations in the curvature of each individual shelf.

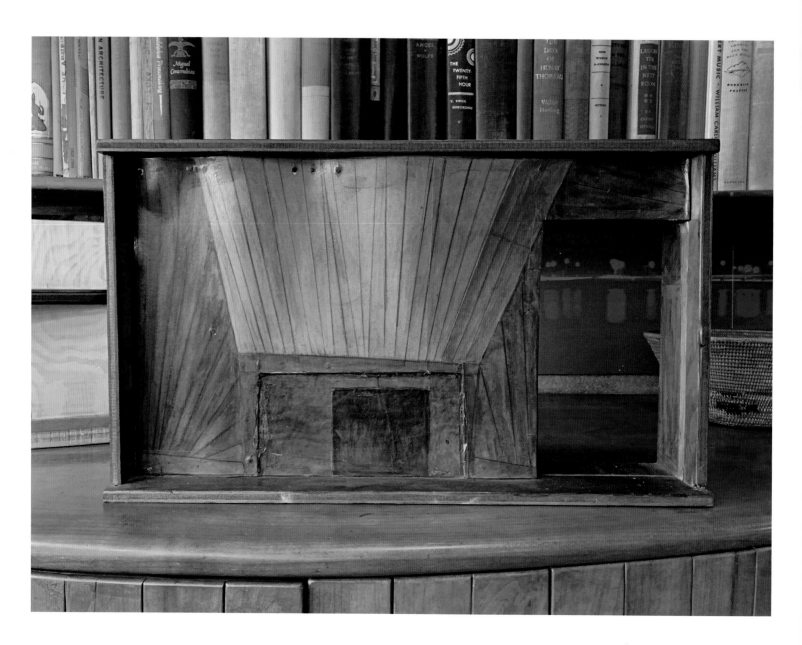

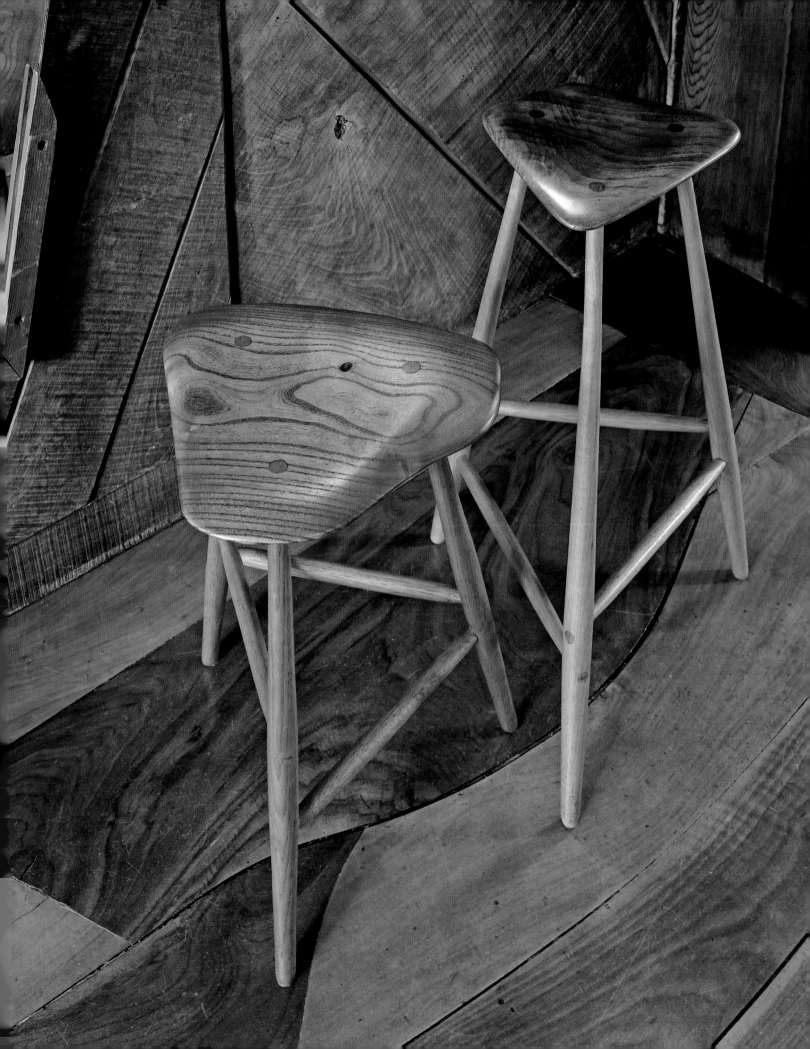

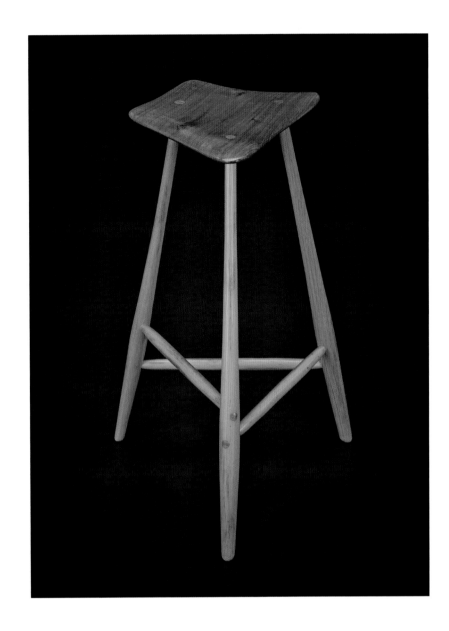

Three-legged stools, 1950s–60s
Various woods

ALTHOUGH ESHERICK DIDN'T MAKE many of his furniture forms in large series, he created several hundred three-legged stools over the course of the two decades they were in production. Originally priced in 1945 at twenty-five dollars, they not only offered emerging collectors an opportunity to live with handmade furniture, but also served as "bread and butter" pieces that supplemented Esherick's income between larger commissions.

The grain of the wood—its inherent pattern and texture—dictated the final form of each seat, which was made of leftover wood from larger commissions. Esherick used the same approach to make other household objects such as trays, bowls, and kitchen implements.

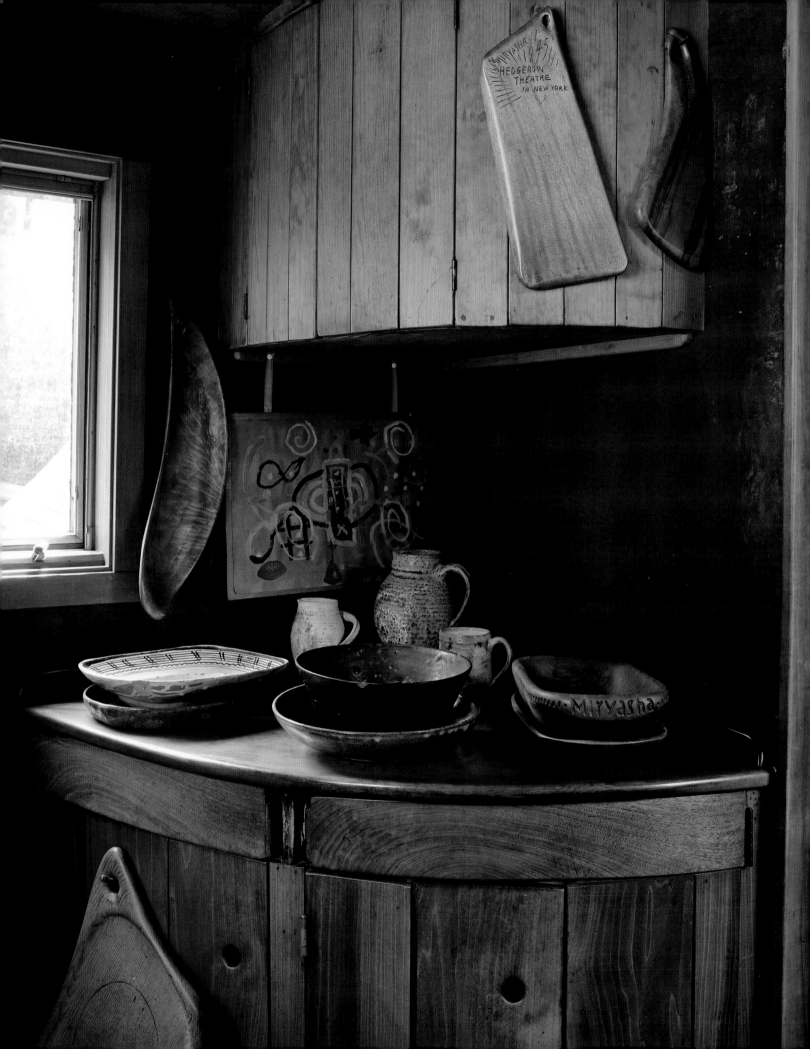

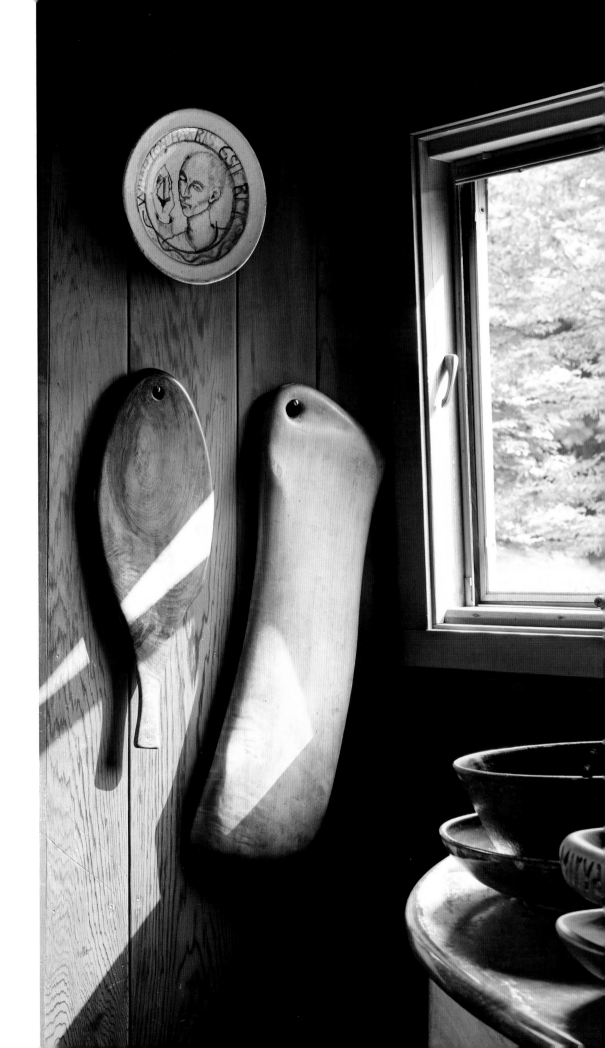

OPPOSITE
Curvilinear Tray, 1968
Cottonwood
5 × 22 in.

RIGHT, FOLLOWING PAGES
*Trays, bowls, and salad
servers*, 1962–68
Various woods

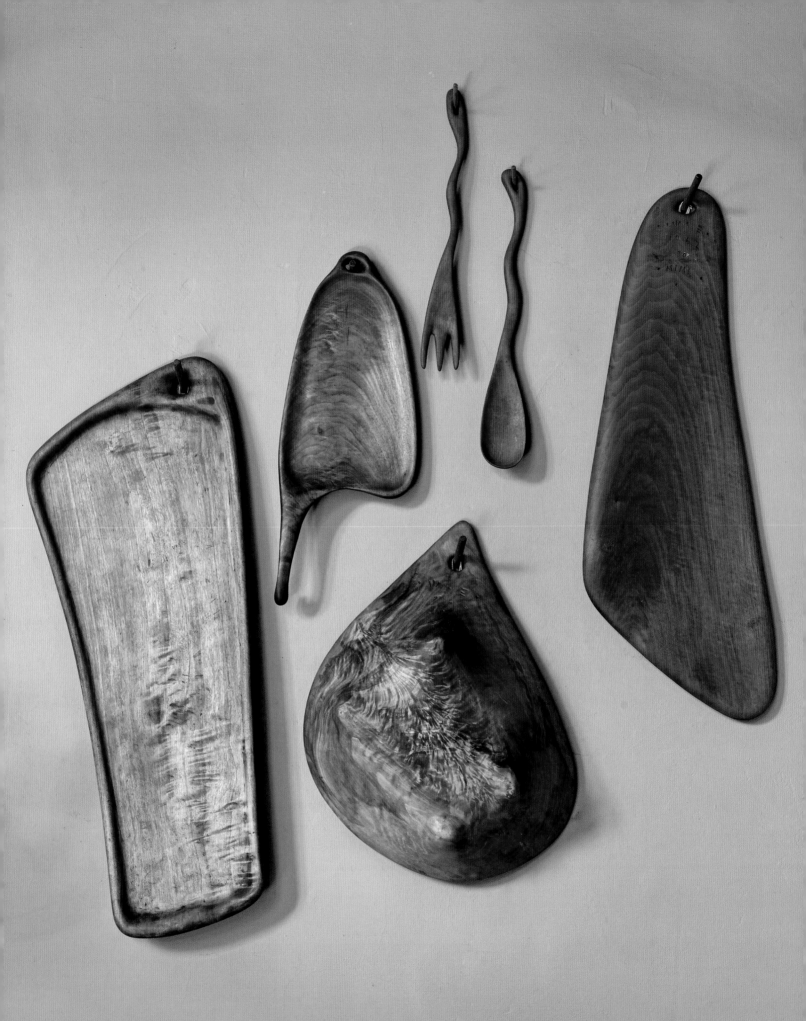

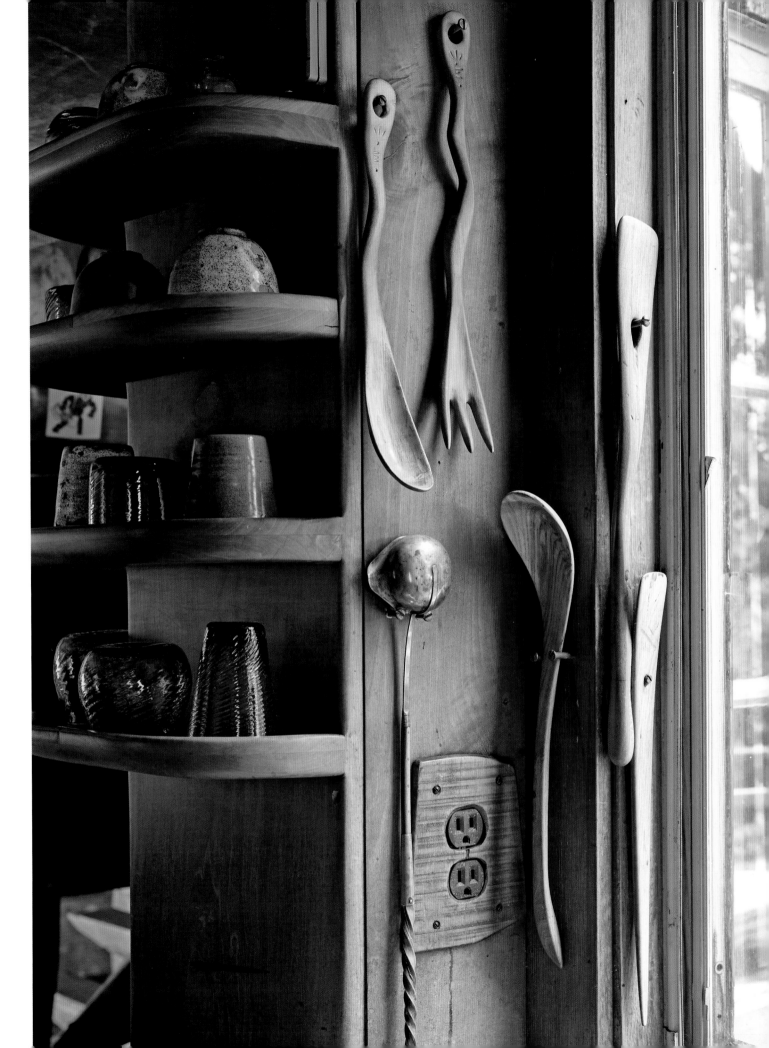

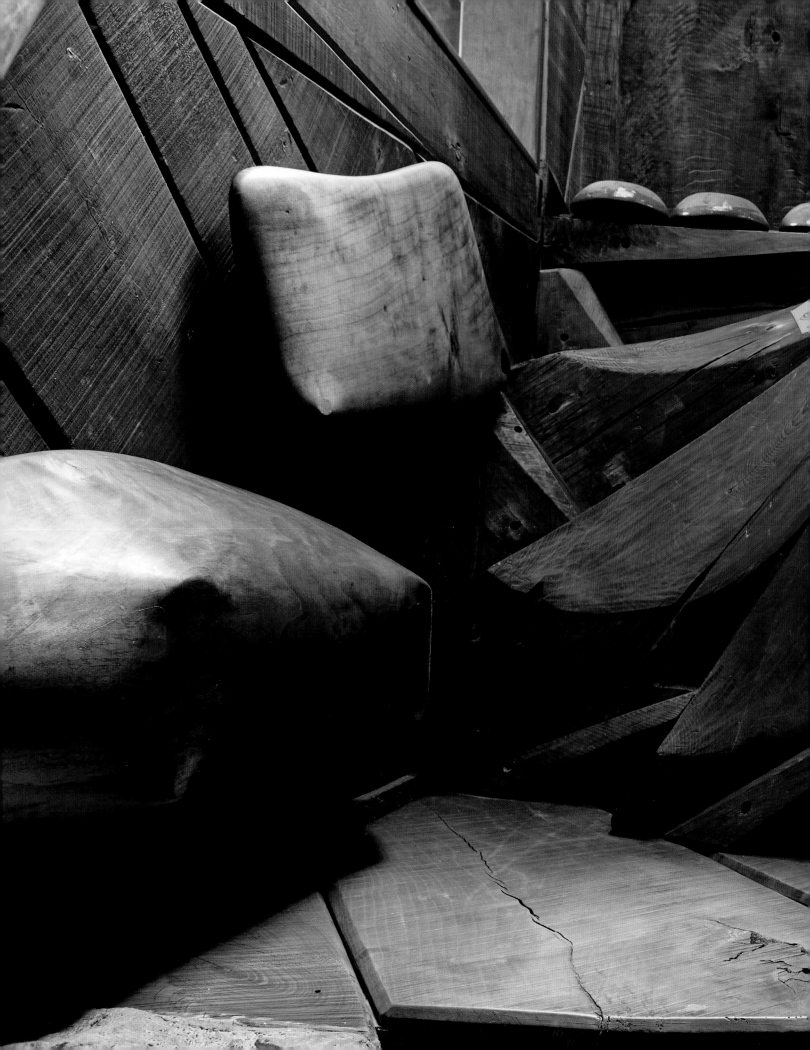

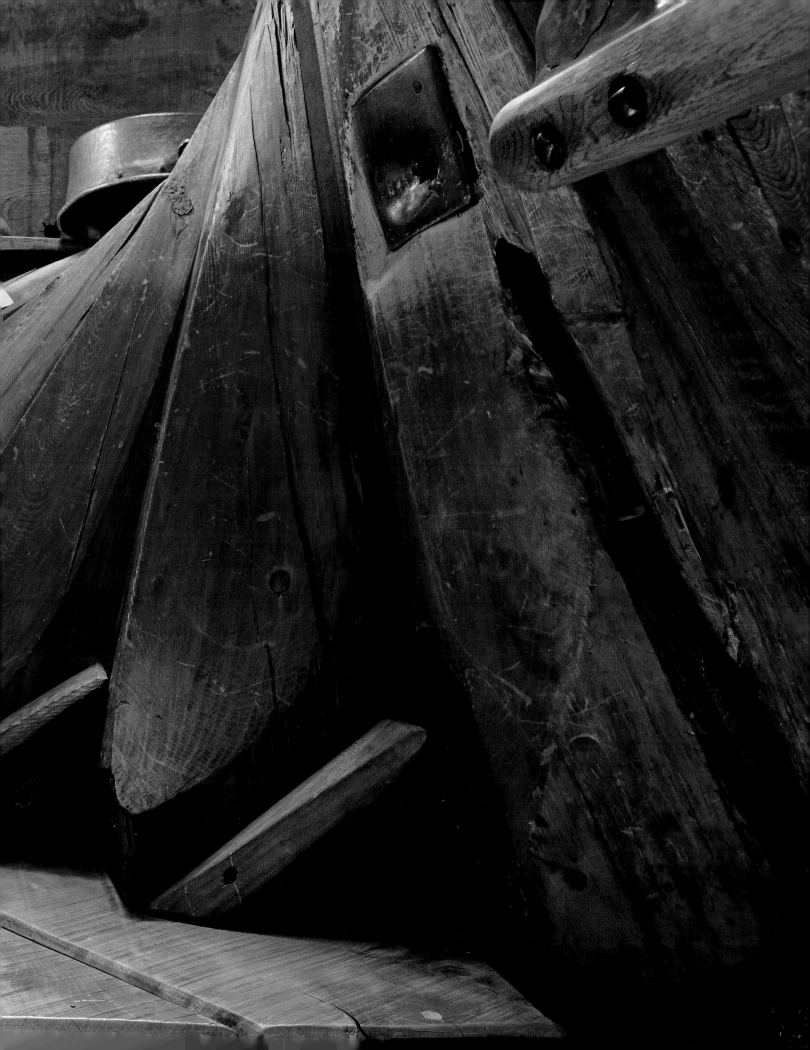

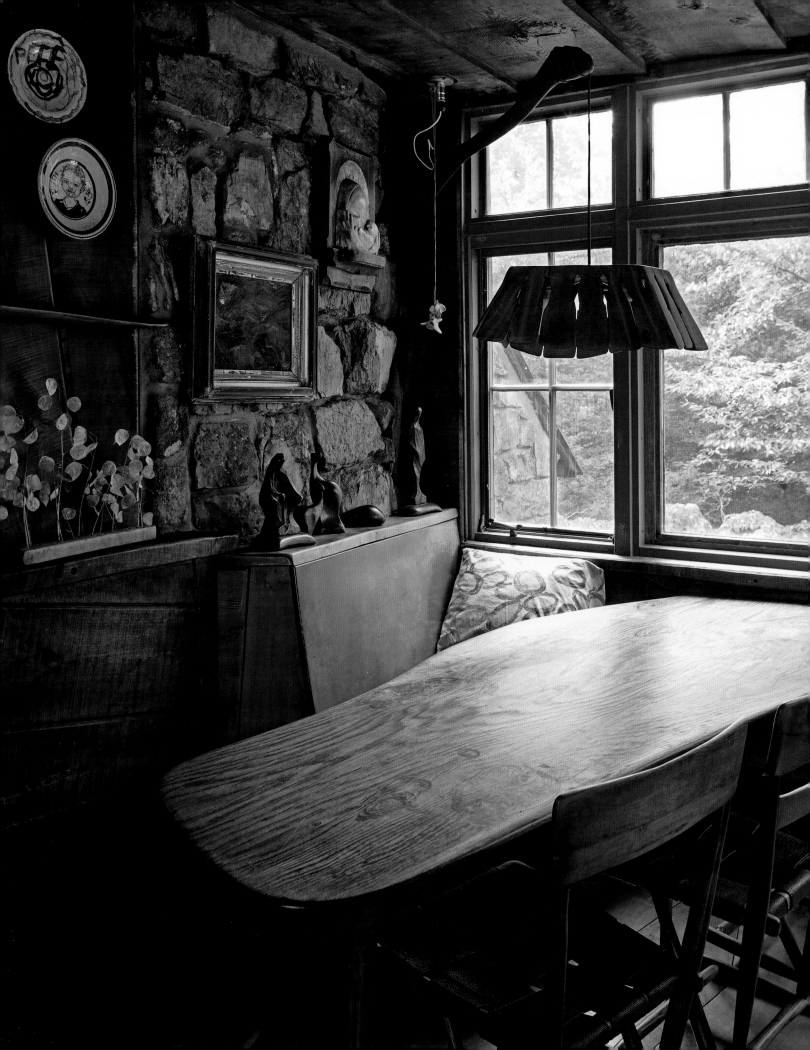

THE WAY THINGS GROW

Wharton Esherick and
the Mechanics of Nature

EMILY ZILBER

► **TO ENTER INTO WHARTON ESHERICK'S** home and Studio, hidden away on the wooded slopes of Valley Forge Mountain, is to step into a rendering of nature's principles made manifest. While this space doesn't ignore Esherick's human needs, those needs also don't dominate its design and function. Instead, the Studio rests on a foundation of interdependent connection between the natural and built environment. Nature was not simply subject matter for Esherick, but was instead fully integrated into his artistic output, identity, and lifestyle.

This integration is evident in Esherick's collaboration with the architect George Howe on a so-called Pennsylvania Hill House for the 1939–40 World's Fair in New York City (fig. 1). The room was one of sixteen featured in the America at Home pavilion, which had been added to the 1940 fair season design to imagine the future of domestic spaces in the context of the fair's broader theme, "The World of Tomorrow." Howe designed the surrounding structure, while Esherick outfitted the space in a way that nodded strongly toward his own home and Studio; as one critic described it: "This hill house bases its decoration—if the word doesn't sound too formal here—on local woods which are used for walls, furniture, and the rather astonishing staircase made of rough hewn oak."[1] Howe likewise leaned on the use of natural and local materials to position Esherick as a translator uniquely equipped to bridge the gap between the forest and the fairgoer: "The peculiar quality of the sculptor's products come from the fact that he actually lives and works in the Pennsylvania Hillside among the trees—oak, hickory, walnut, and cherry—which he cuts down, seasons in his lumberyard and tools with his own hands."[2] This is just one of many times throughout his career that Esherick is described as working with, alongside, and within the forest, giving him special access to its aesthetic and creative potential.

By the time the Pennsylvania Hill House made its first appearance, Esherick had moved away from his earlier use of exotic imported woods like cocobolo, padauk,

OPPOSITE The Studio dining table sits under a window with a verdant view of the hillside

rosewood, and ebony and toward seeing his immediate surroundings as his material collaborator. Supporting this shift was his relationship with Ed Ray, a local logger who had been a child when he and Esherick first met (fig. 2). Ray, one of Esherick's most significant— and underrecognized—partners, provided woods from which he felt the artist could draw something essential. Ray gleaned this information from his deep understanding of the physical personality of each tree—its growth, its grain, its shape—as well as from sketches that Esherick provided so that he might have specific forms in mind when he was out in the woods. *Twin Twist* (1940), a ten-foot column of carved oak, is perhaps the best example of this carefully cultivated relationship (fig. 3). After Ray had delivered the "crazy old twisted log," Esherick sketched directly on the wood with chalk attached to a long stick. He then used an axe to uncover its inherent curvature, noting about the process, "You know with a piece of wood you have to go along with the shape of the wood—you can't change its character. That's the reason the twist is there—developed by me from the original piece of wood."[3] *Twin Twist* spent almost twenty years outdoors on Esherick's property, until 1958, when it came inside as part of his career retrospective at the Museum of Contemporary Crafts in New York City.

Even in the artist's earliest experiments with woodworking, where iconography reigns, we see evidence of a dual consciousness, as Esherick sought to depict representational nature alongside its underlying principles. *Moonlight on Alabama Pines* (1919–20) is bordered by one of Esherick's earliest hand-carved wooden frames, which he treated as more than a mere supplement to the image (fig. 4; see p. 61). Surrounding an impressionistic forest landscape, the frame zooms in on a single element of that forest: the bundles of pine needles adorning each tree. Artfully scattered around the frame,

FIG. 1. ABOVE LEFT George Howe (1886–1955) and Wharton Esherick, Pennsylvania Hill House interior, 1940, from America at Home pavilion, New York World's Fair

FIG. 2. ABOVE RIGHT Bill McIntyre, Ed Ray, and Esherick at work on *Rhythms*, 1965

FIG. 3. OPPOSITE Wharton Esherick, *Twin Twist*, 1940. White oak, 183½ × 31¼ × 44 in. Pennsylvania Academy of the Fine Arts, 1968.21. Harrison Earl Fund and gift of the Pennsylvania Academy Women's Committee

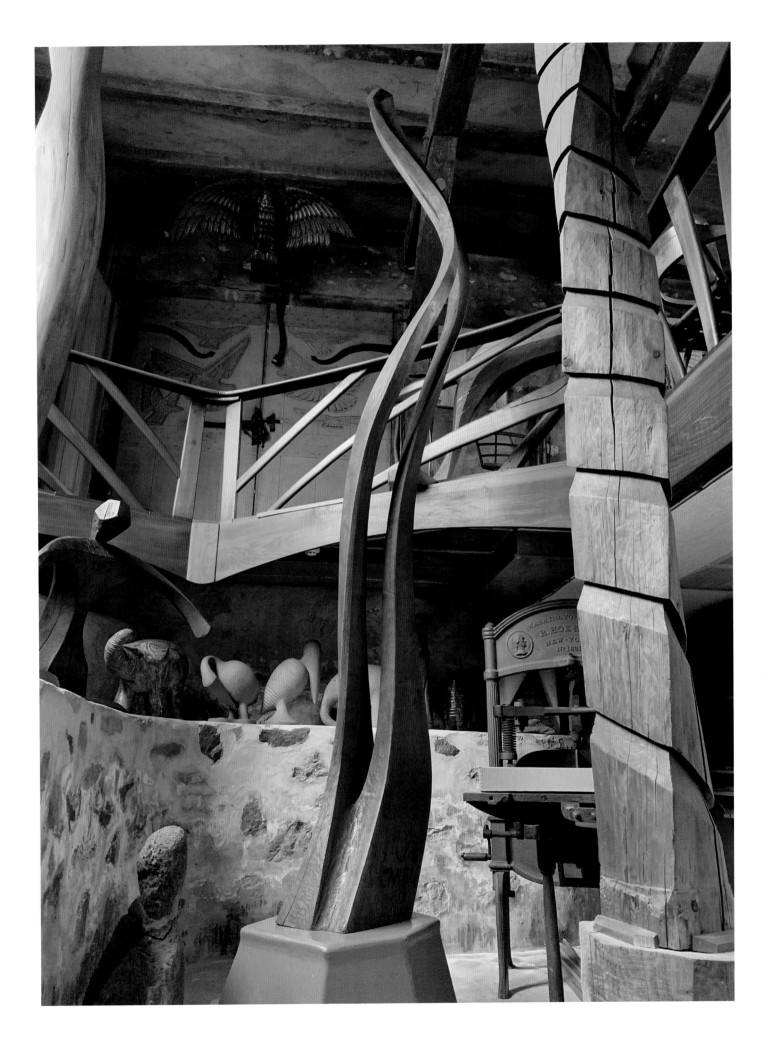

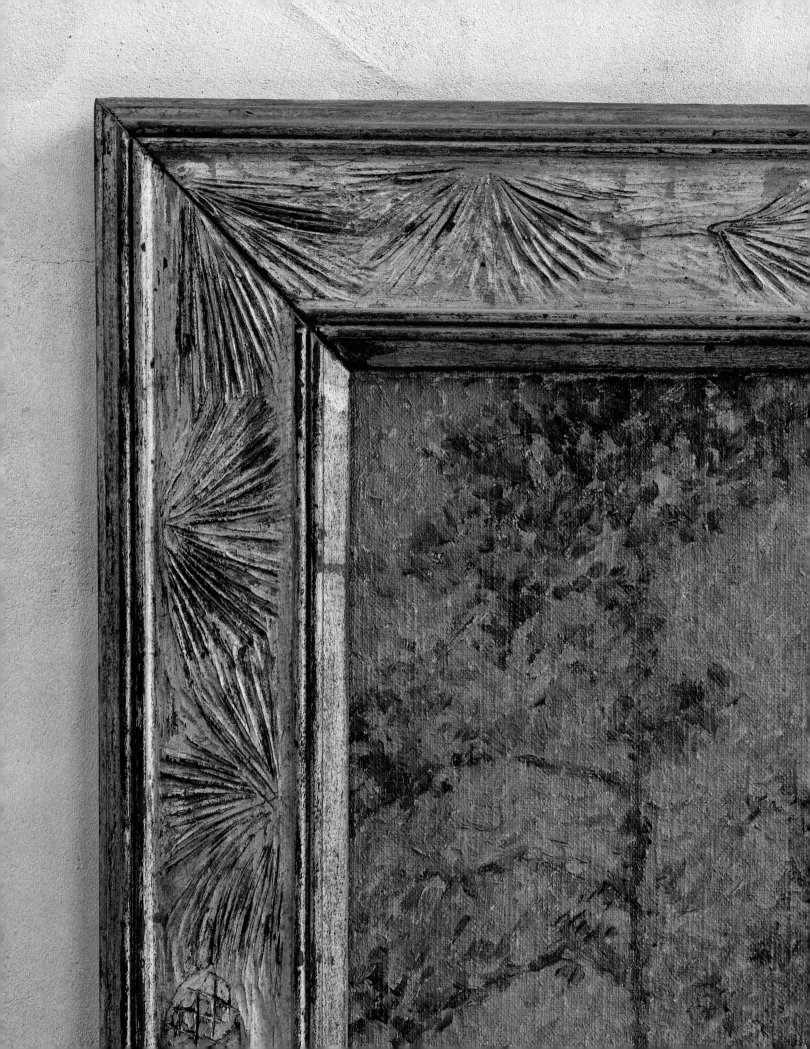

these needles encourage the viewer to notice the part as it relates to, and gradually builds toward, the whole.

Across various stylistic approaches, Esherick centered his visual language on small details of the earth as well as its awe-inspiring landscapes. This holistic approach stems in part from Esherick's formative exposure to changing ideas about the environment that proliferated in the late nineteenth and early twentieth centuries. Born of the desire to recalibrate humanity's relationship with nature after the onslaught of rapid industrialization (largely in the United States and Europe), many of these propositions came from artists who chose to live surrounded by nature as part of their creative practice. The Arts and Crafts reformer William Morris, whose books pepper Esherick's library, cast his attention backward to the reverence for nature he saw in preindustrial medieval art. Morris directly observed nature while living in his self-designed Red House in Kent, where he cultivated a garden and collected historic herbals detailing the structural and medicinal properties of plants (fig. 5). In 1881 Morris wrote, "There is no square mile of earth's inhabitable surface that is not beautiful in its own way, if we men will only abstain from wilfully destroying that beauty; and it is this reasonable share in the beauty of the earth that I claim as the right of every man who will earn it by due labor."[4] The assertion that the very acts of studying and working directly with nature entitled an artist to use it as a source of inspiration resonates with the life in the woods that Esherick would build for himself.

When Esherick studied at the Pennsylvania Academy of the Fine Arts (PAFA), he was part of a community of American Impressionists seeking to reconceptualize the cultivation

FIG. 4. OPPOSITE Wharton Esherick, *Moonlight on Alabama Pines*, 1919–20 (detail). Oil on canvas, carved wood frame with metallic paint, 23½ × 17½ in. Collection of the Wharton Esherick Museum

FIG. 5. BELOW The cut-flower garden at William Morris's Red House in London

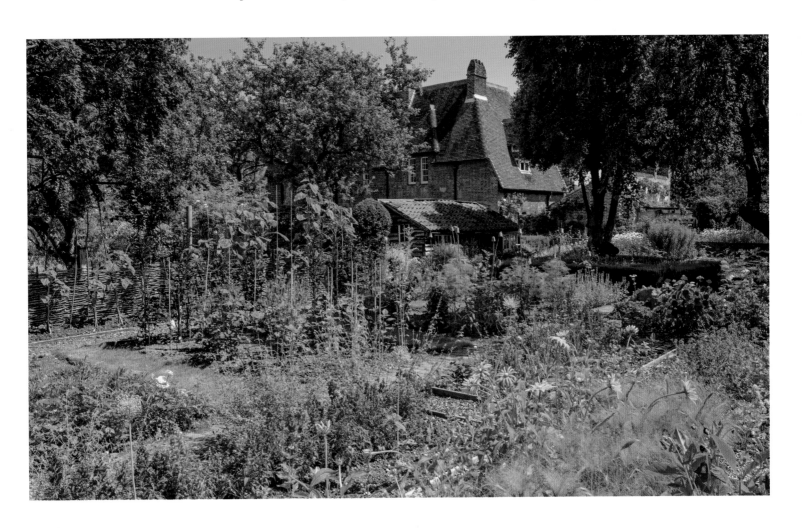

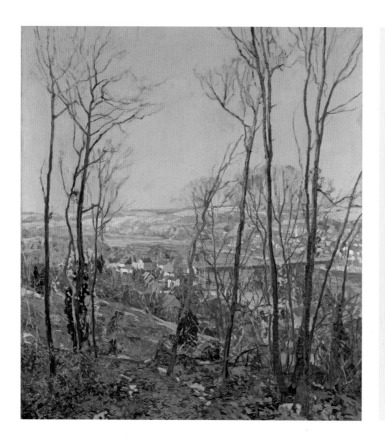
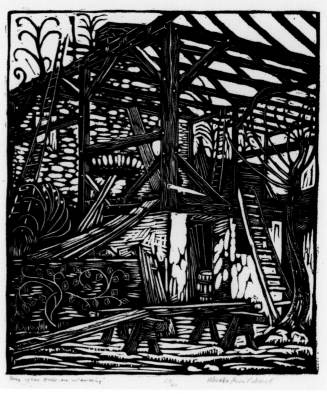

of informal gardens, laden with local flora, as creative spaces. In turn, they framed the act of tending the earth as artistic labor.[5] One of Esherick's instructors, the painter Edward Willis Redfield, directly modeled for the young artist the possibility of a post-academic life integrated with the land. In the summer of 1898, Redfield and his family relocated to a rural village near the Delaware River just north of New Hope, Pennsylvania, becoming instrumental to the development of a nearby colony of landscape painters. On his 127 acres, Redfield grew crops and crafted furnishings from driftwood for what one contemporary journalist called "a dry and comfortable house . . . if not an elegant one."[6] Redfield prioritized natural resources over style, choosing to site his house there "not for the beauty of the countryside, but because this was a place where an independent, self-sufficient man could make a living from the land, bring up a family and still have the freedom to paint as he saw fit."[7]

Redfield was, in his own time, held up as a model for creative iconoclasts. In 1907, just a year before Esherick began his time at PAFA, the Redfield family's choice was described in inspiring terms: "The Country called them and they went forth not knowing what the outcome would be. They have blazed the trail for those who follow."[8] In paintings like *A Pennsylvania Landscape* (1916), Redfield depicts houses commingled with the environment in such a way that it's almost impossible to tell where the constructed world begins and nature ends (fig. 6). Esherick's *Building* (1924) is one of twelve woodblock illustrations that he completed to accompany the Centaur Press edition of Walt Whitman's "Song of the

FIG. 6. ABOVE LEFT Edward Willis Redfield (1869–1965), *A Pennsylvania Landscape*, 1916. Oil on canvas, 56 × 50 in. Philadelphia Museum of Art. Gift of CIGNA, 2005, 2005-108-1

FIG. 7. ABOVE RIGHT Wharton Esherick, *Building*, 1924, illustration for Walt Whitman, *Song of the Broad-Axe* (Centaur Press, 1924). Woodblock print, 10 × 9 in. Collection of the Wharton Esherick Museum

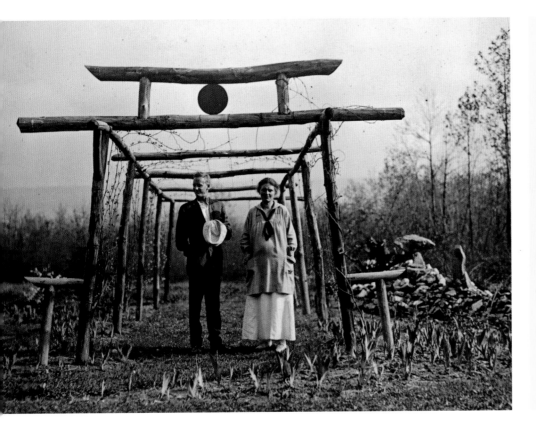

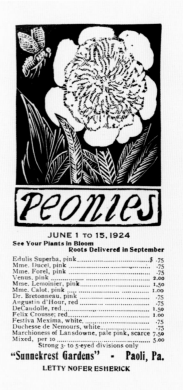

Peonies

JUNE 1 TO 15, 1924
See Your Plants in Bloom
Roots Delivered in September

Edulis Superba, pink	$.75
Mme. Ducel, pink	.75
Mme. Forel, pink	.75
Venus, pink	2.00
Mme. Lemoinier, pink	1.50
Mme. Calot, pink	1.00
Dr. Bretonneau, pink	.75
Augustin d'Hour, red	.75
DeCandolle, red	1.50
Felix Crousse; red	1.00
Festiva Mexima, white	.75
Duchesse de Nemours, white	.75
Marchioness of Lansdowne, pale pink, scarce	7.50
Mixed, per 10	5.00

Strong 3- to 5-eyed divisions only

"Sunnekrest Gardens" - Paoli, Pa.

LETTY NOFER ESHERICK

FIG. 8. ABOVE LEFT Photograph from Esherick family photo albums of Wharton and Letty under the grape arbor at Sunekrest, 1915 or 1916

FIG. 9. ABOVE RIGHT Wharton Esherick, *Peonies*, 1924. Woodblock print used in an advertisement for peony roots from "Sunnekrest Gardens," 2⅞ × 2⅛ in. (image). Collection of the Wharton Esherick Museum

FOLLOWING PAGES Carved birds adorn the Studio loading doors

Broad-Axe," itself a paean to freedom from societal restraint through craftsmanship and connection with the outdoors. The print offers a similar sense of interweaving between the framing of a house and the surrounding trees and vines (fig. 7).

Esherick's life at Sunekrest, the family farmhouse that brought him and his wife, Leticia (Letty), to Valley Forge Mountain in 1913, echoes the artistic and literary models offered by Morris, Redfield, Whitman, and others. He made drawings and painted quick oil studies in the countryside, capturing both nature itself and the material culture of rural existence, then translated them into paintings ranging from conventional landscapes to murals of fruits and vegetables that adorned the walls of the kitchen and dining room. A photograph from 1915 or 1916 depicts Wharton and Letty, heavily pregnant, under a Japanese-style arbor erected in the garden (fig. 8). A disk representing the sun—the home's namesake—is aloft at center, while plants shoot up through the earth below. Letty planted flower beds and gardens around Sunekrest, where the day-to-day domestic and financial life likewise belonged to nature. A sales ad designed and printed by Esherick for peonies grown by Letty makes explicit just how reliant the Esherick family was on their land for their daily comforts and livelihood, especially when Wharton's paintings didn't sell (fig. 9). This was, unfortunately, a regular occurrence.

Depictions of stylized local flora and fauna make their way into a variety of elements of the Studio building, beginning with its initial construction. Esherick carved images of local birds onto loading dock doors made from white pine, a reminder that just outside the

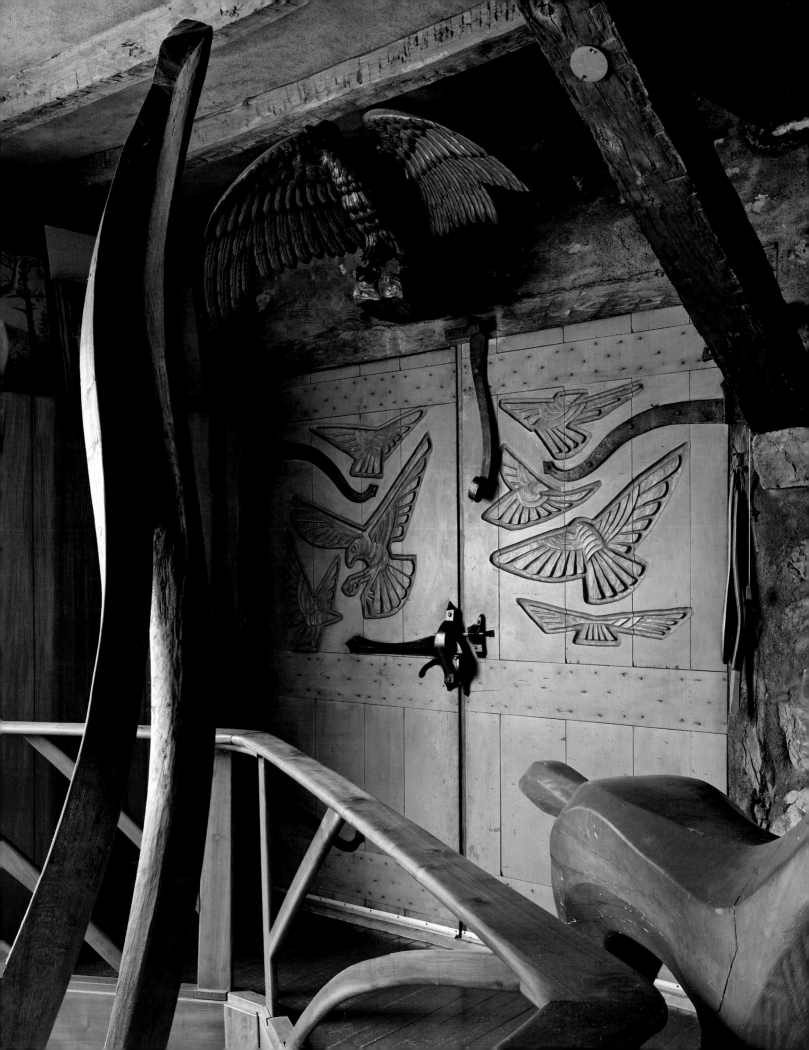

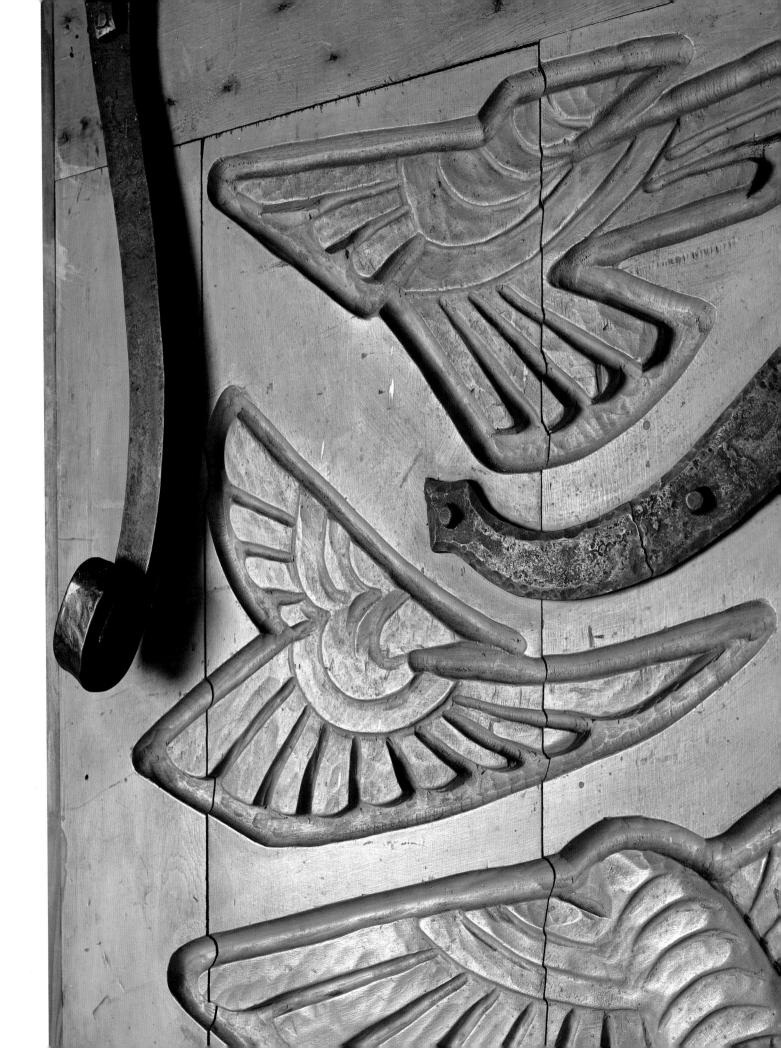

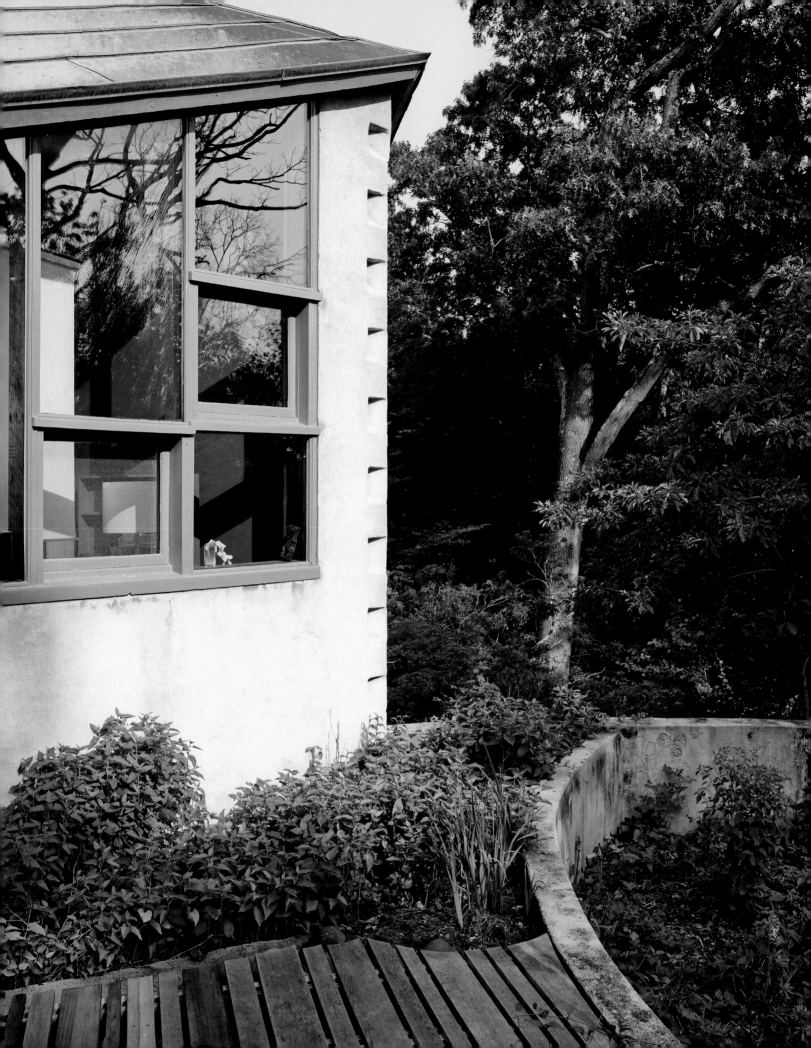

Studio's walls the natural world awaits. Opened with handles carved from dark macassar ebony, the doors reveal a flat grassy area on which Esherick often worked, bridging the distance between the space of art making—the Studio—and the raw material held in the woodshed outside. The *Drop Leaf Desk* (1927) that stands opposite these doors offers a call-and-response in its iconography (see p. 95). The desk's front panels are oak, carved with pictorial patterning and offering the viewer multiple abstracted glimpses of a single landscape. Turkey buzzards fly above a forest dense with tree branches, which in turn shield abstracted depictions of the crops grown on the surrounding farms—and perhaps even in the gardens at Sunekrest—below.

Just a few years later, Esherick's shifts away from iconography and toward creating three-dimensional objects celebrated the "organic" as one viable path to modernity.[9] Instead of a dogmatic Modernism prioritizing strict geometry, a lack of ornamentation, and the regularity of the machine, organic creative disciplines—including art, architecture, education, and dance—emphasized the integration of all aspects of life. Esherick admired the ideas of Frank Lloyd Wright, who introduced the descriptor "organic" into writings on architecture as early as 1908.[10] Wright believed that seeking harmony between form and function would lead to the integration of all parts of an architectural site, including the building and its surroundings.

From the outset, Esherick put this principle into action in his architectural approach to the Studio. In an unpublished essay describing his experience of identifying the site for the Studio, Esherick's opening salvo reflects his philosophy: "To start with, we must have a piece of land. Through a wood, on an old worn path, a path buried in briar and brush—but it still stands as evidence of patting feet. . . . I went through the path to a clearing, saw several trees which I imagined should be sheltering a roof."[11] This notion—that a building offers shelter for its inhabitants, while trees offer shelter for the building—is one of interdependence. Trees protect us regardless of whether they exist untouched in the forest or are shaped into shelter by human hands. The archetypal form of the tree undergirds other parts of the Studio's construction, including the masonry laid for its foundation. Hard sandstone sourced from the surrounding hillside formed the original footprint of the space. These blocks were intentionally laid so that the Studio's walls taper upward, recalling the flaring of tree roots into the earth below. Esherick's friend the writer Ford Madox Ford emphasized this sense of rootedness in the earth in his description of Esherick's workspace: "a studio built by the craftsman's own hands out of chunks of rock and great balks of timber, sinking back into the quiet woods on a quiet crag with, below its long windows, quiet fields parceled out by the string-courses of hedges and running to a quietly rising horizon."[12]

Despite Wright's clear influence on Esherick, the artist was enamored more by his philosophies than by his designs. Aesthetically, he had more in common with the Swiss architect-philosopher Rudolf Steiner, whose ideas permeated Esherick's social circles.[13] His library contains several works by Steiner, including *Ways to a New Style in Architecture* (1927). This series of lectures was given at the First Goetheanum (1913–22), a building that served as the center for Steiner's Anthroposophical Society and which was designed

OPPOSITE A view of the artist's 1956 Workshop, designed in collaboration with the architects Louis Kahn (1901–1974) and Anne Tyng (1920–2011)

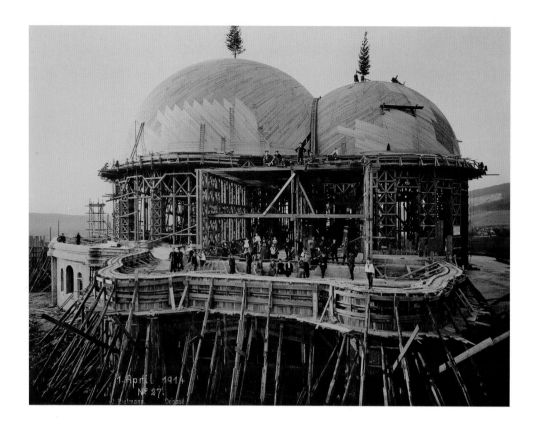

as an intentional *Gesamtkunstwerk* (total work of art) embodying the principles of his philosophy.[14] Steiner believed that a building was fully functional when all of its potential effects on its inhabitants—physical, emotional, visual, psychological, and spiritual—were developed organically, with nature viewed as an animating force rather than a thing to be tamed or an antagonist to overcome in the name of progress. Furthermore, Steiner theorized that the spiritual and natural worlds were the product of a single wellspring, as the processes and forms of nature mirrored those of a higher power.[15] Knowledge grounded in nature then offered paths for people working across all disciplines—from artists to farmers—to align their efforts with something greater than themselves.[16] Art, by echoing processes of change from germination to growth to decay, helped affirm that these natural shifts were responsible for the totality of the world.

Images of the Goetheanum accompany Steiner's text, offering both visual and conceptual points of connection with Esherick's own aesthetics as he moved away from representation. Unusual forms in carved wood undergird intersecting domes, which serve as an allegory for the connection between spirit and matter (fig. 10). A person experiencing the building and its various components should be able to "read" their functions from their physical appearance—for example, door handles designed to fit the hand that grasps them. For Steiner, a wall was not merely a wall; instead it was "living, just like a living organism that allows elevations and depressions to grow out of itself."[17] This calls to mind an image of Esherick taken by his friend the American Modernist photographer Consuelo Kanaga, in which the artist leans against the walls of the Studio, relatively newly built but seeming

FIG. 10. ABOVE The First Goetheanum, in Dornach, Switzerland, during construction work, 1914

OPPOSITE The Studio silo and back deck

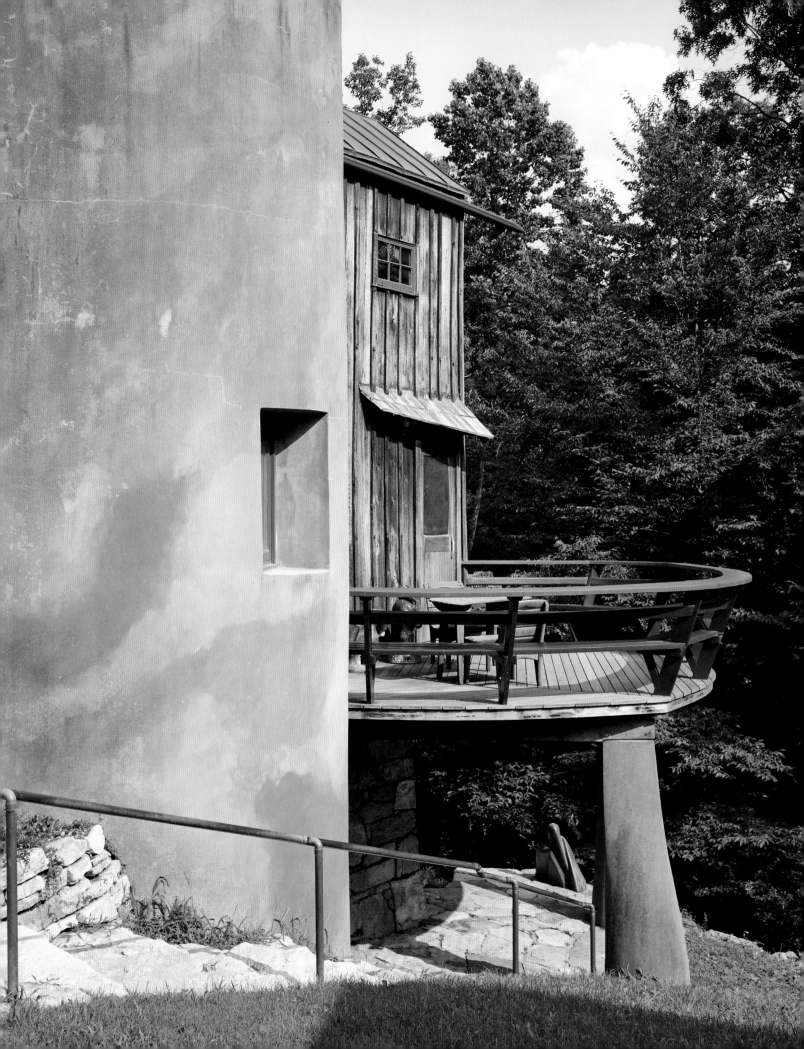

already to have weathered many seasons (see p. 39). Esherick got this effect by scraping out the mortar between the stones, creating rough channels that later were studded with found treasures. He seems to grow out of the plants below as he poses, rooted in both the doorway and the earth.

Aesthetic markers of Anthroposophically informed art and architecture—sprouting and biologically inspired forms, skewed and crystalline shapes, lyrical twists and curves, a deep sensitivity to color—appear regularly in Esherick's work. The upward twist that seems to grow and spiral toward the sun appears in models for major interior commissions as well as in furniture, sculpture, and architectural features. Perhaps Esherick's most iconic example of this form is the twisting spiral staircase that he added to the Studio in 1930, replacing a set of straight stairs. Captured in a photograph by Emil Luks taken shortly after its construction, the undulating central column is circled by a series of cantilevered steps that seem to float in midair, reaching upward from the dark floor to the light above (see p. 113). Today the staircase is flanked by a series of railings, added later, made from materials including a curved mastodon's tusk found in Alaska and a branch of dogwood with a natural curvature that echoes the twist of the central column (see p. 111).[18] The staircase leads from working studio space below to the bedroom above, where Esherick aligned his bed with a long, rectangular window to offer an expansive view of the valley below to its occupant while lying in repose, as if reclining in a field of verdant foliage.

Esherick's collaboration with Louis I. Kahn and Anne Tyng for his new Workshop (1956) brought the mechanics of nature into an integrated conversation with two champions of Modernism in the mid-century. While Tyng noted that the organic curves Esherick originally envisioned for the space were "really sculpture; it's not really architecture," she reframed the geometry of the final design as embodying both activity and form in nature. Three large hexagonal bays, which resemble the structure and order of a beehive, nod toward the labor and industry that would take place as Esherick created new work there. Tyng has said that in the process of working on this space, its creators "began to see it (geometry) as a natural principle, a natural law that followed the different geometries and with that basis you could then randomize, and geometry, in a sense, was a kind of underlying order."[19]

The final addition to the Studio, a silo-shaped tower that nodded to grain storage structures on the surrounding farms, was built in 1966, in the last years of Esherick's life. It was designed to connect intimately with the landscape in a way that synthesizes the various paths into nature that the artist followed throughout his career. A fresco of dappled color, made from integrating saturated pigment into stucco, speaks to his training as a painter and colorist. During several months in autumn, these hues offer a call-and-response with the surrounding foliage.[20] For the remainder of the year, they remind viewers of what is to come as well as what is lost as cyclical nature does its essential work. The silo reflects nature both as concrete earthly phenomena—color, light, air, shadow, patina, pattern—and as a source of symbolic or spiritual meaning. Esherick's work is a constant reminder that the mechanics inherent in the way things grow offer paths for life, art, and everything in between. ▼

NOTES

1 Elizabeth MacRae Boykin, "That 'Cabin in the Pines' Can Be Both Modern and Rustic," *Philadelphia Bulletin*, June 4, 1940.

2 George Howe, "New York World's Fair 1940," *Architectural Forum* (July 1940): 36.

3 Quoted in "'Twin Twist' by Wharton Esherick Is Purchased," *Pennsylvania Academy of the Fine Arts Quarterly* 2, no. 1 (Spring 1969): 1.

4 William Morris, "Art and the Beauty of the Earth,'" William Morris Archive, morrisarchive.lib.uiowa.edu/items/show/2497. Esherick acquired a copy of Morris's *News from Nowhere* (1890), a speculative allegory of an agrarian society in which learning took place through nature, during a stay in Fairhope. He would have been aware of a version of Morris's experiment much closer to home, however, in nearby Rose Valley, where the Quaker architect Will Price had founded an intentional community of artisanal workshops modeled after the principles described by Morris.

5 See Anna O. Marley, ed, *The Artist's Garden: American Impressionism and the Garden Movement* (Philadelphia: University of Pennsylvania Press, 2015).

6 Walter A. Dyer, "Two Who Dared: How a Well-Known Artist and His Wife Cut Loose from the City and Started Life Anew in the Country, with No Capital—The Building of a Studio Home," *Country Life in America*, Dec. 1907, p. 194.

7 Quoted in Constance Kimmerle, *Edward W. Redfield: Just Values and Fine Seeing* (Doylestown, PA: James A. Michener Art Museum, 2004), 23.

8 Dyer, "Two Who Dared," 194.

9 See Holly Gore, "Organic Form in the Functional Woodworks of Wharton Esherick," (master's thesis, Stanford University, 2013).

10 In "In the Cause of Architecture," Wright states as one of his propositions that "A building should appear to grow easily from its site and be shaped to harmonize with its surroundings if Nature is manifest there, and if not try to make it as quiet, substantial and organic as She would have been were the opportunity Hers." Frank Lloyd Wright, "In the Cause of Architecture: The Work of Frank Lloyd Wright," *The Architectural Record* 23 (March 1908): 155–65.

11 Wharton Esherick, "He Helps Me Build a Building," n.d., Theodore Dreiser Papers, Kislak Center for Special Collections, Rare Books and Manuscripts, University of Pennsylvania.

12 Ford Madox Ford, *Great Trade Route* (New York: Oxford University Press, 1937), 202.

13 Esherick was first exposed to Anthroposophy by Louise Bybee, a pianist who worked at a dance camp the family attended over the course of several summers. In the summer of 1920, Bybee accompanied performers practicing eurythmy, a form of Anthroposophist expressive movement. See Roberta A. Mayer and Mark Sfirri, "Early Expressions of Anthroposophical Design in America: The Influence of Rudolf Steiner and Fritz Westhoff on Wharton Esherick," *The Journal of Modern Craft* 2, no. 3 (2009): 299–323.

14 The Goetheanum was named for the German author Johann Wolfgang von Goethe, who was a significant source of inspiration for Steiner, and was developed on the foundation of Goethe's theory of natural life cycles and studies in biology. Anthroposophy comes from the Greek roots *anthropos* (human) and *sophia* (wisdom). Steiner's initial definition states that "Anthroposophy is a path of knowledge aiming to guide the spiritual element in the human being to the spiritual in the universe." Quoted in Anna P. Sokolina, "Biology in Architecture," *The Routledge Companion to Biology in Art and Architecture*, ed. Charissa N. Terranova and Meredith Tromble (Abingdon, UK: Routledge), 53–54.

15 Steiner often quoted Goethe's adage "Art is a manifestation of the secret laws of nature, without which they would never be revealed." David Adams, "Rudolf Steiner's First Goetheanum as an Illustration of Organic Functionalism," *Journal of the Society of Architectural Historians* 51, no. 2 (June 1992): 182–204; 188.

16 Steiner is commonly given credit for inventing the idea of biodynamic agriculture, the first modern organic farming movement, which championed the farm as an integrated, interdependent, living organism. He introduced the concept in a series of eight lectures in 1924 at Koberwitz in Silesia (now Kobierzyce, Poland). John Paull, "Attending the First Organic Agriculture Course: Rudolf Steiner's Agriculture Course at Koberwitz, 1924," *European Journal of Social Sciences* 21, no. 1 (2011): 64–70.

17 Adams, "Rudolf Steiner's First Goetheanum," 186.

18 "Now the bannister for the stairway in the museum from the dining room down—it was about two years getting that piece of wood and then one day when we found it we couldn't haul it. There was no way we could load it . . . there was no way we could load the thing because it was so crooked. So Mr. Esherick got a dray rig that we could put it on and drag it along. And then he had a crane out here that he unloaded it with because it had so many different angles. (Interviewer: Was it root or branches or both?) It was both. It was bent in all angles. And it was quite a big log and it was cut down that much. But he had to have that much, so that he could get that angle so that it followed the stairway down." Ed Ray, Oral History Archive, Wharton Esherick Museum.

19 Anne Tyng, oral history interviews with Mansfield Bascom, Ruth Bascom, and Susan Hinkel, June 1987. Oral History Archive, Wharton Esherick Museum.

20 The painting of the silo also seems to echo another of Wright's propositions : "Colors require the same conventionalizing process to make them fit to live with that natural forms do; so go to the woods and fields for color schemes. Use the soft, warm, optimistic tones of earths and autumn leaves." "In the Cause of Architecture," p. 157.

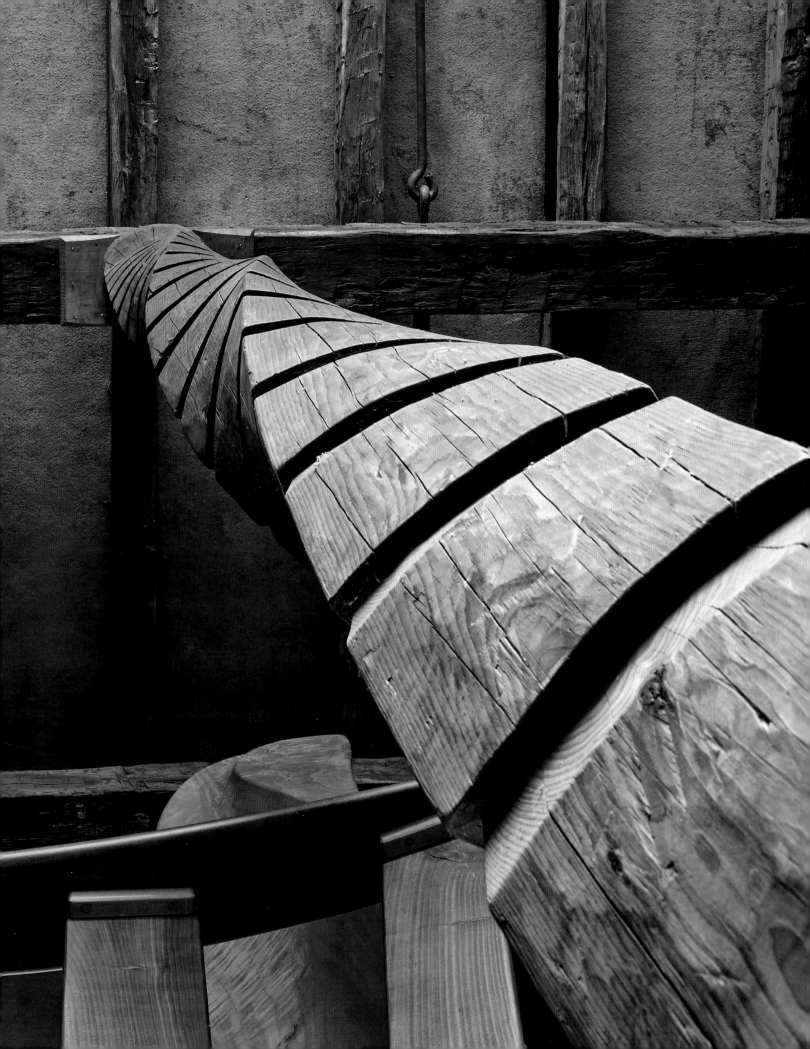

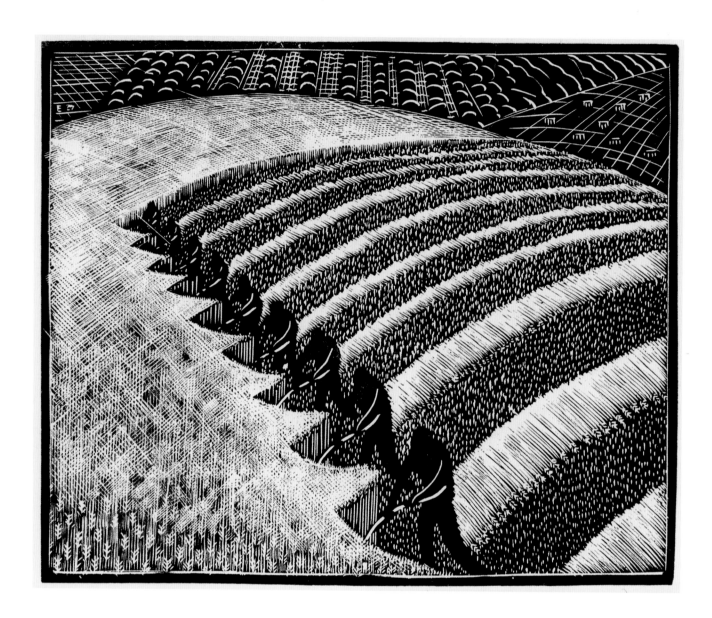

ABOVE
Harvesting, 1927

OPPOSITE
Harrowing, 1927

Illustrations for Walt Whitman,
*As I Watch'd the Ploughman
Ploughing* (Centaur Press, 1927)
Woodblock prints
Each: 6½ × 7½ in.

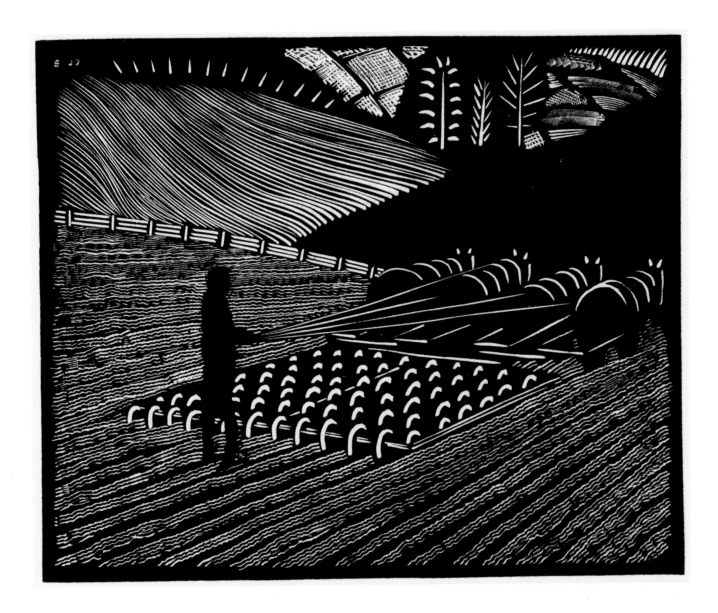

ESHERICK CREATED NINE WOODBLOCKS to illustrate a musical score by his friend Philip Dalmas, a composer and singer, which drew its lyrics from a four-line poem that appears in Whitman's collection *Leaves of Grass*:

> *As I watch'd the ploughman ploughing,*
> *Or the sower sowing in the fields—or the harvester harvesting,*
> *I saw there too, O life and death, your analogies:*
> *(Life, life is the tillage, and Death is the harvest according.)*

Esherick's prints depict the cyclical agricultural work of the poem using sharp, modern geometry. By drawing our eyes to the ways that a line of figures gathering crops or a team of horses tilling the soil make their own patterns, he emphasizes Whitman's reflection that nature's rhythms offer us ways to understand our own existence.

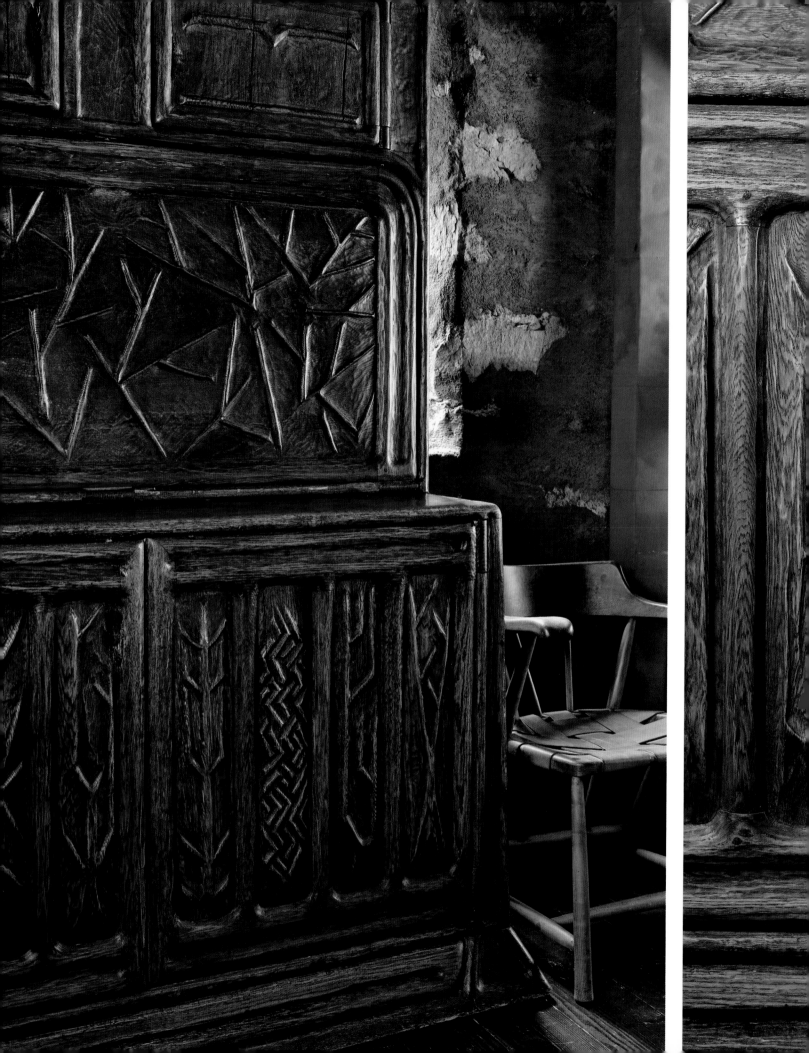

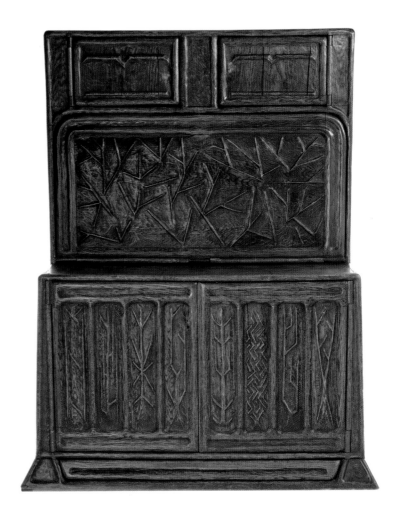

Drop Leaf Desk, 1927
Red oak, leather
78 × 55½ × 22 in.

DROP LEAF DESK WAS THE first major piece of furniture Esherick produced largely without the assistance of his regular collaborators, such as the cabinetmaker John Schmidt. It also marks a transitional moment, as one of Esherick's last three-dimensional works featuring extensive surface decoration. The pictorial patterning, which recalls the un-inked surfaces of the artist's woodblocks, offers multiple abstracted views of a single landscape.

Specifically designed to contain the artist's own prints and printmaking materials, the *Drop Leaf Desk* features large compartments, flat-file drawers, and a leather-clad work surface inside the drop leaf. By 1929, Esherick had moved away from creating patterned surfaces and begun to assert that furniture, like sculpture, should depend on its overall form alone for visual interest.

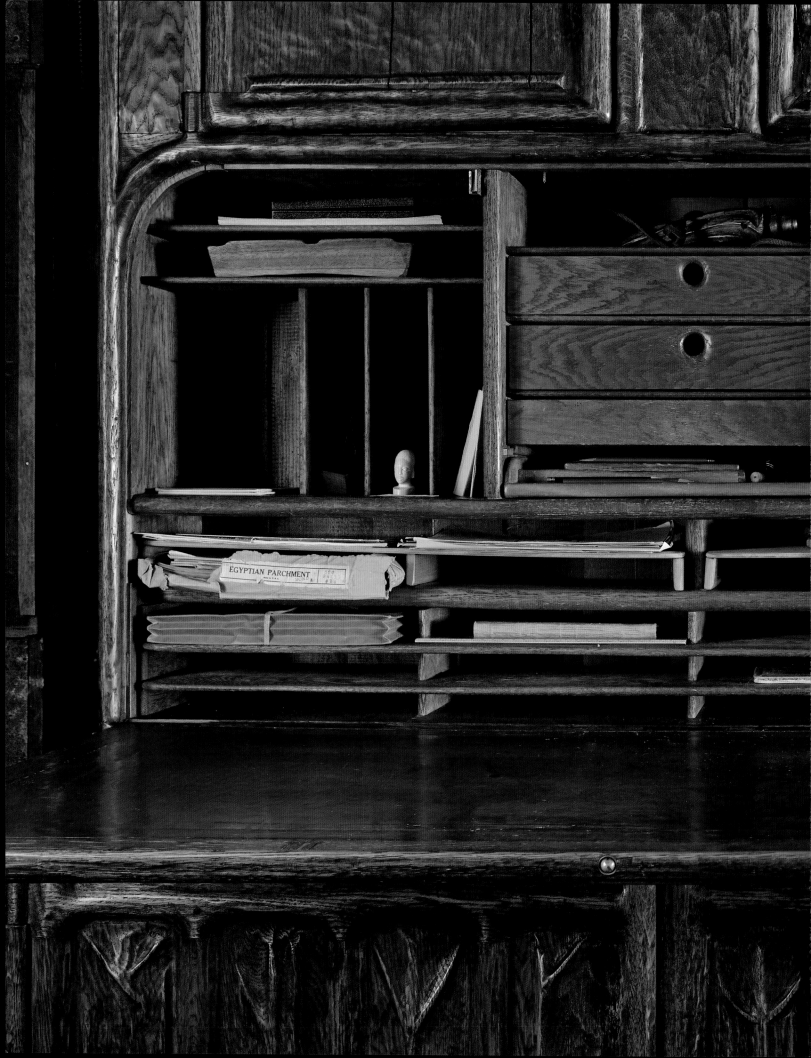

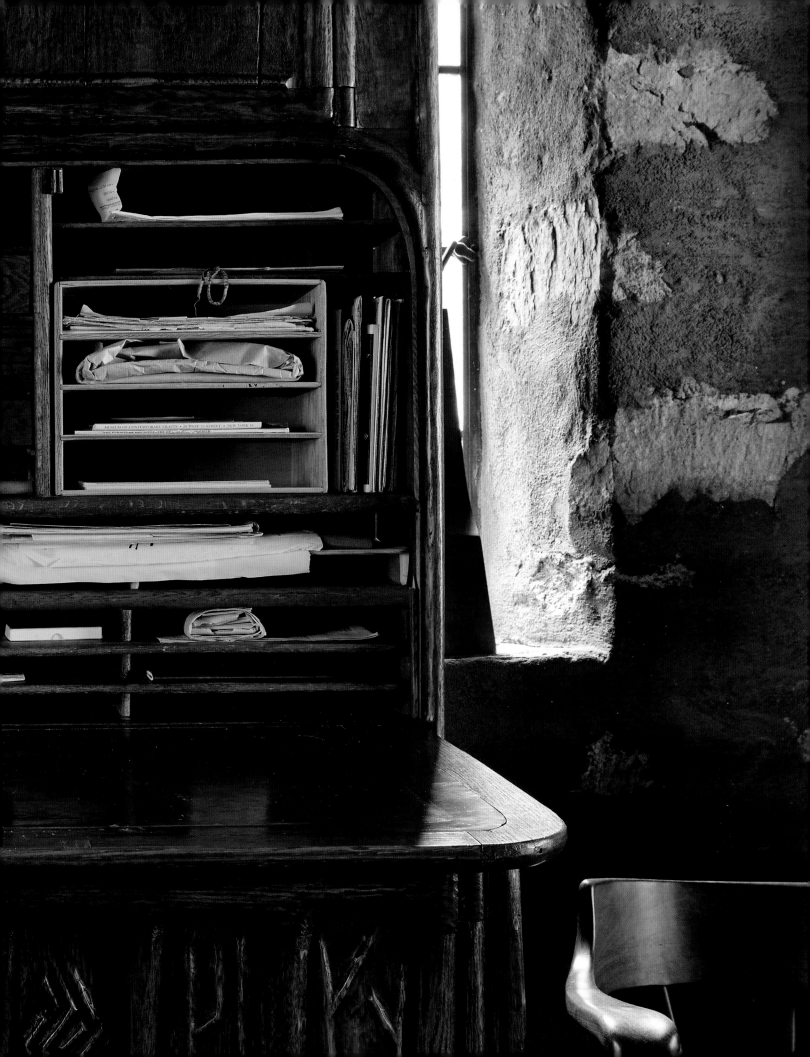

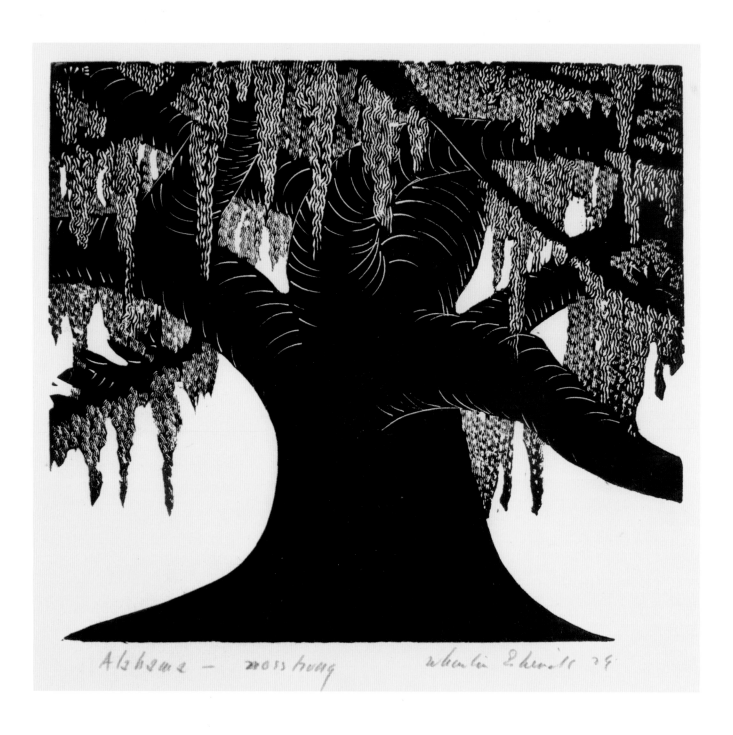

Alahama — moss hung whentin Edwards 29

ABOVE

Alabama Moss Hung, from
the *Alabama Trees* series, 1929
Woodblock print
8 × 7½ in.

OPPOSITE

Moonlight and Meadows, 1932
Woodblock print
7½ × 8 in.

108

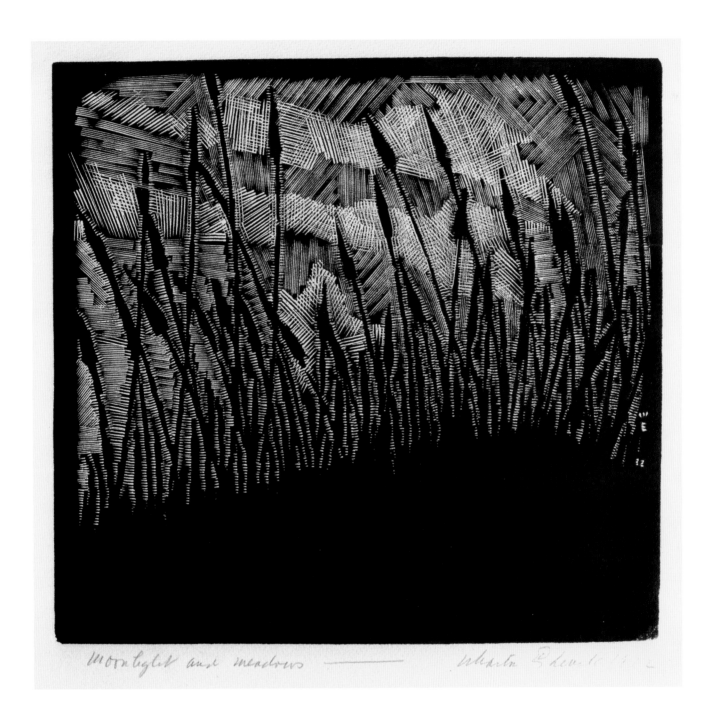

Moonlight and meadows ———— Wharton Esherick

IN BOTH OF THESE PRINTS, Esherick juxtaposed detailed mark-making against solid dark forms to create a sense of atmospheric nature. *Alabama Moss Hung*, produced during the family's final trip to the artist communities of Fairhope and Daphne Bay, recreates languid strands of the hanging plant through small repeating curves. *Moonlight and Meadows* has a similar softness, with white hatched lines outlining a field of tall, swaying grasses.

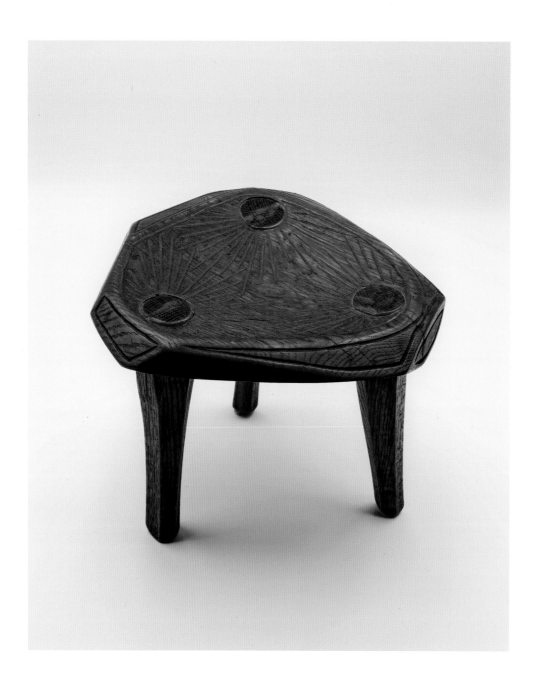

Three-Legged Stool, 1931
Oak
11 × 11½ × 12½ in.

ESHERICK DESIGNED THIS STOOL for Sunekrest, the artist's rural family home. It was placed next to the farmhouse's fireplace, into which Esherick had laid a hammered copper hearth depicting a rising sun to echo the name of the property. The lines that radiate across the seat can be seen as a geometric rendering of rays of sunlight.

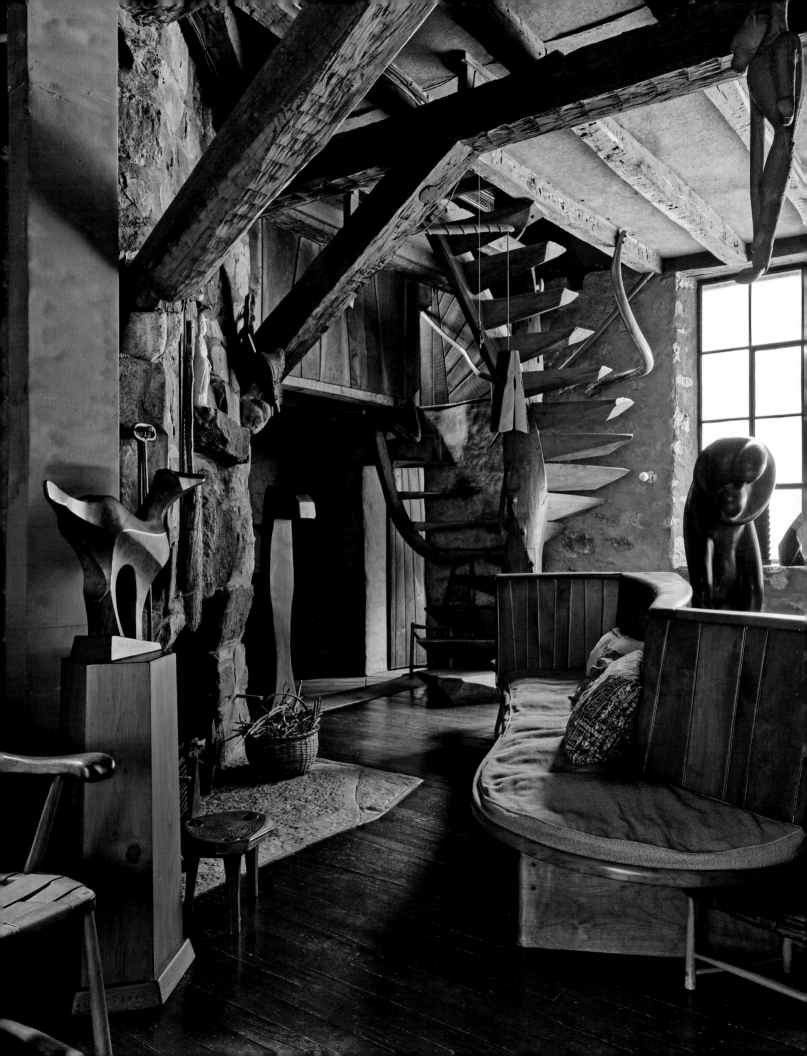

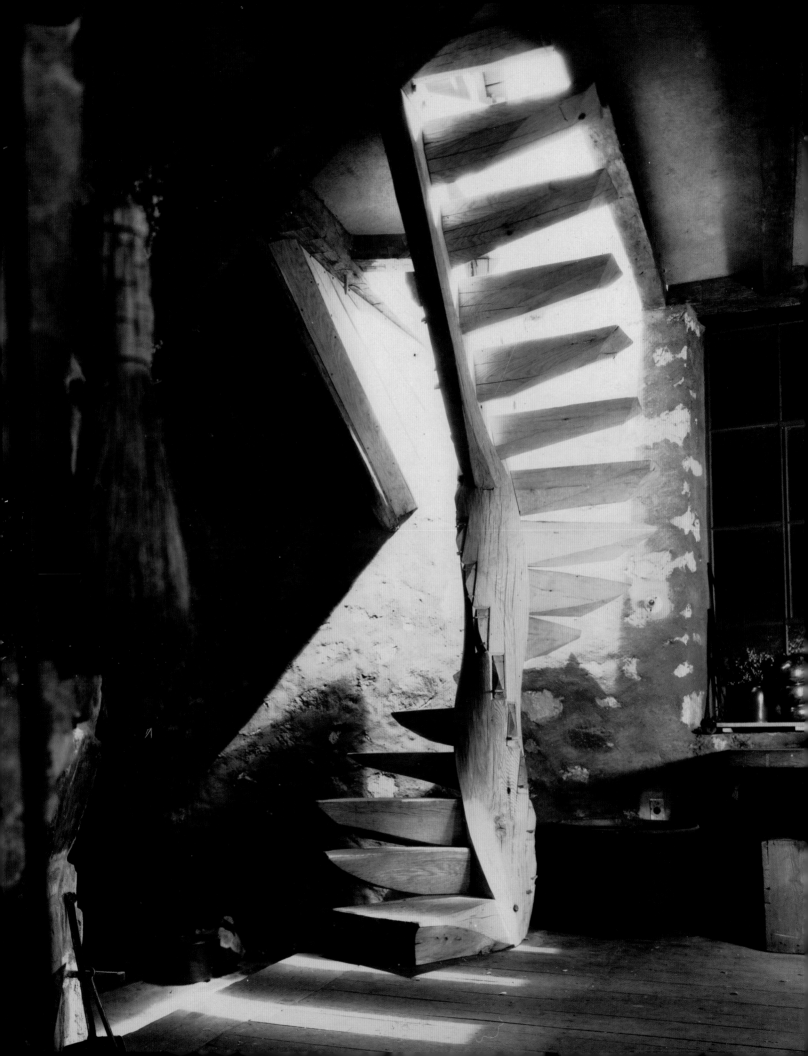

Emil Luks (active 1930s)
Spiral Stair, ca. 1934
Photographic print
6⅜ × 4¾ in.

PERHAPS THE MOST ICONIC architectural feature of Esherick's Studio is this twisting spiral staircase, here captured by the photographer Emil Luks in its original form, shortly after it was installed in 1930. The cantilevered steps, supported by tenons mortised into a central column, appear to float, making the staircase seem precarious despite its sturdy construction.

The *Spiral Stair* is one of several dramatic examples of a recurring form that reflects Esherick's deep interest in organic expression, which led to the creation of objects centering on a twist or spiral to represent natural growth. He returned to this form in models for staircase commissions for the Bok House—in which the spiral is created through gradual shifts in the shape and width of each step—and for the Hedgerow Theatre, which, like the staircase in the Studio, revolves around a center post.

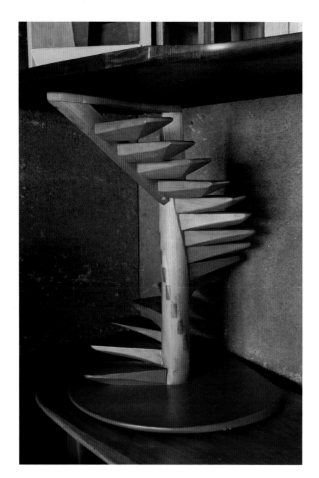

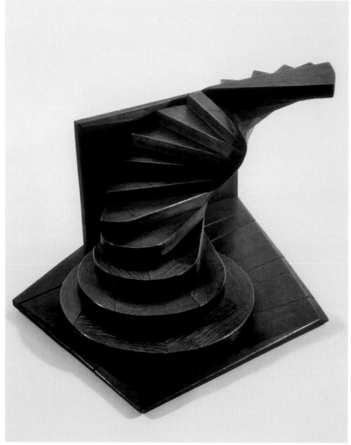

ABOVE LEFT
Spiral Stair model, 1963
Pine
21¼ × 19 × 16½ in.

ABOVE RIGHT
*Bok House Chimney
Stair model*, 1937
Painted wood
12 × 11 × 11 in.

OPPOSITE
*Hedgerow Theatre
Lobby Stair model*, 1934
Walnut
26¼ × 14½ × 12 in.

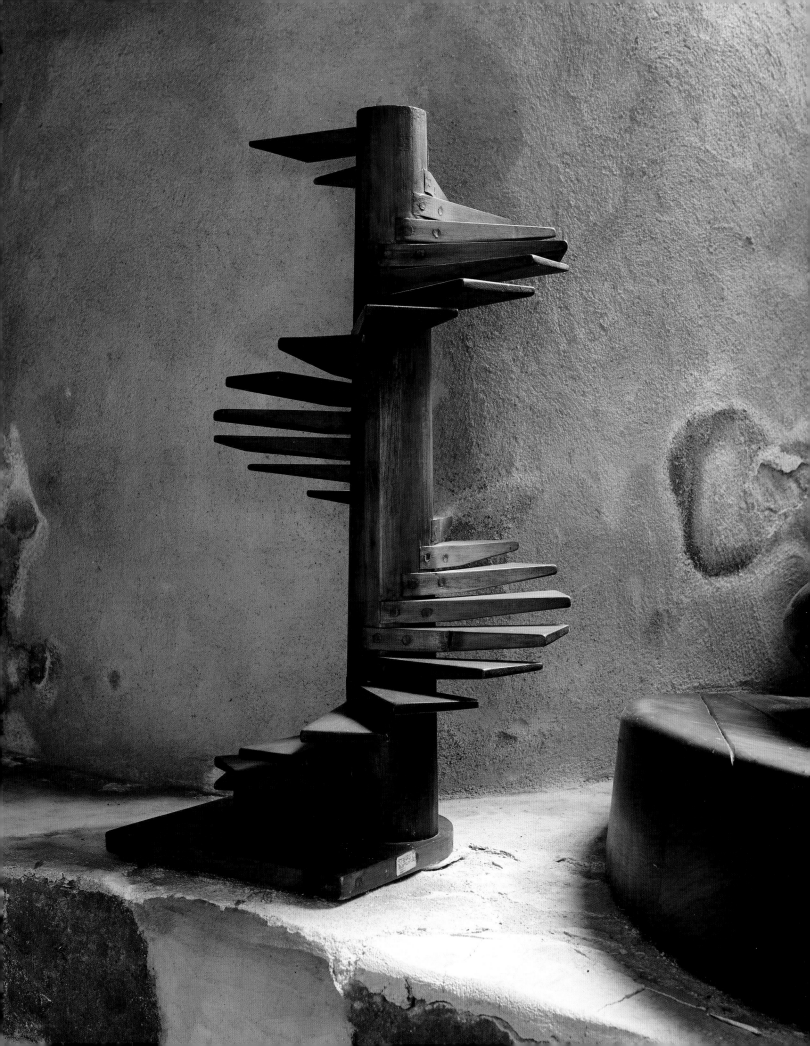

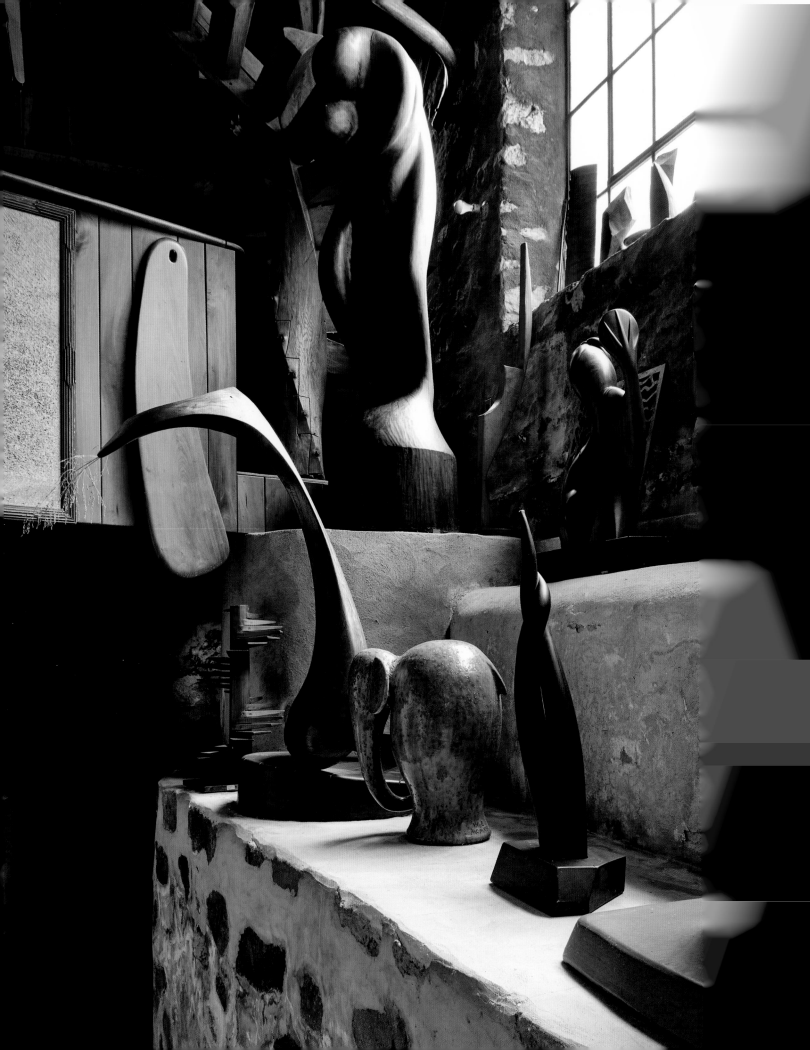

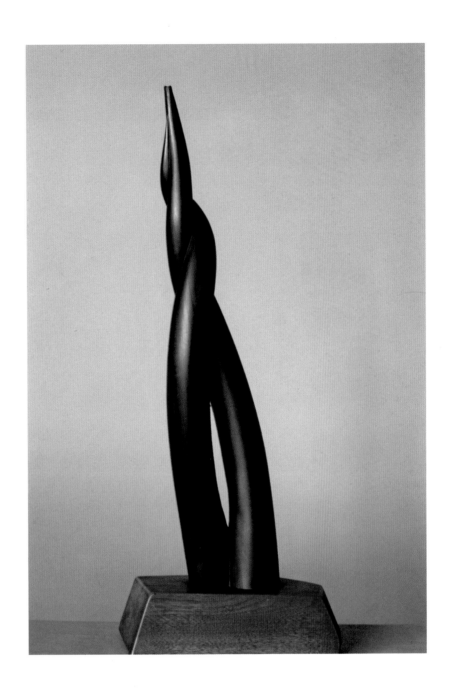

The Pair, 1951
Ebony and walnut
32 × 12¾ × 9½ in.

SPIRALING GROWTH REAPPEARS in this abstracted sculpture of an embrace inspired by Esherick's relationship with Miriam Phillips, his partner in the latter decades of his life. To entice potential buyers, Esherick called it by a variety of titles including *He and She*, *Bill 'n Anne*, and *Adam and Eve*. Despite these humanizing titles, the piece resembles a close-up view of shoots of grass or leaves. Two slender forms entwine together seamlessly, reaching toward the sun.

Piano Table, 1956
Walnut
28 × 52½ × 39½ in.

WORKS FROM ESHERICK'S LATER YEARS exhibit softer, free-flowing biomorphic forms that evoke the natural world. Many American artists and designers turned to biomorphism at mid-century as a reaction against the hard edges of Modernism, although Esherick's own engagement with the idea was deeply rooted in his way of viewing the world from the start of his career. The top of this *Piano Table* exemplifies the ebb and flow of curved forms and smooth edges that came to define the artist's style in the late 1950s and 1960s.

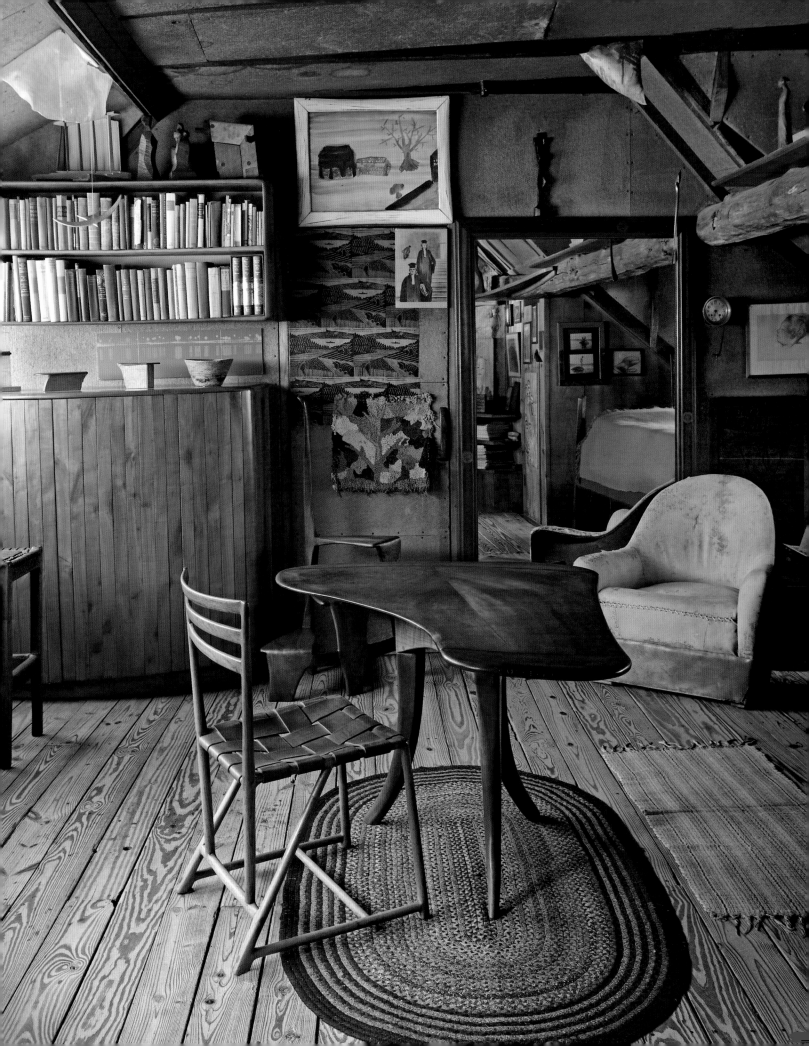

BETWEEN WORLDS

Wharton Esherick's Rural and Urban Entanglements

COLIN FANNING

► **A 1909 PHOTOGRAPH TAKEN** from Philadelphia's towering City Hall shows us the city Wharton Esherick would have known as a student (fig. 1). Factories, mercantile buildings, and railway infrastructure butt up against regular ranks of workers' row houses and the occasional grand residence. With the central civic gesture of the Benjamin Franklin Parkway still a gleam in the eye of "City Beautiful" boosters, and with the major reconfigurations of post–World War II urban planning still decades in the future, there is little to alleviate the gritty atmosphere of density and industry.[1] Plumes of smoke and tall chimneys attest that this is not only an urban landscape but a productive one as well— where people, machinery, and capital work together to make the modern world.

Contrast this hard-edged metropolis with a view down a quiet country road, captured around 1905 by the photographer Edgar J. Parker in Malvern, Pennsylvania (fig. 2). In a sparsely populated landscape still scattered with vestiges of America's War of Independence, the human presence is more subdued, nature more prominent. It's tempting to think that—apart from the visibly modern intrusion of utility poles—life here might not be so different from the way it was in the days of Washington and Jefferson.

These two photographs handily illustrate the rural-urban dichotomy as it manifested in Philadelphia and its surroundings in the late nineteenth and early twentieth centuries, when Esherick was coming of age as an artist and establishing the rural existence that would define his public reception and private life. Indeed, the farmhouse Esherick and his wife, Letty, occupied from 1916, not far from Malvern, is a degree further isolated from the Lancaster Pike running through Malvern. From its perch on Valley Forge Mountain, Esherick's home looks out on hilly terrain dense with trees, as his 1923 woodblock print effectively evokes (see p. 38). In cultivating an image as a predominantly rural artist, working close to nature and free from urban noise and distraction, Esherick built on pastoral ideals rooted deep in the American cultural imagination. By the late nineteenth

OPPOSITE Light streams through the Studio windows onto a shelf of small sculptures in the Main Gallery

123

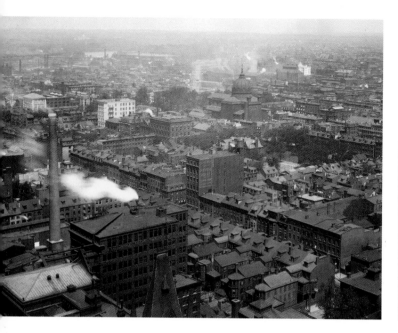

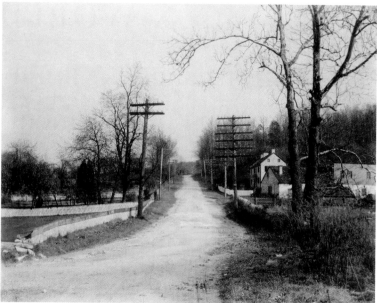

century, with American industrialization having firmly arrived in urban centers, the rural landscape bore an increasingly potent charge as a nostalgic foil to the perceived evils of cities.[2] But despite a deep-rooted sense of their division, the categories of rural and urban are not always a hard-and-fast binary.

The border between city and country, conventionally defined as opposites, is often a more porous interface. William Penn's famous 1682 dictum that Philadelphia was to be a "greene country towne" already envisioned a negotiation between the organizing ambitions of urban development and the ostensible freedom and naturalness of rural life.[3] By the later nineteenth century, even America's more isolated denizens were enmeshed with infrastructure (railways, canals, the telegraph) and policies that connected them to a national market and larger flows of labor and commerce.[4] Esherick's quiet hillside was no exception. A woodblock map he printed for an 1923 invitation to a viewing of new work at his studio shows how his rural compound was both distant from and close to Philadelphia's urban core at the same time, very much by design (fig. 3). The rail lines running vertically across the map indicate the Pennsylvania Railroad's east-to-west Main Line, whose proximity and relatively recent extension drew the Eshericks to their homestead in the first place, allowing them to maintain ties to the relatively moneyed world of their upbringings.[5] Stitching together rural and urban, the Main Line brought a wide world of friends, clients, and collaborators to Esherick's studio, just three miles from Paoli Station.[6]

Narratives of the rural landscape as a font of authenticity and individualism persisted throughout the twentieth century, even as industrialization and suburban development drove deeper into the countryside and challenged easy divisions between city and not-city. Esherick's work and life reflect the creative tensions between these two spheres. Straddling

FIG. 1. ABOVE LEFT Aerial view from Philadelphia City Hall, looking northwest along the axis of the future Benjamin Franklin Parkway, May 24, 1909

FIG. 2. ABOVE RIGHT Edgar J. Parker (active 1900s), view of Lancaster Pike, Malvern, Pennsylvania, ca. 1905

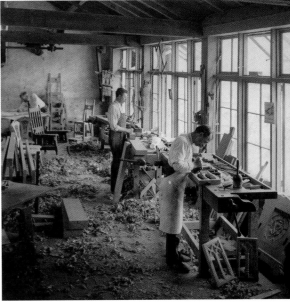

the dichotomy of rural and urban, he was able to craft his own relationship with each and make use of the differing opportunities they afforded.

▼ ▼ ▼

FIG. 3. ABOVE LEFT Wharton Esherick, map of the route from Paoli to Sunekrest, early 1920s, from an invitation to an open studio event. Woodblock print, 12¼ × 10¼ in. (untrimmed). Collection of the Wharton Esherick Museum

FIG. 4. ABOVE RIGHT The architect William Lightfoot Price in the Rose Valley furniture shop about 1903, working at a drafting table at rear; in the foreground, the craftsman John Maene carves Gothic panels

While Esherick's agrarian leanings developed against this broader American backdrop—inflected further by his avid reading of the Transcendentalist writer Henry David Thoreau, whose mid-nineteenth-century writings would reshape American naturalism—he was also indebted to the pastoral stance and artistic philosophies of the international Arts and Crafts movement. Initially taking root in nineteenth-century England as a reaction against the social, economic, and ecological predations of industrialization, Arts and Crafts emphasized the importance and inherent integrity of individual artful workmanship—as opposed to repetitive, dehumanizing factory labor—and the need for beauty in the everyday.[7] The reform-minded movement spilled into more utopian experiments as well. Some advocates established dedicated rural communities to explore alternatives to the fragmentation and alienation they saw in modern life.[8] One such case was Rose Valley, an art colony founded in and around disused textile mill buildings near Moylan, Pennsylvania, that epitomized the attempt to integrate art into daily life and foster a culture of dignified handicraft (fig. 4).[9] Esherick was familiar with Rose Valley from his work for the community's Hedgerow Theatre.[10] But while Rose Valley and the other utopian communities of the Arts and Crafts movement tended to stress the collective nature of their enterprise—drawing on the precedents of medieval guilds or colonial American workshops—Esherick preferred to work more independently, collaborating with other craftspeople but living out a more solitary pursuit of the Arts and Crafts ideals of truth to materials and honesty in construction.

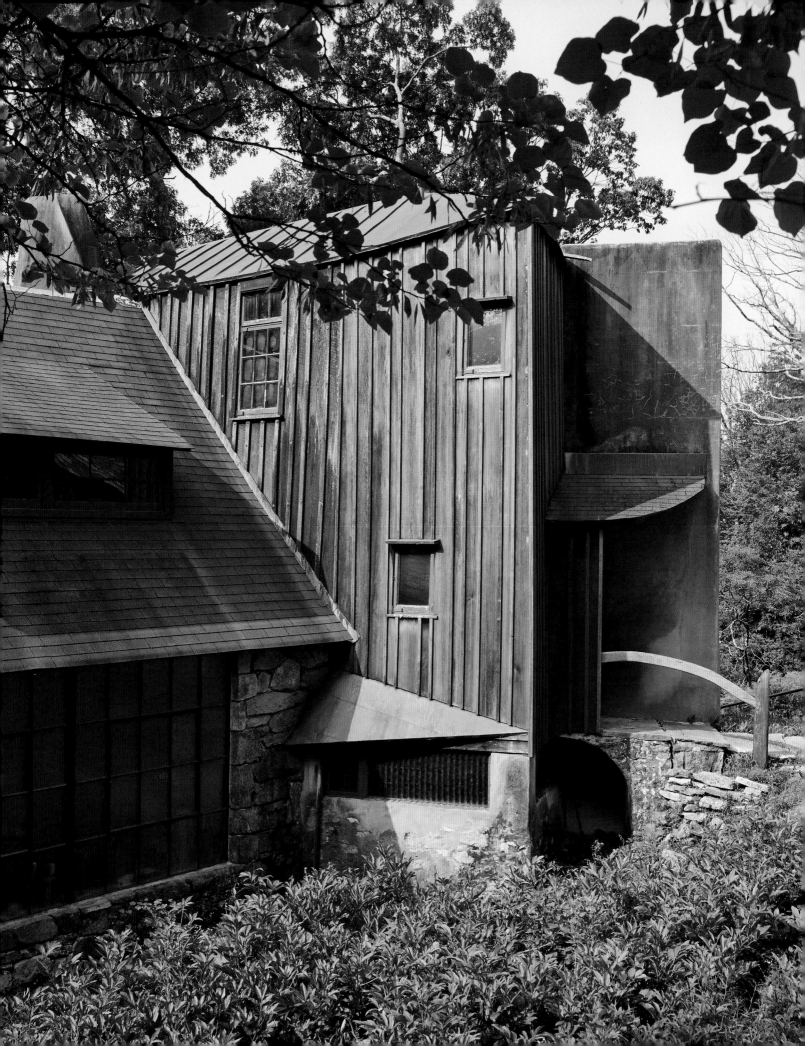

In his early career, Esherick turned to the medium of print to articulate his affinities with the land and the image of the rural craftsperson. In this, he was aided by Philadelphia's deep history as a center of publishing, relying on an urban literary infrastructure to forward his themes of labor and landscape. A prime example of this duality in action was Esherick's suite of thirteen woodblock illustrations for a 1924 edition of Walt Whitman's poem "Song of the Broad-Axe" (first published in 1856), issued as the inaugural publication of the Centaur Press. Initially established as a bookshop in central Philadelphia in 1921 by Harold Mason, the shop and its press became a cornerstone of the city's cultural circuit, with a penchant for controversial or iconoclastic strains of modern literature that seems to have rhymed with Esherick's own artistic drive.[11] The pairing of artist and poet for the book *Song of the Broad-Axe* was likewise a happy one—Esherick was already an avid reader of Whitman's poetry, finding that it dovetailed with his own experiences of physical labor and his love of the natural world. His illustrations express a strong sympathy with Whitman's textual homage to the American landscape and the dignity of physical work, together positioned as the source of the nation's vitality (see pp. 140–41).[12] While Esherick's images of craftspeople at work relate to a longer history of the depiction and romanticization of rural workers through art, they also stand somewhat apart from a vein of American culture in the 1920s and 1930s that emphasized the collectivity, scale, and, above all, modernity of industrial (and largely urban) labor.[13] Esherick's craftspeople, abstracted from their environments, sit comfortably within the poem's global lineage of labor that stretched back to the ancient world, with timeless tools that (Whitman writes) "served all great works on land, and all great works on the sea, for the mediaeval ages and before the mediaeval ages."

For *As I Watch'd the Ploughman Ploughing*, an edition of Philip Dalmas's musical setting of another Whitman poem, Esherick turned his attention to the laboring body within an agricultural landscape (see pp. 102, 103). These and other depictions of country life, like his 1925 print *Coal Wagon* (see p. 139), were a consistent theme running through Esherick's printmaking in the 1920s. Several of his furniture works likewise allude to his affinity for the rural environment, such as his 1931 *Wagon Wheel Chair* (see p. 138). Gesturing in both name and form to a horse-and-cart world that had disappeared within a single generation, it also self-consciously signifies rural resourcefulness—the pride of making do with the materials at hand. Esherick channeled much of the same spirit into his growing Paoli compound, especially in his barnlike Studio building, begun in 1926.

▼ ▼ ▼

Although Esherick's self-constructed rural existence shaped his work in many ways, his urban engagements were just as crucial. The creative communities of Philadelphia and nearby New York provided numerous opportunities to exhibit his work, learn from others', and build relationships that helped sustain his long and prolific practice. Even so, urban art critics latched onto Esherick's strong association with the hinterlands, alluding to his "quaint little studio" in their writings.[14] A profile in Philadelphia's *Public Ledger* went further, describing his home and Studio in rhapsodic detail and characterizing Esherick as a contented, sage-like figure "stepping from stone to stone of the path . . . to spare

OPPOSITE This exterior view of the Studio shows elements of the original stone building (1926), prismatic wooden addition (1940), and colorful silo (1966)

FIG. 5. ABOVE C. B. (Charles Buckles) Falls (1874–1960), "The City of My Dreams," ca. 1923, frontispiece to Theodore Dreiser, *The Color of a Great City* (1923)

and protect the plants that bloomed in the crannies"—a creator and caretaker of an "earthly paradise."[15] Such impressions echoed the archetype at the heart of the American agrarian myth: the rural farmer (or craftsperson), as one historian has put it, as "the incarnation of the simple, honest, independent, healthy, happy human being" embodying "a wholesomeness and integrity impossible for the depraved populations of cities."[16]

But alongside the rural imagery, Esherick's dynamic work extended to cosmopolitan subjects. Some of these reveal how Esherick's experience of the city was often filtered through relationships with artists and writers who made their homes in the metropolis. The author Theodore Dreiser was one such key friend for Esherick. Over their long acquaintance, the two exchanged visits between Paoli and Manhattan and corresponded regularly about matters both artistic and mundane; Esherick carved two abstracted portrait busts of the author, a sure sign of a valued friendship (see p. 142). The two met not long after Dreiser published *The Color of a Great City*, a 1923 collection of essays dramatizing his own New York experiences, illustrated with sketch-like urban scenes by Charles B. Falls (fig. 5).[17] Esherick subsequently borrowed a fragment of its title for a dynamic woodblock view of the author in his Manhattan element (see p. 146). More overtly modern in style than Falls's more documentary illustrations, it shows a silhouetted Dreiser at work, nearly subordinate to the throng of people and buildings outside the window of his 57th Street apartment. An homage to a close and admired friend, the work—of which the artist was proud enough to submit it to *Vanity Fair* for consideration—shows that Esherick was as able an observer of the bustling city as he was of the quiet countryside.[18]

Esherick also made connections in New York's rich design professional networks that supported his growing practice in furniture making. In 1929 he exhibited his *Flat Top Desk* and a matching chair (see pp. 146–49) at the American Designers' Gallery, cofounded by a collective that included Esherick's friends and fellow artist-designers Henry Varnum Poor and Ruth Reeves. The gallery's members sought to integrate the principles of European Modernism into what they saw as a retrograde American design field, embracing the decorative possibilities of contemporary technologies and materials.[19] As the angular forms of the desk and chair suggest, Esherick's formal and material sympathies lay less with the rigid machine aesthetic of the vaunted Bauhaus school and more with the animated approaches of German Expressionism. Esherick was certainly familiar with the contours of this broad movement in the arts through his reading and from the Hedgerow Theatre's more avant-garde productions.[20] He was particularly interested in Rudolf Steiner, the Austrian writer and founder of the spiritualist Anthroposophy movement, who argued for architecture and design to reflect processes of natural and spiritual transformation.[21]

Esherick experienced the expression of this philosophy firsthand in the interiors and furniture of the German émigré Fritz Westhoff (a keen follower of Steiner) made for the Manhattan restaurant and rooming house run by the Anthroposophical Threefold Commonwealth Group, a collective primarily based north of the city in Spring Valley (fig. 6). Esherick's woodwork in this period shares with Westhoff's an odd yet enticing blend of geometric and organic form (see, for example, his three-legged hearthside stool for Sunekrest on p. 110, with its polygonal form and linear carvings). Though the exact

FIG. 6. Interior of Threefold Restaurant, 318 West 56th Street, New York City, designed by Fritz Westhoff (1902–1980), ca. 1929–30

degree of direct influence is unclear, Esherick clearly engaged with a wider realm of artistic and philosophical ideas through his robust urban networks.[22] These influences were never irreconcilable with his largely pastoral posture; when the *Flat Top Desk* failed to sell through the American Designers' Gallery, Esherick was happy to place it before a large window in his Studio, where its angularity formed a counterpoint to the organic forms of the wooded landscape outside.

Those same networks generated many of the commissions that solidified Esherick's repute as a singular furniture maker—though it's important to note that his lauded projects for city-based clients also had crucial support closer to home, in the cabinetmaker John Schmidt, a Hungarian immigrant who established a workshop and sawmill near Esherick's house in 1907 and helped to fabricate many of his works.[23] Esherick's decades-spanning work for Helene Koerting Fischer, president of the Philadelphia-based industrial manufacturer Schutte & Koerting, was crucial not only for her recurring material support but also because her aptitude as an active partner in the design process set the functional parameters within which Esherick's sculptural imagination could play.[24] Commissions like the furnishings for Fischer's study, including its famed *Corner Desk* (fig. 7), or a boardroom suite for the Schutte & Koerting headquarters made between 1942 and 1944 (see p. 194–95), fostered a shift in Esherick's practice toward interiors conceived as larger aesthetic and functional compositions.[25]

In 1932 he provided another context-sensitive and client-specific metropolitan space, for the photographer Marjorie Content, a friend and correspondent from the late 1920s.[26]

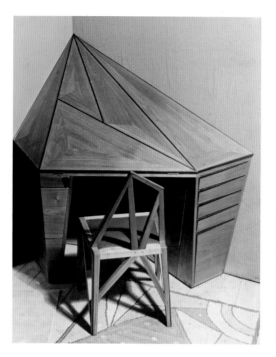
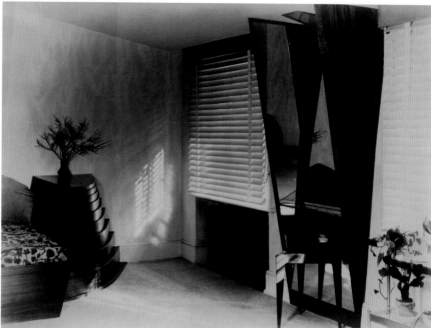

The daybed and arrestingly angular dressing table that anchored her quarters on 10th Street in Manhattan constituted Esherick's thoughtful response to the needs of urban living—they are compact, multifunctional, and visually elegant (fig. 8). The cleverly articulated storage at each end of the bed and faceted vanity could be seen as an Expressionist nod to the dynamism of the modern metropolis, but an alternate source of inspiration has also been suggested: Content's photographs of the muscular, geometric landscapes of the American Southwest. Esherick's Paoli compound was a regular first stop for Content on her sojourns to rural New Mexico and Arizona; it's easy to imagine her sharing photographs with him on the return journey, perhaps further shaping Esherick's playful triangulation between modern and primeval in his work.[27]

▼ ▼ ▼

By the late 1930s, the dichotomy between city and country had become even more blurred with the growth of suburbs and the rise of what social scientists called the "rural-urban fringe"—an ambiguous transition zone that challenged existing thinking about land use, economic policy, and interactions between the two spheres.[28] As policymakers grappled with a changing (literal) landscape, and cultural commentators took up the theme of suburban ennui, the communities near Esherick's once-rural compound began to look more like the suburbia familiar to us today. Esherick was no stranger to the environment of the suburbs—his largest commission, a series of elaborate interiors and furniture for Judge Curtis Bok made between 1935 and 1938, was in suburban Gulph Mills—but by the middle of the twentieth century the horizons of the American rural idyll had been perceptibly circumscribed.[29]

FIG. 7. ABOVE LEFT *Corner Desk* and chair for Helene Fischer, 1931

FIG. 8. ABOVE RIGHT Marjorie Content (1895–1984), *Bedroom Suite by Wharton Esherick*, ca. 1932

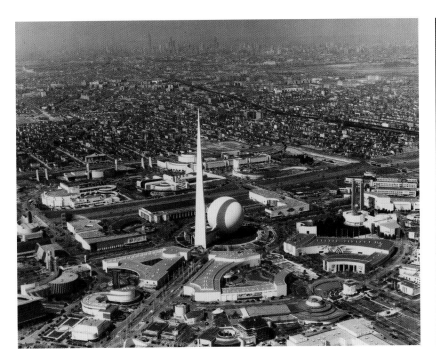

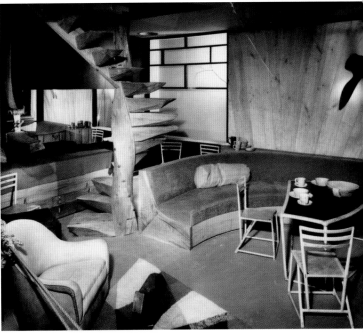

FIG. 9. ABOVE LEFT Aerial
view of New York World's Fair,
ca. 1939

FIG. 10. ABOVE RIGHT George
Howe and Wharton Esherick,
Pennsylvania Hill House interior,
1940, from America at Home
pavilion, New York World's Fair

This shifting balance was palpable at the 1939–40 New York World's Fair. At the
sprawling fairgrounds in Queens, the "World of Tomorrow" took shape across corporate
and governmental exhibits, offering convenience, novelty, and order in stark contrast with
the crowded skyline of Manhattan looming nearby through a haze of urban pollution (fig. 9).
The future, the fair seemed to suggest, was of the city but also apart from it, as were many
of the technological and domestic innovations offered up for attendees: the General Motors
"Futurama" display, for example, envisioned an elaborate system of private transportation
that would whisk drivers from jumbled cities to their suburban retreats with ease.[30]

Amid this technological bombast, Esherick's contribution to the World's Fair struck
a visibly different note. In collaboration with the Philadelphia architect George Howe,
Esherick took part in the America at Home pavilion, an addition to the fair's 1940 season
that featured "regional" domestic interiors commissioned from notable architects and
designers.[31] The duo's Pennsylvania Hill House, with the temporarily relocated spiral stair
from Esherick's Studio as its centerpiece, highlighted Esherick's connection to his materials
and the land, as well as a willingness to iterate on his own prior efforts (fig. 10). Gathered
around an asymmetrical table topped with phenolic resin (a material composed from both
organic and synthetic ingredients, often used for laboratory worktops) were redesigned
versions of his earlier *Hammer Handle Chairs*, initially made for the Hedgerow Theatre.
True to their name, the Hedgerow chairs were made from repurposed stock handles,
almost an echo of Whitman's praise in "Song of the Broad-Axe" for such humble tools as
symbols of American vitality (see p. 192). Reworked into a slightly less rustic form for the
World's Fair—though the official America at Home press release went so far as to describe
Esherick's work as "simple, almost peasant furniture"—the chairs and the rest of Esherick

and Howe's interior offered an appealingly handmade vision of the domestic future that caught attendees' attention.[32] One reviewer wrote that the space evoked America's "pioneer tradition that translates well into a modern idiom," capturing the same straddling of worlds that characterized Esherick's career nearly from its start.[33]

▼ ▼ ▼

Following this major exposure at the World's Fair, Esherick would find that such rural associations remained highly appealing to urban audiences through the rest of his career, which saw numerous exhibitions in American cities large and small. Writing after the 1958 opening of his first major retrospective at the Museum of Contemporary Crafts in Manhattan, the critic Gertrude Benson described the artist as "a Thoreau of our time," firmly articulating the place he had achieved in the pantheon of American pastoralism.[34] Perhaps most striking is just how consistently Esherick's work and life were understood through this lens over the decades, whether during the heady days of the United States' postwar affluence or the lean times of the Great Depression. Enduring across a period of major social and economic change in the United States, the image of the humble country-dwelling artisan clearly held utility not just for Esherick himself, but also for those who saw in his work potential answers to the unresolved questions of modernity.

Decades before the New York retrospective exhibition, a writer for the *Philadelphia Record* reviewing a 1932 exhibition at the Philadelphia Art Alliance that included Esherick, Henry Varnum Poor, and Ruth Reeves offered their lives as a model for the nation's unemployment struggles: the artists were united "in their conviction that only by drawing on the resources of the land may the country return to a permanent normalcy. They profess to have discarded any ambition for fame or fortune, but do acclaim a love for congenial work that will assure them of the essentials of life."[35] But as Esherick's own fame came to show, artistic renown and romanticized seclusion were not mutually exclusive. Neither were the persistent twentieth-century fictions of pioneer ways ever truly divorced from the urban networks and influences that they claimed to reject, or the broader systems of intergenerational wealth and support that allowed these artists to stake such radical positions in the first place. Standing with a foot on each side of an urban-rural divide, Esherick put America's long-standing agrarian myths to strategic use, sustaining his creative practice and crafting an enduring legacy. ▼

OPPOSITE The windowsill above the Sculpture Well holds a selection of small sculptures and models

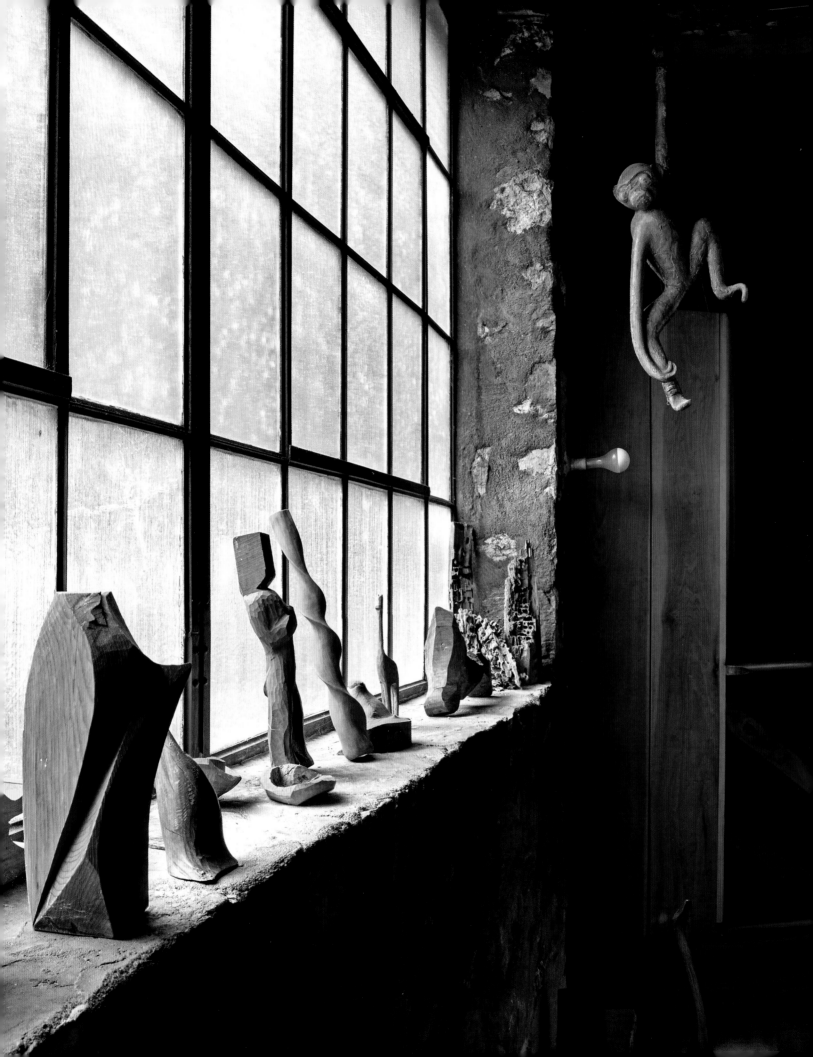

NOTES

1 Visible at top center is a first phase of what would become the city's iconic parkway; see David Brownlee, *Building the City Beautiful: The Benjamin Franklin Parkway and the Philadelphia Museum of Art* (Philadelphia: Philadelphia Museum of Art, 1989), esp. chap. 1.

2 As the historian Richard Hofstadter put it, "The more rapidly farmers' sons moved into the towns, the more nostalgic the whole culture became about its rural past." See Richard Hofstadter, *The Age of Reform* (New York: Knopf Doubleday, 1960), 24.

3 On Philadelphia's relationship to natural space, see Elizabeth Milroy, *The Grid and the River: Philadelphia's Green Places, 1682–1876* (University Park: Pennsylvania State University Press, 2016).

4 See David E. Nye, *America as Second Creation: Technology and Narratives of New Beginnings* (Cambridge, MA: MIT Press, 2003).

5 See Paul D. Eisenhauer, "Introduction: A Song Well Sung," in Paul D. Eisenhauer and Lynne Farrington, eds., *Wharton Esherick and the Birth of the American Modern* (Atglen, PA: Schiffer Publishing, 2010), 13–14.

6 See Katie Wynne, "Finding Wharton Esherick's House (Before GPS)!," March 3, 2017, whartonesherickmuseum.org/finding-wharton-eshericks-house-before-gps/.

7 For an overview, see Wendy Kaplan, *The Arts and Crafts Movement in Europe and America: Design for the Modern World* (New York: Thames and Hudson, 2004). On the fundamental urban networks of the movement, see Alan Crawford, "The Importance of the City," in Karen Livingstone and Linda Parry, eds., *International Arts and Crafts* (London: V&A Publications, 2005), 62–81.

8 See Eileen Boris, *Art and Labor: Ruskin, Morris, and the Craftsman Ideal in America* (Philadelphia: Temple University Press, 1986), esp. chap. 9, "The Communal Impulse: Back to the Land with Arts and Crafts." See also Mary Greensted, "Nature and the Rural Idyll," in Livingstone and Parry, *International Arts and Crafts*, 92–107.

9 See William S. Ayers et al., *A Poor Sort of Heaven, a Good Sort of Earth: The Rose Valley Arts and Crafts Experiment* (Chadds Ford, PA: Brandywine River Museum of Art, 1983); and Wendy Kaplan, *"The Art That Is Life": The Arts and Crafts Movement in America, 1875–1920* (Boston: Museum of Fine Arts, 1987), 120–21.

10 Eisenhauer, "Introduction: A Song Well Sung," 30–35; see also Anne d'Harnoncourt, Preface to *The Wharton Esherick Museum: Studio and Collection* (Paoli, PA: Wharton Esherick Museum, 1977), 3.

11 Eisenhauer and Farrington, *Wharton Esherick and the Birth of the American Modern*, 25–28 and 74–79.

12 See Burton Hatlen, "Song of the Broad-Axe," in J. R. LeMaster and Donald D. Kummings, eds., *Walt Whitman: An Encyclopedia* (New York: Garland Publishing, 1998), 660–61.

13 See, for example, Erika Doss, "Looking at Labor: Images of Work in 1930s American Art," *Journal of Decorative and Propaganda Arts* 24 (2002): 230–57.

14 Dorothy Grafly, "W. H. Esherick Exhibiting Woodcut Series at Paoli," newspaper clipping, May 27, 1923, Wharton Esherick Family Papers, Box 1, Folder 1.

15 Victor Henderson, "Wharton Esherick and His Paradise of Art, Painted, Graved and Carved," *Philadelphia Public Ledger*, July 5, 1925, clipping in Wharton Esherick Family Papers, Box 1, Folder 1.

16 Hofstadter, *The Age of Reform*, 24.

17 Eisenhauer and Farrington, eds., *Wharton Esherick and the Birth of the American Modern*, 98–99.

18 "The Dreiser–Esherick Camaraderie," *Wharton Esherick Museum Quarterly* (Spring 1991); online at whartonesherickmuseum.org/the-dreiser-esherick-camaraderie-2/.

19 See Marilyn F. Friedman, "Defining Modernism at the American Designers' Gallery, New York," *Studies in the Decorative Arts* 14, no. 2 (2007): 79–116; see also Grace Lees-Maffei, "Introduction: Professionalization as a Focus in Interior Design History," *Journal of Design History* 21, no. 1 (2008): 6.

20 K. Porter Aichele, "Wharton Esherick: An American Artist-Craftsman," in *The Wharton Esherick Museum: Studio and Collection* (Paoli, PA: Wharton Esherick Museum, 1977), 7.

21 On Rudoph Steiner's impact on design, see Mateo Kreis and Julia Althaus, eds., *Rudolf Steiner: Alchemy of the Everyday* (Weil-am-Rhein: Vitra Design Museum, 2010).

22 See Roberta A. Mayer and Mark Sfirri, "Early Expressions of Anthroposophical Design in America: The Influence of Rudolf Steiner and Fritz Westhoff on Wharton Esherick," *Journal of Modern Craft* 2, no. 3 (2009): 299–324.

23 Laura Turner Igoe and Mark Sfirri, *Daring Design: The Impact of Three Women on Wharton Esherick's Craft* (Doylestown, PA: James A. Michener Art Museum, 2021), 14, 27.

24 Igoe and Sfirri, *Daring Design*, 27.

25 Igoe and Sfirri, *Daring Design*, 44. See also letter from S. E. Hess to Wharton Esherick, Aug. 18, 1950, Wharton Esherick Family Papers, Box 8, Folder 24; and Holly Gore, "Immovable Authority: Wharton Esherick's *President's Desk* for Helene Fischer," Jan. 2022, https://whartonesherickmuseum.org/immovable-authority-wharton-eshericks-presidents-desk-for-helene-fischer/.

26 Regarding Esherick's relationships with both patrons, see Eisenhauer, "Introduction: A Song Well Sung," 39–41. For details of his ongoing work for Content, see Wharton Esherick Family Papers, Box 8, Folder 24.

27 See Laura Turner Igoe, "Marjorie Content and Wharton Esherick," in Igoe and Sfirri, *Daring Design*, 53–55. Igoe identifies some suggestive visual rhymes between Content's photographs and the furniture forms.

28 The term was apparently coined by T. Lynn Smith in *The Population of Louisiana: Its Composition and Changes*, Louisiana Bulletin 293 (Baton Rouge: Louisiana State University, 1937). See also George S. Wehrwein, "The Rural-Urban Fringe," *Economic Geography* 18, no. 3 (1942): 217–28; and Robin J. Pryor, "Defining the Rural-Urban Fringe," *Social Forces* 47, no. 2 (1968): 202–15.

29 See David de Muzio, "Wharton Esherick's Music Room from the Curtis Bok House, Gulph Mills, Pennsylvania, 1935–1938," *Winterthur Portfolio* 46, no. 2–3 (2012): E58–E74.

30 Arthur J. Pulos, *The American Design Adventure* (Cambridge, MA: MIT Press, 1988), 1–10; see also Marco

Duranti, "Utopia, Nostalgia and World War at the 1939–40 New York World's Fair," *Journal of Contemporary History* 41, no. 4 (2009): 663–83.

31 Eisenhauer, "Introduction: A Song Well Sung," 44–45; see also Pulos, *American Design Adventure*, 3–7.

32 Leo Casey, "News Release No. 511," Worlds' Fair of 1940 in New York; typescript in Wharton Esherick Family Papers, Box 1, Folder 12.

33 Elizabeth MacRae Boykin, commenting initially in the *Philadelphia Bulletin* ("That 'Cabin In The Pines' Can Be Both Modern and Rustic," *Philadelphia Bulletin*, June 4, 1940) and picked up as far afield as Timmins, Ontario ("Pleasant Homes," *The Porcupine Advance*, Oct. 24, 1940, p. 5).

34 Gertrude Benson, "Wharton Esherick," *Craft Horizons* 19, no. 1 (Jan.–Feb. 1959): 33. See also Robert A. Laurer, *The Furniture and Sculpture of Wharton Esherick* (New York: Museum of Contemporary Crafts, 1958).

35 "Return to Primitive Life Will Solve Unemployment: Craftsmen Adopt Pioneer Ways, Wrest All Needs from Nature; Urge Jobless 'Back to Land,'" *Philadelphia Record*, Feb. 7, 1932, p. (4)B, clipping in Wharton Esherick Family Papers, Box 1, Folder 5.

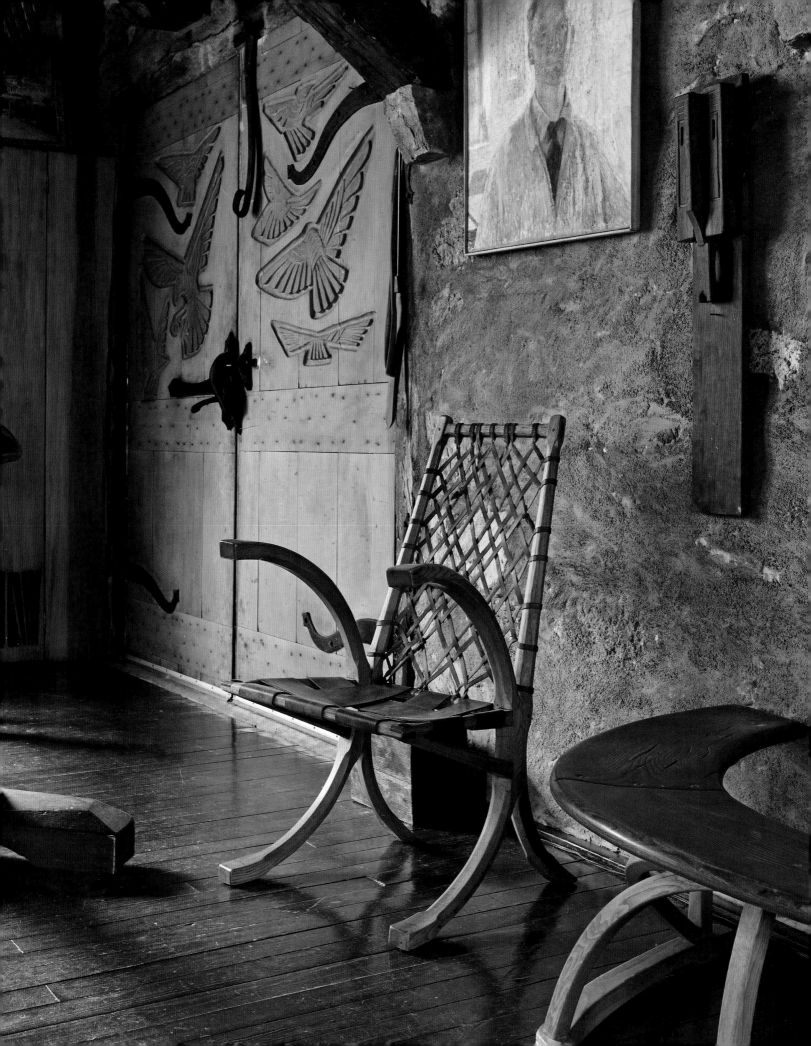

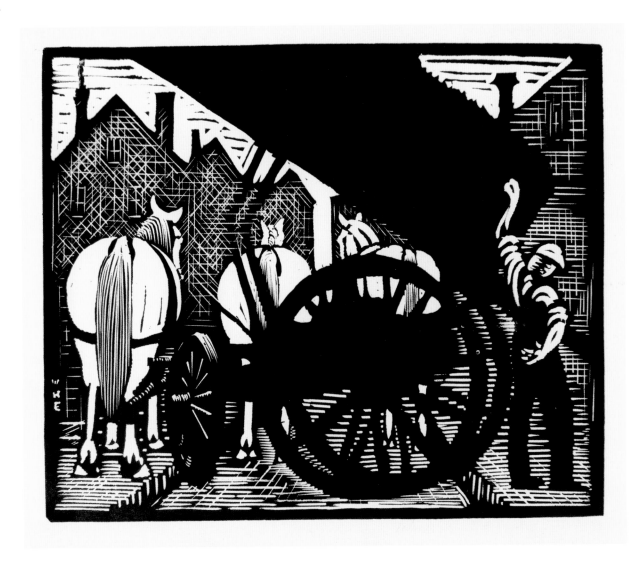

OPPOSITE
Wagon Wheel Chair, 1931
Hickory, laced leather seat and back
40 × 20 × 22 in.

ESHERICK CREATED THIS CHAIR using actual wagon wheels, which he bought in a number of sizes as overstock from a local manufacturer. The chair's connection to the past through these repurposed objects is balanced by its nods to modern design. The oversize rounded arms, which become the chair's front legs, recall sleek cantilevered chair designs made from steel, which first appeared in the 1920s from Bauhaus designers including Mart Stam and Marcel Breuer. Woven strips of leather loop around the frame to create the seat and back.

ABOVE
Coal Wagon, 1925
Woodblock print
6½ × 8 in.

THIS PRINT SHOWS A DELIVERY MAN bringing coal to houses in an urban environment. The houses in the distance are close together, reflecting the fact that one of the effects of coal's wide usage as heating fuel was a higher density of housing. Wagon wheels, much like those that Esherick was to repurpose for furniture making, dominate the center of this image.

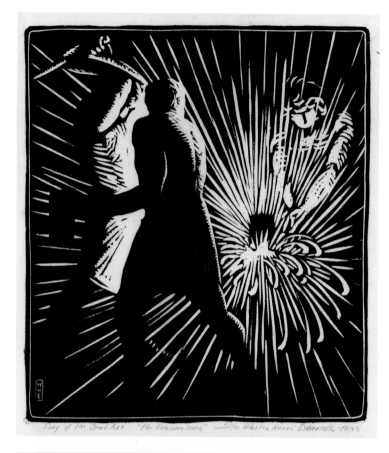

The Hammersmen, 1924

Forger at His Forge-Furnace, 1924

The Solid Forest, 1924

Illustrations for Walt Whitman,
Song of the Broad-Axe (Centaur Press, 1924)
Woodblock prints
10 × 9 in.; 9¼ × 8½ in.; 9⅝ × 8⅞ in.

THESE THREE PRINTS are from twelve that were commissioned for the Centaur Press's first publication, a 400-copy printing of Whitman's *Song of the Broad-Axe*. Esherick would have found his own values reflected in Whitman's words extolling freedom from societal restraint through craftsmanship and connection with the outdoors.

In *The Hammersmen*, Esherick uses thickly gouged lines to render the power of sparks as they pierce the darkness, while *Forger at His Forge-Furnace* is illuminated by a roaring fire depicted with dramatic contrast between light and dark. The light streaming through the trees in *The Solid Forest* evokes a sense of wilderness as a sacred space, echoing American romantic painting conventions of rendering nature as an outdoor cathedral.

Song, & the Broad Axe "Solid Forest" 37/40 Charles Harris Schoueller

Head of Dreiser
(Portrait of
Theodore Dreiser), ca. 1927
Pine
17½ × 7½ × 6 in.

THE WRITER THEODORE DREISER is best known as a practitioner of American realism, exploring themes such as the lure of urban environments, ambition and crime, and the hollowness of material success in novels such as *Sister Carrie* (1900) and *An American Tragedy* (1925). Esherick first met Dreiser in 1924 through the Hedgerow Theatre. They became fast friends, corresponding regularly between visits and encouraging each other's creative pursuits. In the summer of 1927, Esherick carved two busts of Dreiser: this rough, geometric sketch in local pine, and a finished piece in exotic mahogany, which was exhibited in group shows alongside other new American artists' works at the Whitney Studio Club—precursor to the Whitney Museum of American Art—in New York's Greenwich Village.

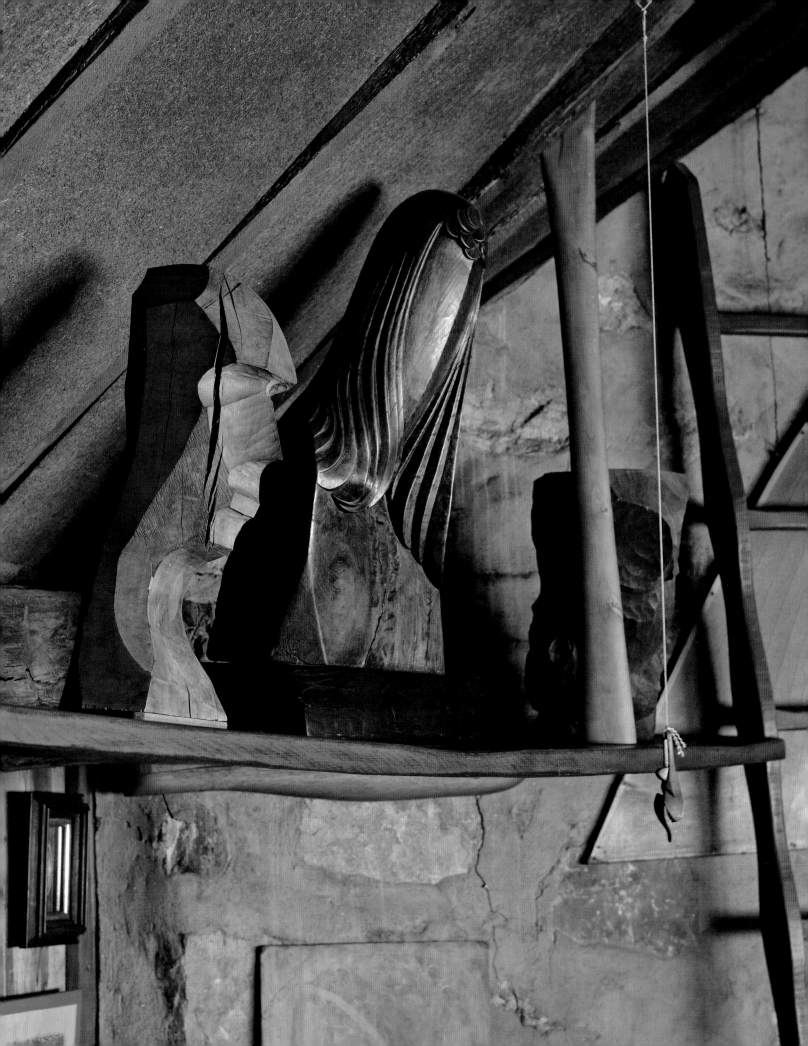

Theodore Dreiser ——————— W.E. — MCM XXVIII
"of a great city

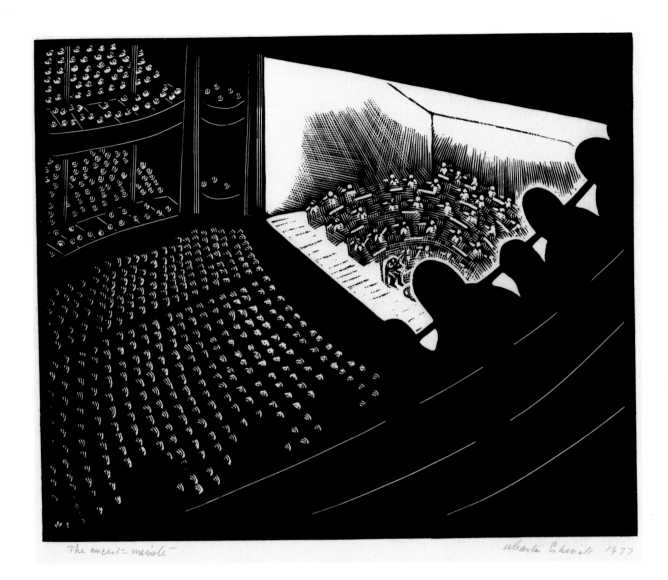

The concert-meister Martin Esherick 1937

OPPOSITE

Of a Great City, 1928
Woodblock print
10½ × 6½ in.

OF A GREAT CITY TAKES ITS TITLE from a phrase in Walt Whitman's
"Song of the Broad-Axe," a poem Esherick also illustrated for Centaur
Press that describes the poet's vision of an ideal urban environment.
The print depicts Dreiser in his apartment on 57th Street in New York
City, working on his semi-autobiographical novel *The Genius* (1915)
surrounded by the stuff of art—books, paintings, a piano. Outside,
angular skyscrapers bookend a wide avenue teeming with people.
Esherick sent a copy of the print to Dreiser, who responded: "I'm
more struck by the drawing of the room and myself as a fixture in it
than I can tell you. The thing has so much originality and force."

ABOVE

The Concert Meister, 1937
Woodblock print
9¼ × 11¼ in.

ESHERICK WAS OFTEN INSPIRED by culture and the work of other
creatives. He enjoyed listening to music, and met several members
of the Philadelphia Orchestra through the Centaur Bookshop and
Press, including Alexander Hilsberg, the orchestra's Polish-born
concertmaster. In this image, Hilsberg is shown at Philadelphia's
Academy of Music, performing with the orchestra to a hall filled
with concertgoers. Esherick depicted himself in this image as the
fourth silhouette from the right in the balcony, his head aligning
with the figure of Hilsberg on stage.

BELOW, OPPOSITE
Flat Top Desk, 1929 and 1962
Walnut and padauk
28 × 82 × 36 in.

BELOW, OPPOSITE, FOLLOWING PAGES, LEFT
Flat Top Desk Chair, 1929
Walnut, padauk, laced
leather seat
28 × 18 × 18 in.

BELOW, FOLLOWING PAGES, RIGHT
Flat Top Desk Figure, 1929
Bronze cast of cocobolo
original
10 × 5 × 4 in.

THE *FLAT TOP DESK* SUITE shows how Esherick brought urban aesthetic influences back to his rural studio, especially the angular, geometric forms found in German Expressionism. Surface decoration is almost absent from this work, appearing only as incised triangular pulls on each drawer front. The desk was originally covered with a rectangle of quarter-inch-thick aluminum plate, in a nod to the Bauhaus practice of mixing natural and manmade materials. Although Esherick ultimately substituted walnut for the metal top—which proved to be a cold and hard surface on which to write—the original design for the desk indicates his willingness to experiment with new ways of approaching materials.

The desk and its accompanying chair were exhibited in 1929 at the American Designers' Gallery in New York City, founded by Paul Frankl, a designer best known for his urban-inspired Skyscraper line of furniture. Friends in Esherick's circle were also members of the gallery, including the painter and textile designer Ruth Reeves and the ceramic artist Henry Varnum Poor.

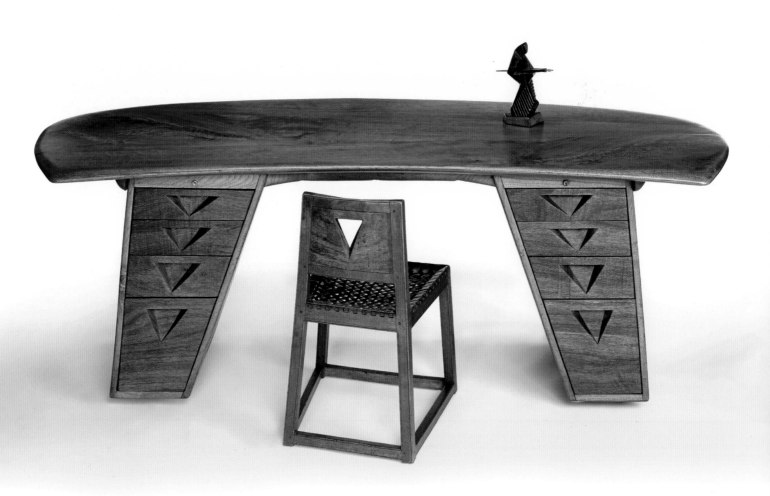

146

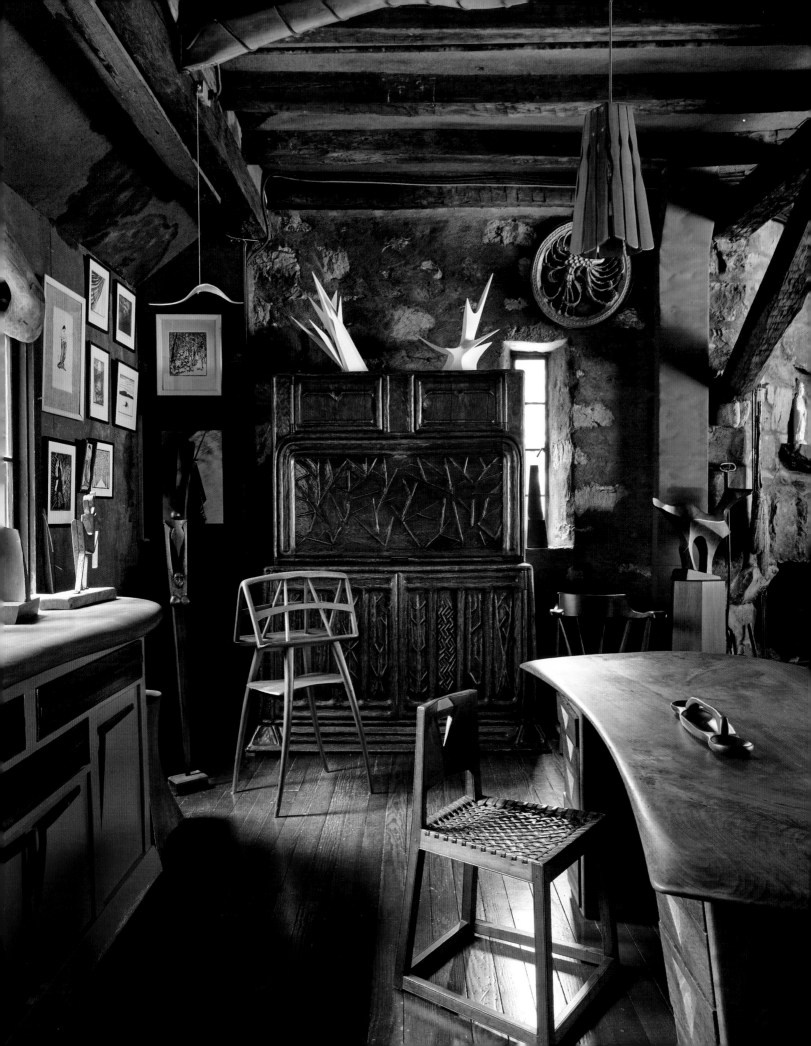

ABOVE
Fjord, 1932
Woodblock print
8 × 9¼ in.

OPPOSITE
Holzhausen, 1932
Woodblock print
9 × 12 in.

ESHERICK FIRST CAPTURED the image for *Fjord*, a stark composition featuring a boat isolated in an expansive landscape, on a train through Norway. He was on a trip to Europe sponsored by Helene Koerting Fischer, one of his most significant patrons and friends, and traveling with Hanna Weil, a German artist who was Fischer's friend and later her daughter-in-law. Esherick documented both rural and urban spaces in his travel sketchbooks and in finished prints. *Holzhausen*, from the same trip, captures the view from Weil's porch in a village west of Munich. Portions of the rural landscape are broken into angled forms, while the human elements of the image—a figure in the foreground, an ox-drawn cart, a distant train, a ship on the lake, a church—are rendered primarily as opaque black shapes.

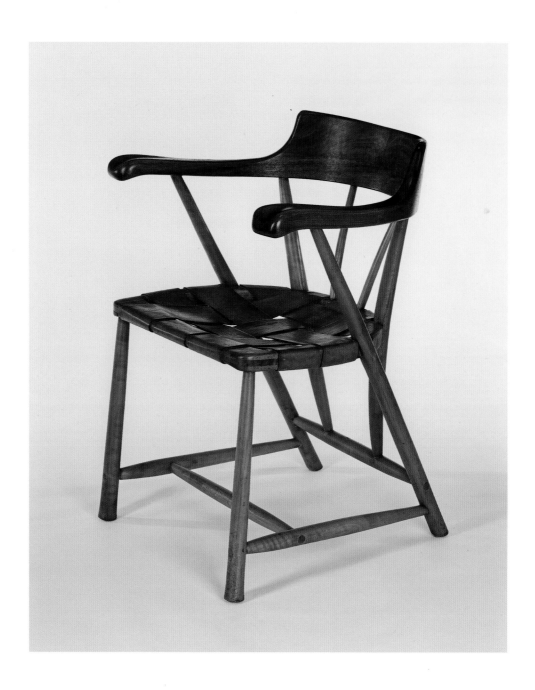

Captain's Chair, 1951
Walnut, cherry, leather
31 × 24 × 21½ in.

AFTER WORLD WAR II, interest in furnishing homes with contemporary, artist-made objects spread to urban and suburban middle-class consumers—not just the wealthy looking to commission one-off works. Esherick's *Captain's Chair* became one of his most marketable forms because its price made it accessible to a wider range of buyers. Often, this would be a first piece of his bought to furnish a home, leading to larger commissions for Esherick down the line.

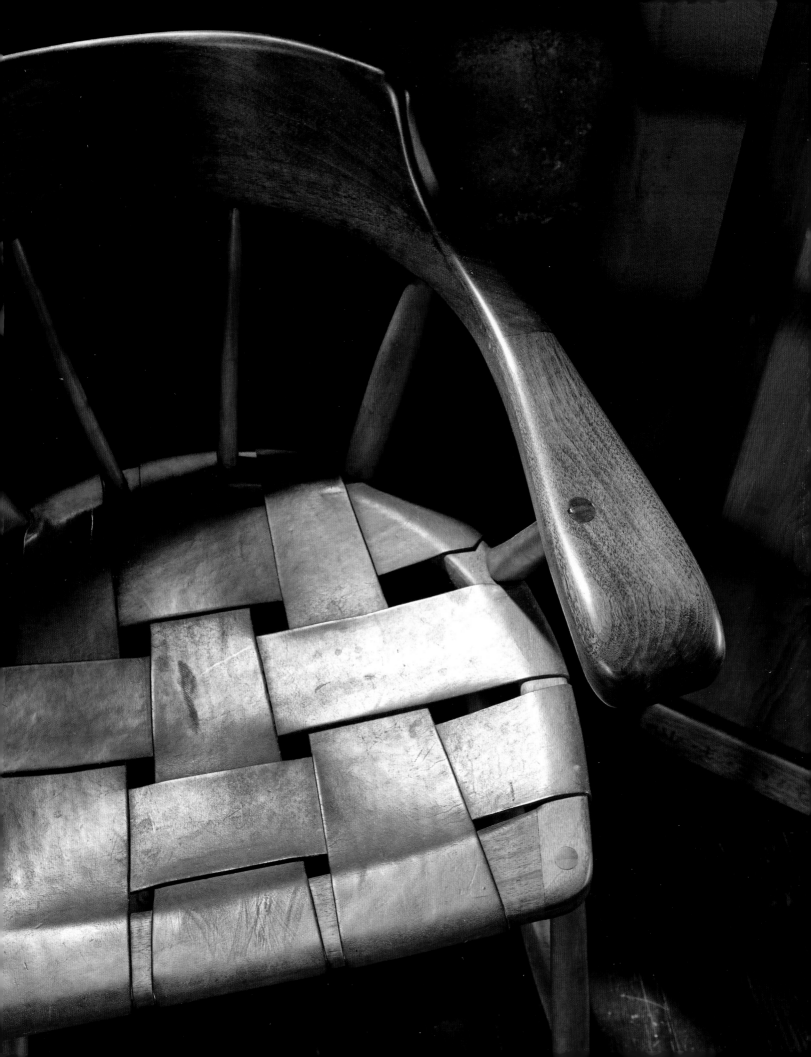

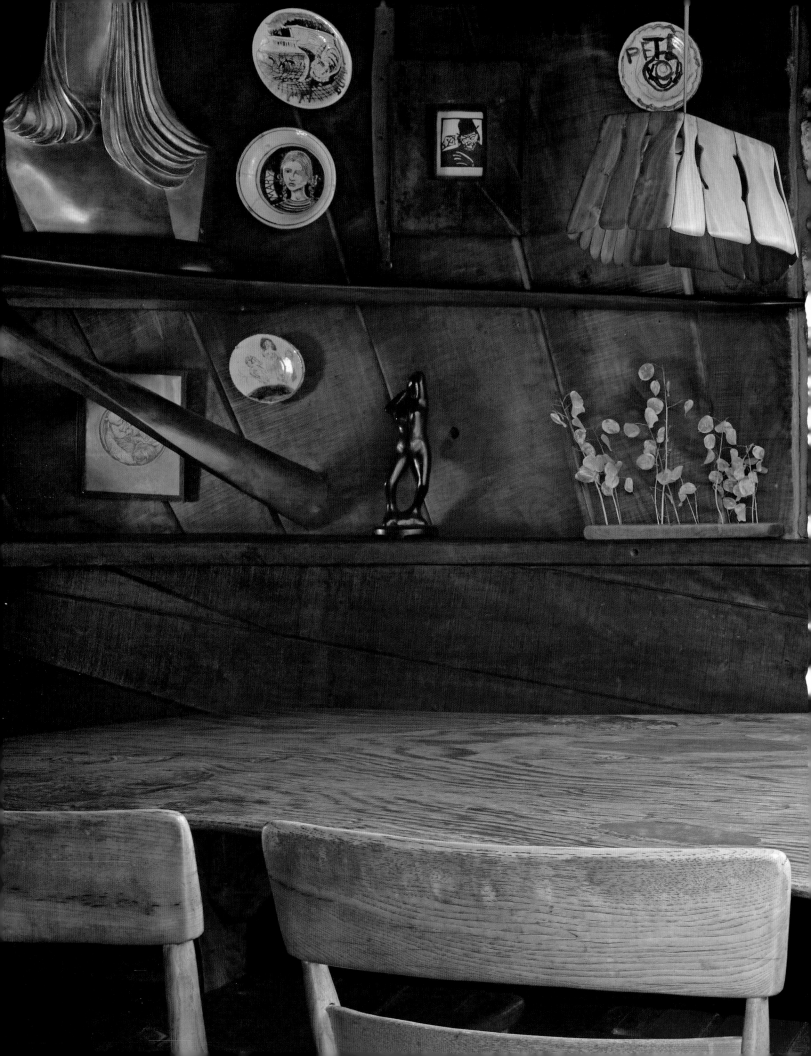

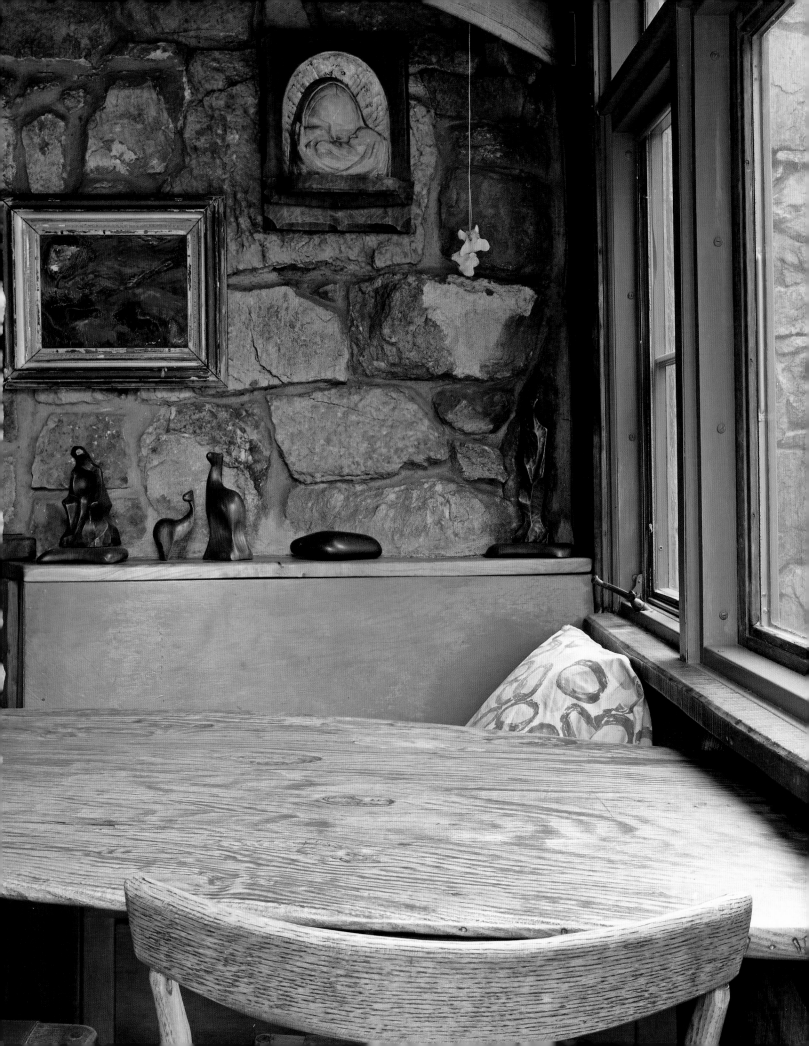

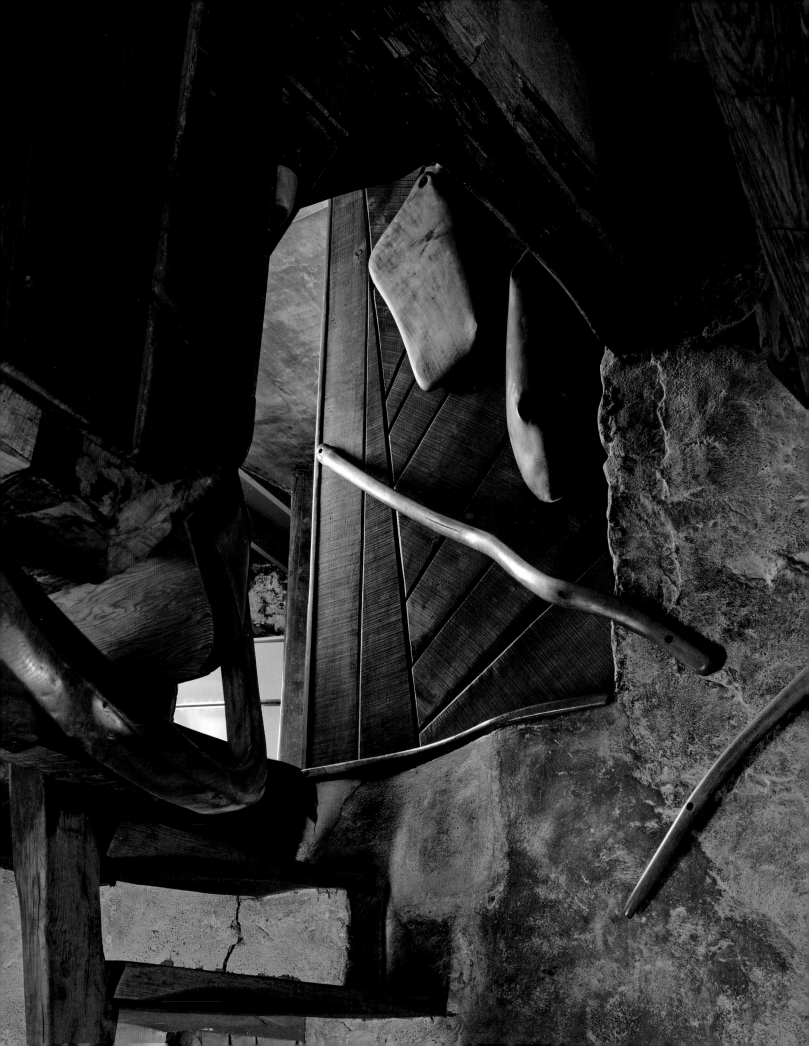

THE ASSEMBLY LINE, THE DANCE CAMP, AND WHARTON ESHERICK'S RHYTHMIC ART

HOLLY GORE

▶ **VITAL FORMS ANIMATE** the *Spiral Stair* that Wharton Esherick created for his Studio in 1930 (fig. 1). Spiraling lines, crystalline contours, swirling wood grain, axe-shaped volumes, and hand-tooled surfaces all contribute to a sense that the piece exists outside of modern time, in a world where biological processes set the pace. Esherick fashioned the staircase during a period when he transformed from an underappreciated painter to a sought-after creator of functional sculpture. Critically important for this development were his connections with communities of women dancers who promoted rhythmic harmony with nature as a means to developing a robust American art.

Esherick hit his stride as an artist at the height of the Machine Age, an era when the human relationship to time underwent unprecedented regimentation. The completion of the transcontinental railroad in the nineteenth century had necessitated the synchronization of local time zones across the United States. In the early twentieth century, wage labor became tightly choreographed with the proliferation of assembly-line work and so-called scientific management. Some people worried that the human body was not evolved to conform to the artificial pace of modern life. Rhythmic dance—a form of physical conditioning designed to reconnect city-worn bodies with rhythms of nature—was one method used to restore health and well-being. Primarily the domain of women and children, rhythmic dance was a fixture in progressive school curricula and was practiced among circles of health-minded adults. Wharton Esherick encountered the communities of women that formed around teaching rhythmic dance through his wife, Letty, who was a weaver, dancer, and progressive educator.

Letty Esherick came to rhythmic dance through progressive education, a reform movement originating in the nineteenth century that aimed at developing the whole child. Progressive educators saw children as biological organisms. They believed that schools should nurture growth, not overtrain on academic tasks nor impose strict

OPPOSITE Looking up into the Studio kitchen from the Main Gallery

behavioral discipline.[1] Letty decided to pursue a career in progressive teaching after hearing a lecture by Marietta Johnson, the founder of the cutting-edge Marietta Johnson School for Organic Education in Fairhope, Alabama. Like many progressive educators, Johnson believed that young children were not developmentally ready for extended periods of reading, which would damage their nervous systems. Accordingly, she did away with desks in the classrooms of the lower grades.[2] Instead of books, she offered a rich assortment of experiential learning activities, including theater, pageantry, set and costume design, visual arts, weaving, shop class (also called "manual training"), and rhythmic dance.

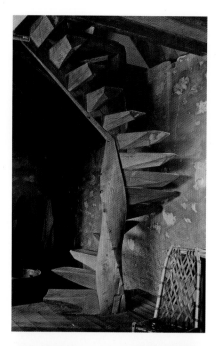

The Eshericks made a months-long visit to Fairhope in 1919–20. There, Letty gravitated toward teaching rhythmic dance.[3] Wharton concentrated on his painting, while simultaneously venturing into functional craft. In Marietta Johnson's manual training workshop, he created decoratively carved frames for his canvases. Meanwhile, Letty was learning about additional places for them to expand their creative horizons. Among the other seasonal residents in town was the sculptor Tennessee Mitchell Anderson. With her husband, the novelist Sherwood Anderson, Tennessee had spent an idyllic summer at Camp Owlyout, a center for rhythmic dance in the Adirondack Mountains of New York.[4]

Alys Bentley, founder of Camp Owlyout, was an influential dance educator who divided her teaching between the Adirondacks and her Carnegie Hall studio in Manhattan. Bentley believed that spectatorship was unnatural to dance and did not perform for audiences. Her teaching-only status kept her out of the public eye, though she was renowned among dancers. She ran Camp Owlyout as a health resort. Her program involved vegetarian diet, outdoor recreation, and evening exercises in rhythmic dance on a lawn near picturesque Upper Chateaugay Lake. Bentley's rhythmic dance resembled the modern, expressive, "natural" dance of Isadora Duncan in many ways. Participants were barefoot and bare-legged. They danced outdoors to classical piano music. And they wore flowing costumes whose similarity to ancient Grecian garb lent an aura of Classical athleticism to the bodies that the gauzy fabric barely concealed.

Industrialism haunted Bentley's theories of modern dance. In an article published in *Vanity Fair* in 1914, she wrote that the impulse to move one's body to music was among the most primal urges of human beings. Dance, she said, belonged at the center of childhood education. Its absence in public schools in the United States was a symptom of cultural overemphasis on business and industry: "America has been too busy with the great task of rendering a new land materially habitable to take time for considering the emotional outlets of its people; it has been too much occupied in hewing forests, digging canals, laying tracks, erecting buildings, and acquiring material riches to pause and consider the need of its people for emotional and artistic expression."[5]

The conviction that the United States had yet to develop significant art was one that Bentley shared with many critics of the early twentieth century. Her *Vanity Fair* article was three years earlier than publication of the famous line, in an anonymous article now attributed to the artists Marcel Duchamp and Beatrice Wood: "The only works of art America has given are her plumbing and her bridges."[6] This provocation came on the heels

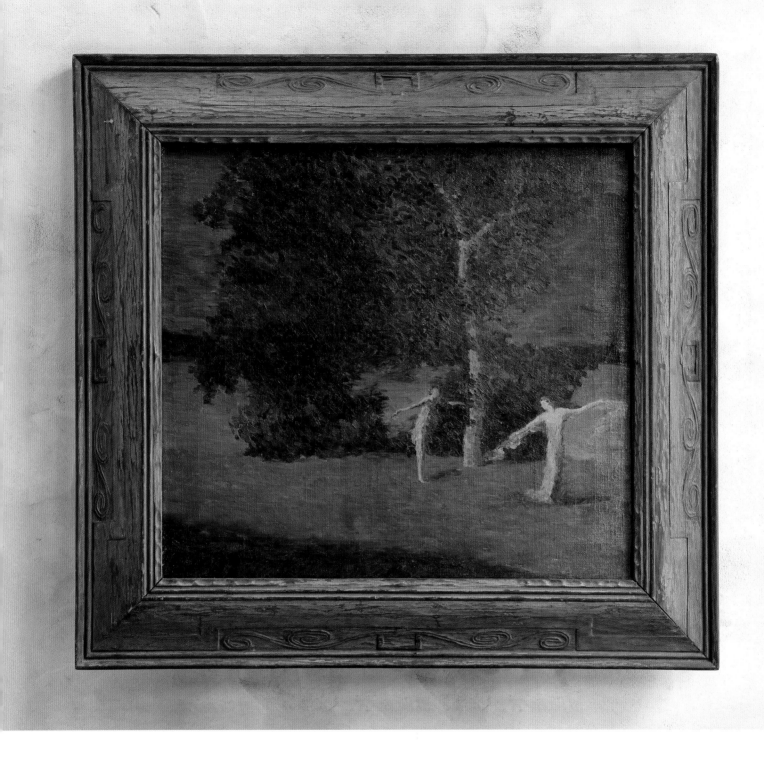

FIG. 1. OPPOSITE TOP Consuelo Kanaga (1894–1978), *Wharton Esherick's "Spiral Stair"*, ca. 1940

FIG. 2. OPPOSITE BOTTOM Alfred Stieglitz, *Fountain by R. Mutt* (1917) (Marcel Duchamp, *Fountain* [1917]), reproduced in *The Blind Man*, no. 2 (1917)

FIG. 3. ABOVE Wharton Esherick, *Rhythms in Twilight*, 1920. Oil on canvas; frame: wood, metallic pigment, 25 × 27 in. (framed). Collection of the Wharton Esherick Museum

of the controversy surrounding Duchamp's *Fountain* (1917), a porcelain urinal turned on its back, signed "R. Mutt," and presented as sculpture (fig. 2).

At first glance, *Fountain* seems to have little in common with the work that Wharton Esherick was doing around the same time, namely, Impressionist paintings artfully mounted within his own hand-carved frames. *Rhythms in Twilight* (1920) is a luminous portrayal of women dancing beside a lake near a grove of birch trees (fig. 3). Daubs of paint in deep blues, rich greens, and shimmering grays capture a quiet, moody scene. The sumptuousness of the painting carries through in the frame, which Esherick ornamented with a shallow abstract relief incorporating linear forms both stepped and spiraling. He coated the frame with warm-toned metallic pigments. An early twentieth-century artwork, *Rhythms in Twilight* predates the rise of New York City as a world center for art. Thus, it was one of many responses that American artists posited to the questions that Bentley's writing on dance skirted: whether the United States, as a nation, had sufficient character to develop a new, American art that was more than a shadow of European culture; and, if so, what would American art be? Esherick answered with a display of soulful regard for nature and artisanry. *Fountain* addressed the same uncertainty but concluded that the soul of America was factory made.

In the summer of 1920 the Eshericks retraced the Andersons' path to the dance camp in the Adirondacks that Bentley had founded. Ironically, their journey toward exploring natural movement took place in the product of an infamous time-regulating development of the era, the Ford Motor Company's conveyor belt. In 1913 Henry Ford initiated the first moving assembly line to manufacture an entire automobile (fig. 4). At his Highland Park, Michigan, plant, he refined this methodology to reduce the time it took to produce a single

FIG. 4. ABOVE LEFT Workers starting engines on Ford Model T assembly line, Highland Park Plant, Highland Park, Michigan, 1914

FIG. 5. ABOVE RIGHT The Esherick family with their Model T at the Ruth Doing Camp for Rhythmics in the Adirondack Mountains, New York, 1923

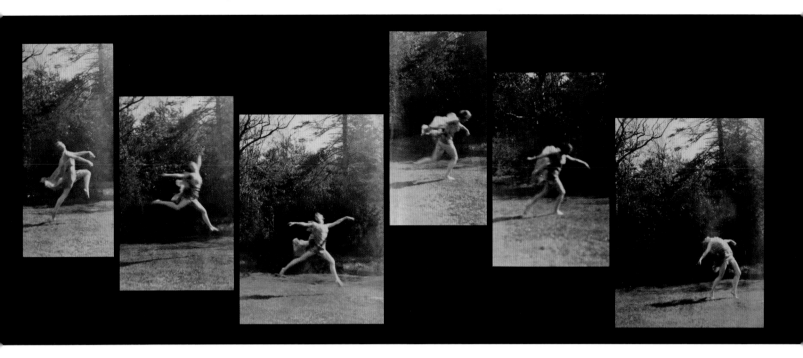

FIG. 6. ABOVE Probably
Delight Weston (active
1920s–30s), Rhythmics dancer,
1920s. Photographs from
Esherick Family Album

Model T to ninety-three minutes, allowing him to drop the price significantly. In 1920 the Eshericks bought a Model T of their own (fig. 5). Their first long drive was to Upper Chateaugay Lake.

By the time Wharton and Letty Esherick turned their new car down the dance camp's drive, Alys Bentley was gone, having sold her business to Ruth Doing, a former student of hers. Doing taught her proprietary variant of rhythmic dance, which she called "rhythmics" (fig. 6). She and her partner, an opera singer named Gail Gardner, ran the Ruth Doing Camp for Rhythmics and the Gardner-Doing Camp for Rhythmics, as it was renamed after relocating to Upper St. Regis Lake in 1925. The camps catered to adults and children, an ideal arrangement for Letty, who was the primary caretaker for the Eshericks' three children. Throughout the 1920s and into the 1930s, the family were regular visitors to the camps. There, Letty joined a community of women with shared interests in health, the outdoors, art, and dance. The social and intellectual aspects of camp were doubtless major reasons that she returned yearly, even after she became a seasoned dancer who taught rhythmics from her home and at other venues in and around Philadelphia.

At camp, Wharton Esherick tried rhythmics. For the most part, though, he concentrated on his own less explicitly feminized forms of expression in the visual arts. During his summers in the Adirondacks, he made hundreds of sketches and watercolor studies of dancers. Some of these he developed as oil paintings, such as *Rhythms in Twilight*. A few were the basis for figurative sculptures. Still others fed his new area of work, woodblock print illustration, which built on his early experiments with woodcarving in Fairhope. Certain prints had an immediate purpose. Offered in exchange for the camp fees that Wharton and Letty could not afford, they graced the pages of camp brochures.

Esherick's woodcuts of dancers elicit movement and energy in ways that show his understanding of rhythmics, both its objectives and its choreography.

With his woodcuts of dancers, Esherick used line, pattern, and abstract motifs to portray rhythmics in terms of the dancers' experience. *Rhythms, Opening* (1922) was the cover illustration for the 1923 camp brochure (fig. 7). The print presents a cluster of figures as a representation of one dancer doing a series of movements. The sequence begins at the lower left of the composition, where the dancer's torso bends toward the ground. Spiraling counterclockwise and up through illusionistic space, her head lifts as her body opens to an upright stance. The graphic composition of swirling, radiating lines conveys energy emanating from within the dancer. *Rhythms, Opening* is an apt illustration of the brochure text, which describes rhythmics as facilitating "free, full, vigorous expression [to] thought and feeling"—applicable not only to dance, but to all forms of creative enterprise.[7] The assertive pattern of repetitive cut marks left by Esherick's carving tools, defining both the figures and the background of the composition, suggests that his work, too, was rhythmic.

One of the few firsthand accounts of Ruth Doing's rhythmics comes from the dancer-choreographer Jane Dudley, who studied with Doing as a child. Dudley reported that Doing

FIG. 7. ABOVE LEFT Brochure for the Ruth Doing Camp for Rhythmics, 1923. The cover illustration is a reproduction of Wharton Esherick's woodcut *Rhythms, Opening* (1922); see p. 172

FIG. 8. ABOVE RIGHT Wharton Esherick, *Rhythms*, 1923. Woodcut, 9 × 6¾ in. Collection of the Wharton Esherick Museum

FIG. 9. OPPOSITE Emil Luks (active 1930s), Wharton Esherick at his printing press, ca. 1930. Photograph, 9¼ × 6½ in.

FIG. 10. Charlie Chaplin in *Modern Times* (1936)

taught her students to move "from the inside out." Dancers improvised in accordance with their own sense of timing. Dudley recollected the choreography: "The way in which we were taught to move was of a piece: there was a sense of one movement flowing into another, often in a sequential way originating in the back. Many of the exercises were also based on deep spiral movements of the body."[8] Several of Esherick's dance prints align with this choreography. The sequential movement depicted in *Rhythms, Opening* develops from a straightening of the spine. Other woodcuts use the spiral motif to represent life energy swirling within the human core. This is especially pronounced in *Rhythms* (1923), where the dancers' torsos and limbs are abstracted spiraling forms (fig. 8).

The spiral would become one of Wharton Esherick's signature motifs. Throughout his Studio, it animates myriad vertical elements. These include bedposts, deck piers, a chimney, utensil handles, several figurative sculptures of dancers, and a work of extraordinary vitality: *Spiral Stair*. Built around a column that is sculpted to a lyrical twist, the staircase resembles a growing tree at the same time it evokes the rotation of a human spine. The treads that splay from the vertical support further the sense of biological dynamism. Each tread is a unique prismatic sculpture. No two are identical, yet all seem to have been shaped along the same design principles. Together, they speak to the inexact ways in which natural forms repeat—leaves, branches, buds, vertebrae, or, in more abstract terms, the biologically paced movements of a person breathing, walking up steps, or carving wood with an axe, as Esherick did in fashioning the staircase.

NOTES

1 See John Dewey, *The School and Society* (Chicago: University of Illinois Press, 1899).

2 See Marietta Johnson, "Breaking our Educational Moulds," *The World Tomorrow* 6, no. 10 (Oct. 1923): 295–97.

3 Variants of rhythmic dance that Letty Esherick encountered in Fairhope and the Adirondacks included rhythmics, rhythms, and eurythmy, the latter developed in Germany by Marie Steiner-von Sivers and Rudolf Steiner for Waldorf education.

4 See Walter B. Rideout, *Sherwood Anderson: A Writer in America* (Madison: University of Wisconsin Press, 2006), vol. 1, 219–22.

5 Alys Bentley, "Some Higher Aspects of the Modern Dance Movement," *Vanity Fair*, April 1914, p. 19.

6 Anonymous (later attributed to Marcel Duchamp and Beatrice Wood), "The Richard Mutt Case," *The Blind Man*, no. 2 (May 1917): 5.

7 *The Ruth Doing Camp for Rhythmics, July 2 to September 10, 1923, Eighth Season*, 1923, n.p.

8 Jane Dudley, "The Early Life of an American Modern Dancer," *Dance Research: Journal of the Society for Dance Research* 10, no. 1 (Spring 1992): 6.

9 Ford Madox Ford, *Great Trade Route* (New York: Oxford University Press, 1937), 222–23.

The intuitive pattern of toolmarks across the handworked surfaces of the spiral staircase testifies to Esherick's shift in identity when he gave up painting for functional craft. In fabricating objects for everyday use, he assumed the working body of a skilled artisan. The novelist Ford Madox Ford celebrated this aspect of Esherick's practice in his book *Great Trade Route* (1937), an anti-industrialist travelogue. Ford characterized the Esherick Studio as a site more for physical labor than for rarefied acts of making art. He described Esherick in heroic terms as a craftsman who had uncommon intelligence regarding his work, because he proceeded at a self-determined speed. Ford's workman-hero does a series of repetitive tasks: he planes wood, makes editions of prints on his hand press, and burnishes a tabletop with extraordinary attentiveness that rises to the level of spirituality; all the while, he moves at a "pace commensurate with the thoughts in a man's head" (fig. 9).[9] With this allusion to a neurologically wired human tempo, Ford aligns, perhaps inadvertently and certainly without acknowledgment, with theories of rhythmic dance.

In the labor framework that Ford Madox Ford proposed, Henry Ford's assembly line would be the dystopian antithesis to the Esherick Studio and the Adirondack dance camps. A popular Charlie Chaplin movie of the era, *Modern Times* (1936), provides a nuanced choreography for this scenario of extreme division of labor and metered repetition (fig. 10). In the film, Chaplin's character, the Little Tramp, is an assembly-line worker whose physical attitudes belie the trauma that his work inflicts: he is frantic in attempting to tighten bolts on the widgets that fly by him on the conveyor belt; he is passive when, swallowed by the factory, he passes through its innards on a series of enormous cogs; and he is robotic when he emerges, soulless, with the singular purpose of driving factory production harder and faster. The rhythmic movements and dynamic motifs of Letty Esherick's modern dance and Wharton Esherick's craft in making functional sculpture are, in a sense, fitting opposites to Chaplin's machine-like, work-induced behavior. But an examination of the couple's biographies shows a further dimension to their undertakings, stemming from their devotion to ideas and art.

Born into affluent families, neither of the Eshericks would have come close to the hardships of the factory floor, nor were they labor activists. The abyss that Letty averted through her involvement with rhythmics communities was the isolation of a wife and mother working in the home. In dance communities, she could bring her efforts in caretaking, feeding, and educating children into a broad world of ideas, exchanged within communities that supported the spiritual well-being of women. For Wharton, the dance camps were the sites of his earliest commissions, in illustration and furniture design. In these progressive enclaves, he found audiences who were uncommonly versed in abstraction, places where people routinely used their bodies to give physical form to inner worlds of thought and emotion. The vital forms of rhythmic dance informed his creative practice as he sketched the dancers' liberatory gestures, and later, when he developed a vocabulary of sculptural abstraction to manifest an American art that was robust, physical, and attuned to human rhythms. ▼

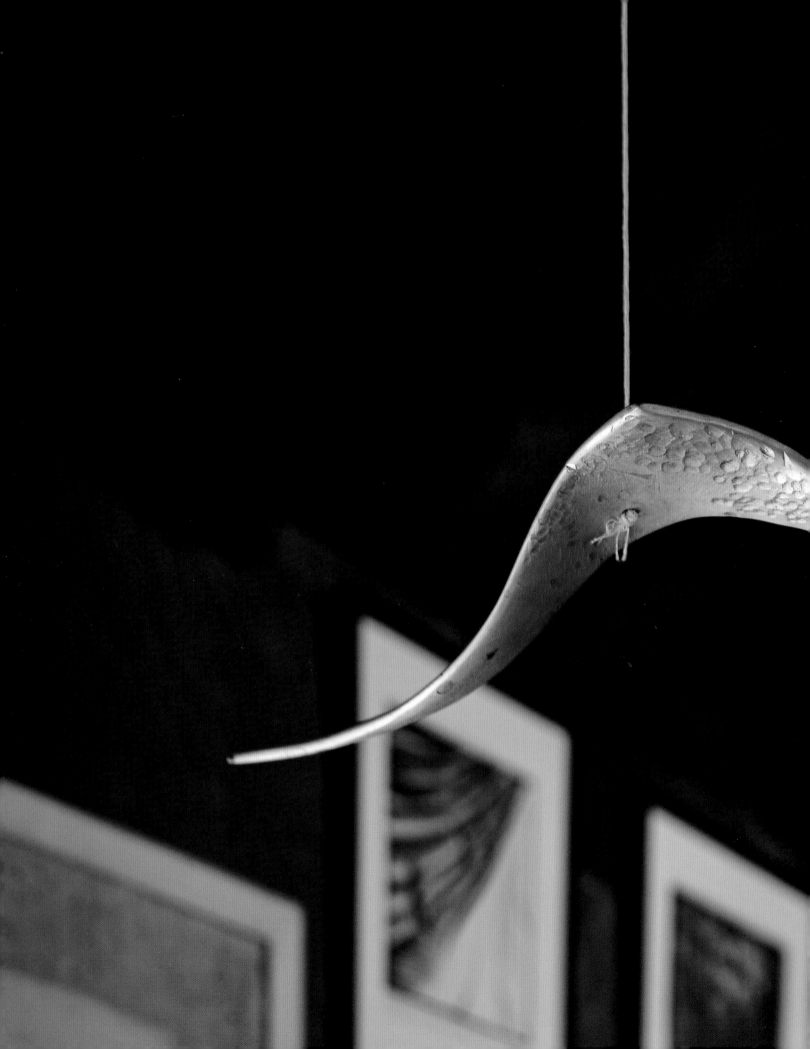

Doris, 1920
Painted plaster casting
11¼ × 6¾ × 5 in.

THIS SCULPTURE DEPICTS the dancer Doris Canfield, whom Esherick observed at the Gardner-Doing Camp for Rhythmics in upstate New York. Artists at the camp explored modern dance forms including rhythmic dance and eurythmy—a type of expressive movement based on the philosophies of Rudolf Steiner, in which dancers sought to express their inner states using movements derived from the rhythms of speech. During summers at the camp, Esherick sketched the dancers; created stage sets, graphic designs, and costumes for performances; and even joined the dancers.

Canfield's body is in motion and her arm is outstretched, culminating in a closed fist. This pose, drawn from eurythmy's "alphabet," represents the human body connecting earth with heaven. The shape is echoed in Esherick's furniture and sculpture throughout his career, in the form of turning spirals and reverse curves.

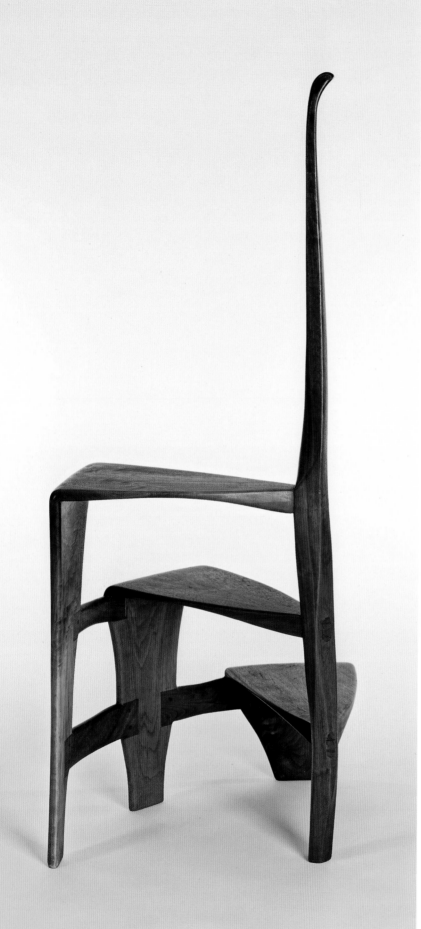

Library Ladder, 1969 (designed 1966)
Cherry
48½ × 25½ × 16½ in.

ONE OF ESHERICK'S MOST celebrated forms, the *Library Ladder* offers its user an intimate moment of tactile pleasure. It was first produced in 1966, when Esherick was 79 years old, after a client asked for something more elegant and graceful than the typical library step stool. Besides fulfilling that brief, it also connects influences from the start of Esherick's career to his design sensibility late in his life. The gentle twist, spiraling treads, and undulating post culminate in a rounded handle that fits pleasingly in the palm of its user. This is the same gesture we see in *Doris*, his figural sculpture of a dancer in motion completed almost fifty years earlier.

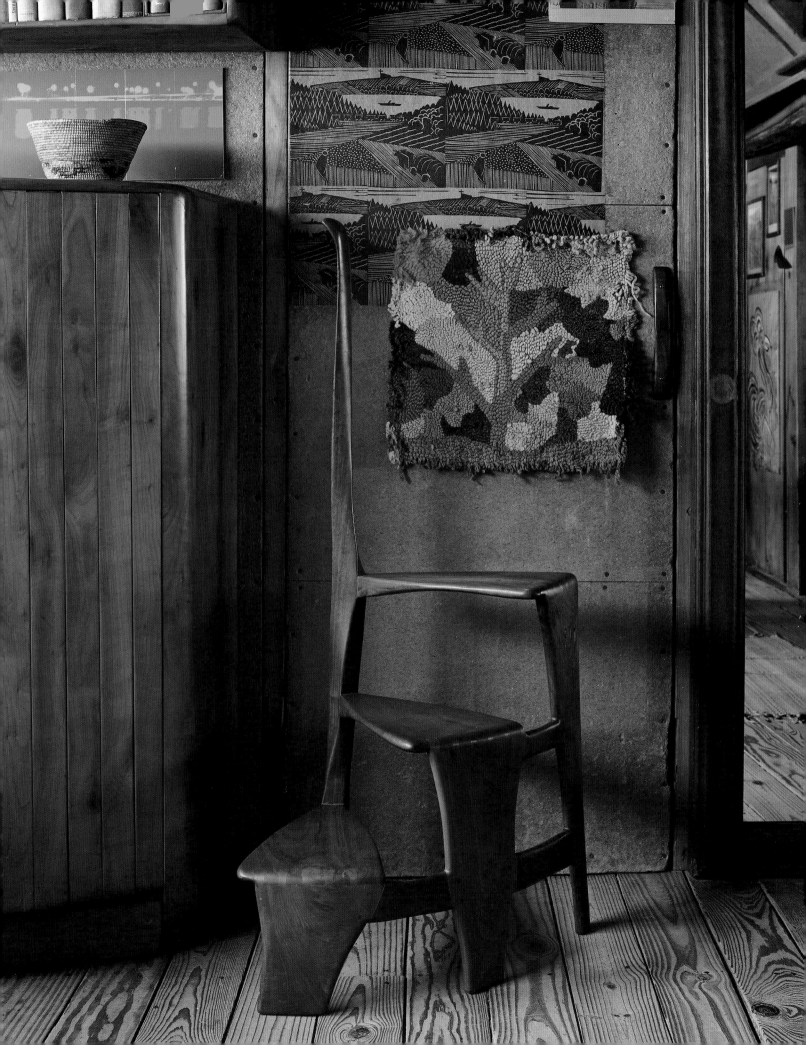

Rhythms-Opening #24/55 Wharton Hom Esherick

Rhythms, Opening, 1922
Woodblock print
8¼ × 8¼ in.

RHYTHMS, OPENING DEPICTS a dancer in a series of sequential poses. Reproduced on the cover of the Ruth Doing Camp brochure, the image embodies a belief common to the progressive artistic communities with which Esherick engaged during the 1920s and 1930s: that human, creative, and natural rhythms are inextricably interconnected.

Song of Solomon, 1924
Bound artist's book,
woodblock prints and
hand lettering
31¾ × 24 in.

Song of Solomon
sketchbook, ca. 1924
Bound sketchbook,
pencil drawings
11½ × 9 in.

ESHERICK'S LARGEST PROJECT for the Centaur Press was a series of
31 illustrations for an edition of the Song of Solomon. In these woodblock
prints, images of lovers' bodies in repose echo the sensual verses of
the biblical poem. The sketchbook and hand-lettered and hand-printed
artist's book both precede the multiple copies printed by the press and
sold to the public. They offer an intimate glimpse into Esherick's process.

"Swing" 39/39 Wharton Esherick '21

ABOVE
Swing, 1925
Woodblock print
10¾ × 9 in.

OPPOSITE
Light pull, ca. 1930
Aluminum cast of
cocobolo original
4¾ × 1 × 1 in.

BOTH THIS PRINT and the light pull center around the female body aloft in space. In *Swing*, Esherick has used a dark, solid surround to emphasize the motion of the swing and its user. The light pull focuses on a female figure, suspended from a thread, who must use all her strength to turn the lights on and off—with help from the hand of its user, of course.

First Born, 1927
Rosewood, padauk,
snakewood
49 × 6¼ × 4¼ in.

THIS FIGURAL SCULPTURE commemorates the birth of Esherick's son, Peter, one of his three children and his only son, in 1926. The abstracted bodies of mother and child typify Esherick's shift from representational to geometric forms around this time.

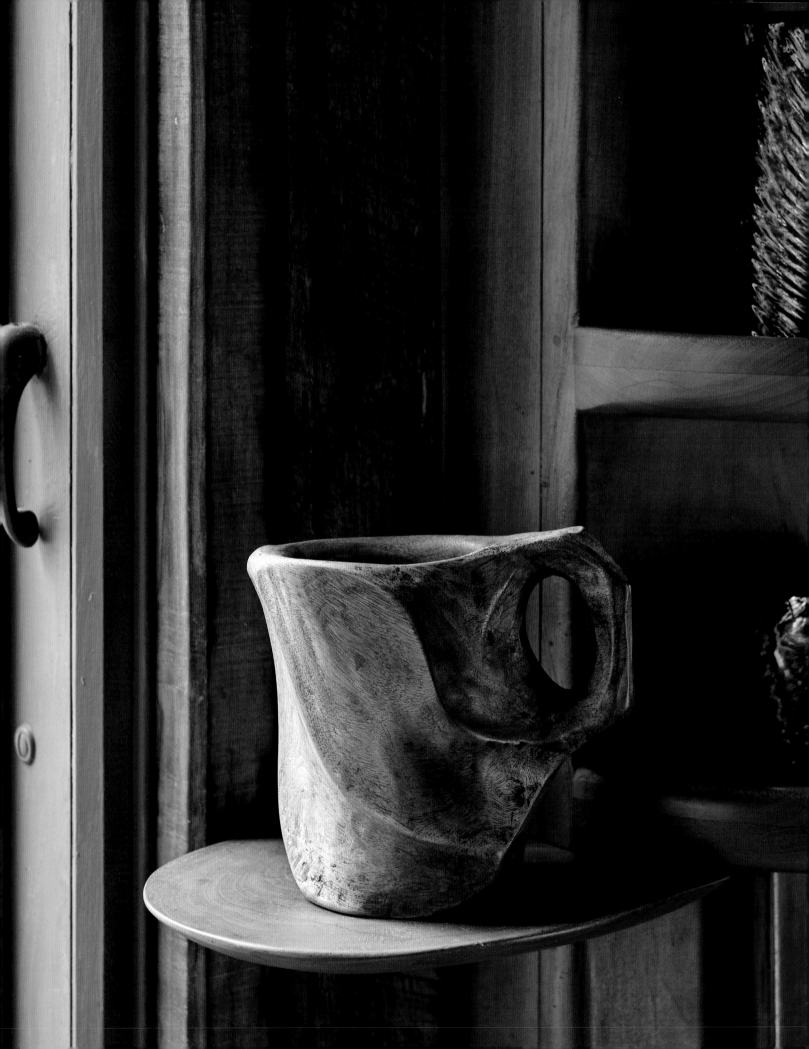

Carved Cup, 1927
Walnut
5 × 5 in.

A CARVED CUP FEATURES undulating sides that offer tactile pleasure to the handler. When designing objects for domestic use, Esherick often considered the relationship between the forms he created and the physical sensations they might engender.

Three *Dance Sketches*, ca. 1929
Ink on paper
Each: 6½ × 8½ in. or 8½ × 6½ in.

Angular Dance I, 1931
Printed reproduction of ink drawing
4½ × 3 in.

Angular Dance II, 1931
Printed reproduction of ink drawing
6 × 4⅓ in.

ESHERICK'S QUICK SKETCHES of dancers in
motion capture the feeling of a performance
with just a few strategic lines. This is also true of
Angular Dance I and II, although the style of these
finished prints is remarkably different. Instead of
fluid soft lines, the strokes are harder and more
minimal, yet they retain strength and energy.

How is the one?

This is
Kitty Hermann hand

always was fond of this.

Here's a page I dug up out of
my collection W.

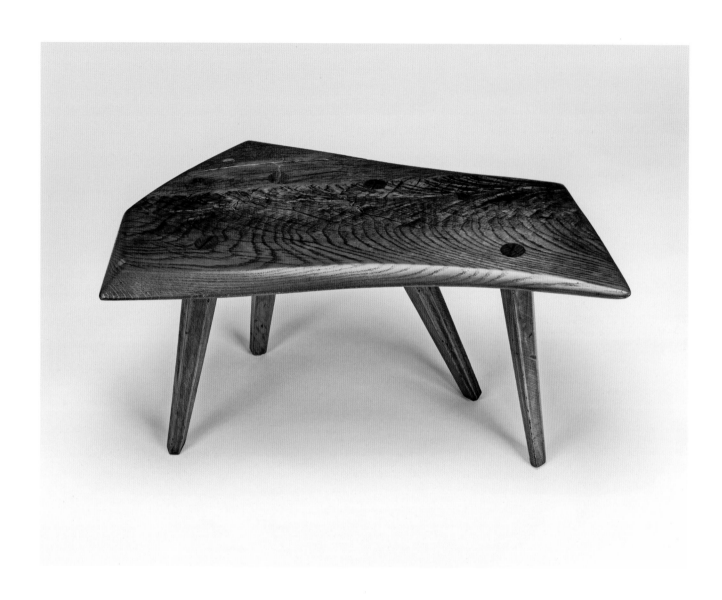

Five-Sided Bench, 1947–50
English walnut,
chestnut, oak, cherry
15½ × 29¾ × 16 in.

THE ANGLES OF ESHERICK'S 1931 prints of dancers resonate with his three-dimensional explorations of skewed planes and irregular and faceted forms in his furniture during the 1920s and 1930s—and are still present in this five-sided bench produced two decades later.

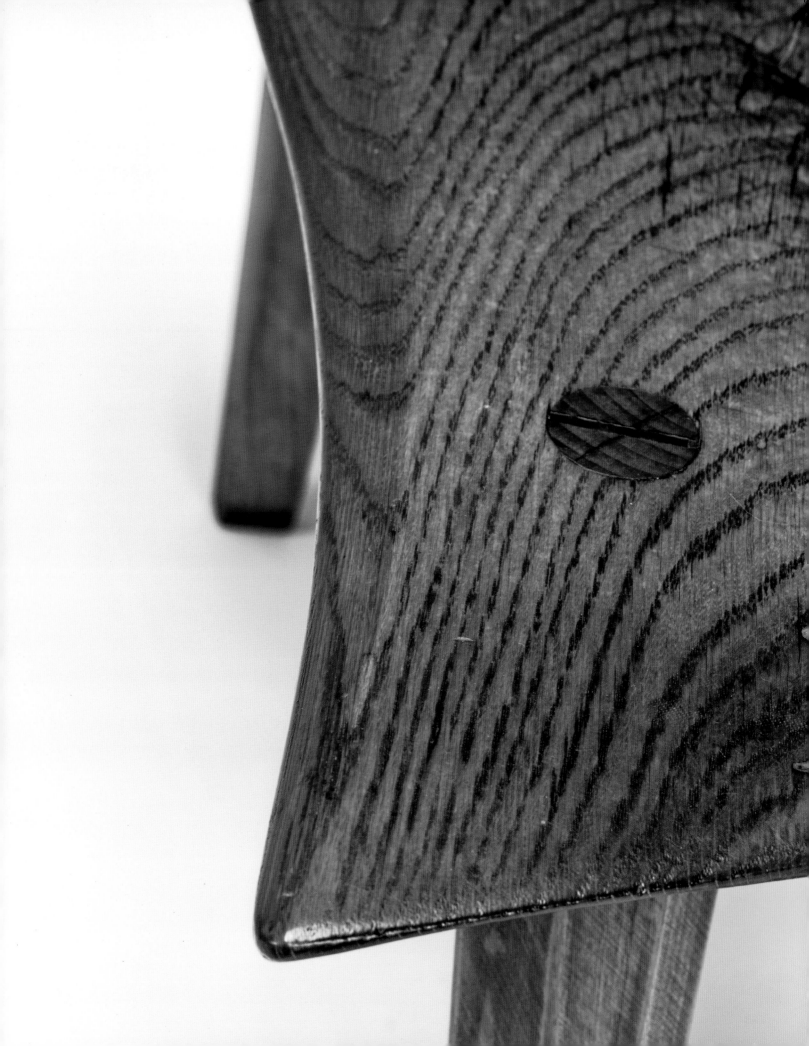

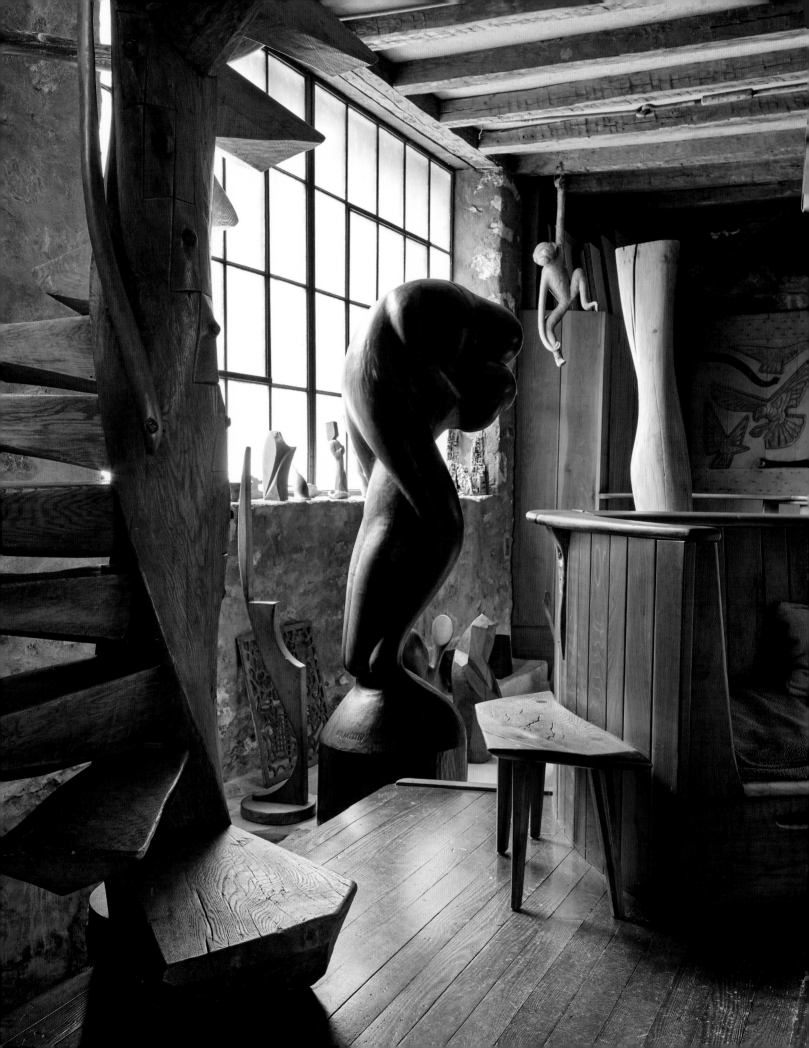

OPPOSITE
Oblivion, 1934
Walnut
77 × 24 × 21½ in.

FOLLOWING PAGES, LEFT
Marjorie Content (1895–1984)
Oblivion, 1934
Photographic print
6⅜ × 4¾ in.

FOLLOWING PAGES, RIGHT
Emil Luks (active 1930s)
*Wharton Esherick
with "Oblivion,"* ca. 1934
Photographic print
6⅜ × 4¾ in.

ESHERICK WAS DEEPLY INSPIRED by the emotion and physicality of actors. He spent many hours in the balcony of the Hedgerow Theatre sketching the performers onstage, and many more designing stage sets, props, posters, and other visual elements for their productions. *Oblivion* was inspired by the passionate embrace of two actors in *The Son of Perdition*, by Lynn Riggs. Sized slightly larger than life, this sensuous and fluid sculpture offers an exaggerated rendering of emotion as two intertwined bodies, carved from a single log, seem to dissolve into one another.

This is one of the first of Esherick's representational sculptures to move toward the softer, organic lines that would characterize works from the latter half of his career. It was featured in the sculpture portion of the second Whitney Biennial, in 1936. Photographs by Emil Luks and Marjorie Content capture *Oblivion* in situ in the Studio. Content, who commissioned major pieces from Esherick during this period, often visited the Studio on her trips from New York to the Southwest to take photographs alongside her close friend Georgia O'Keeffe. Her image focuses on the sculpture itself, but allows us a glimpse into the Studio as a working space. Luks's image places Esherick's own languid body in relation not only to the bodies of his creation but also to his well-worn woodworking tools.

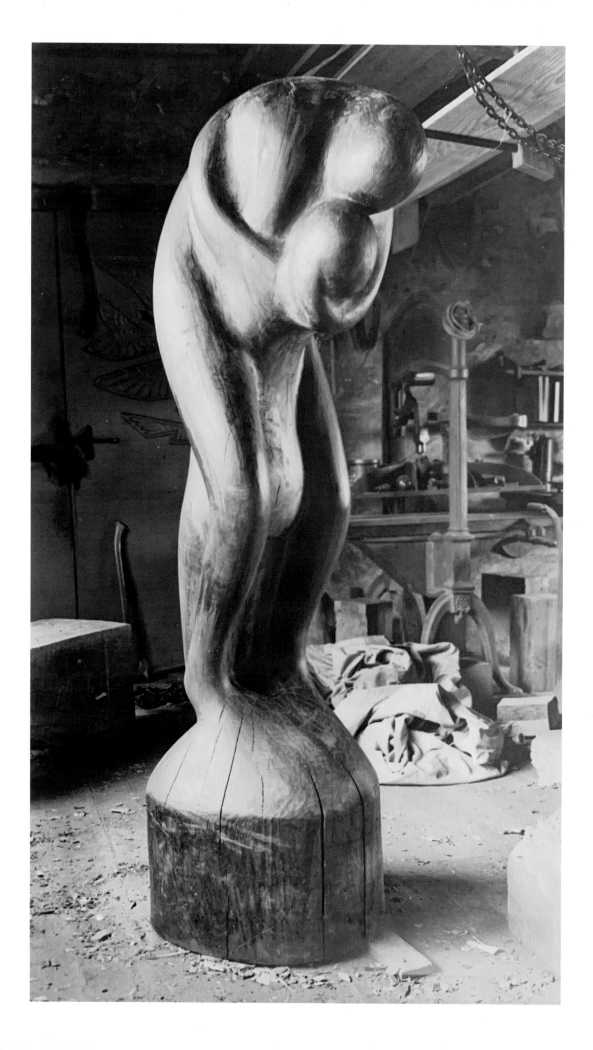

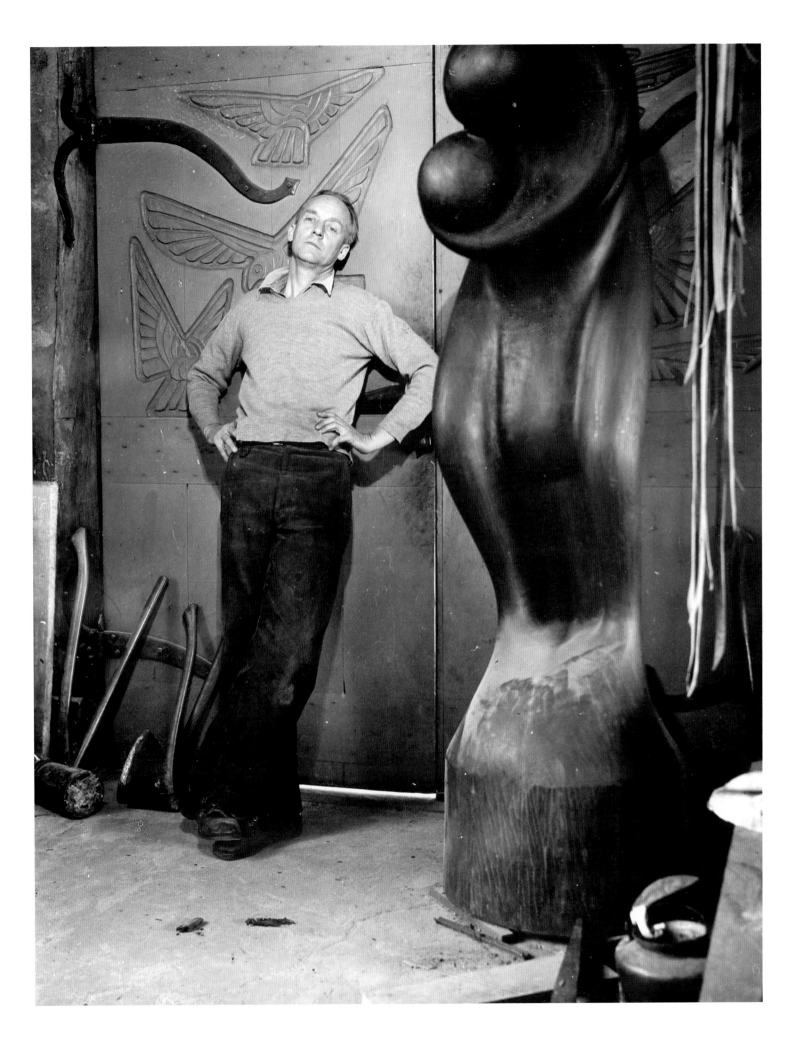

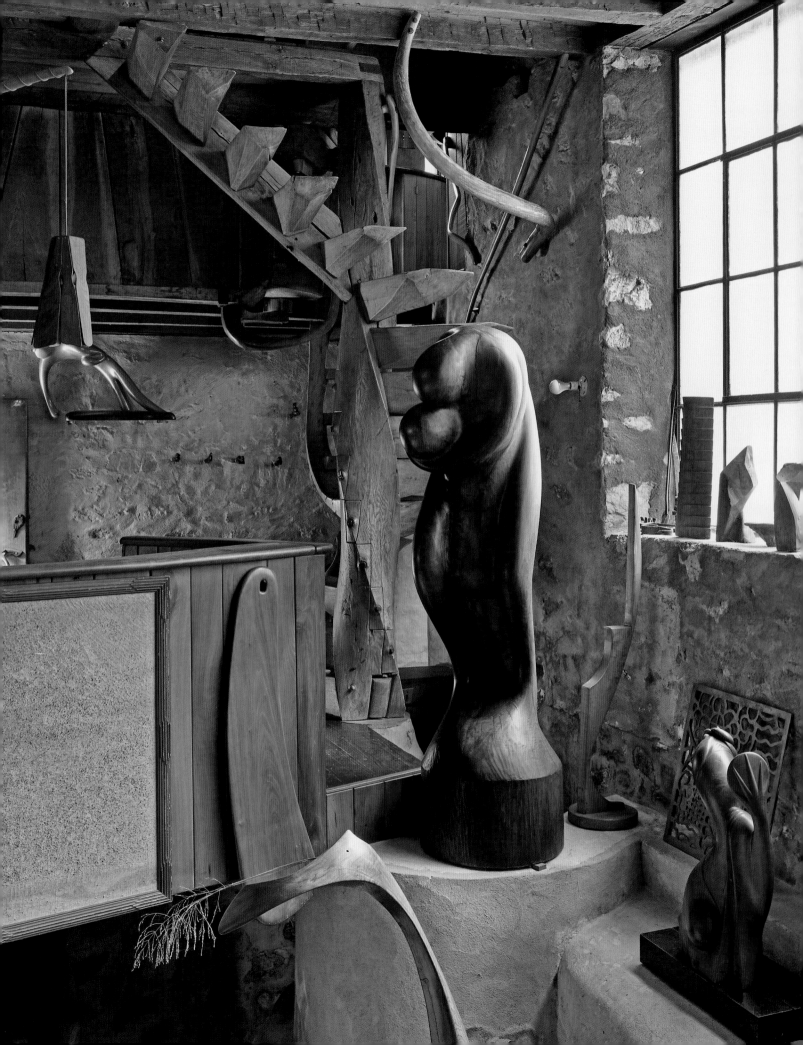

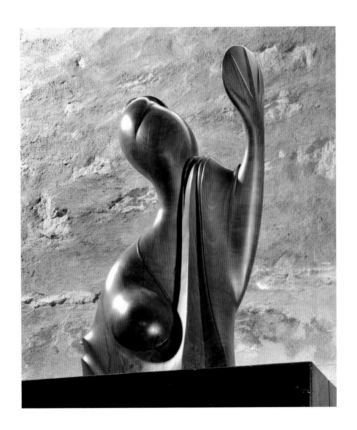

The Actress, 1939
Cherry
29 × 16 × 10 in.

ESHERICK MODELED THIS SCULPTURE after a photograph of his daughter Mary, who often acted at the Hedgerow Theatre, in the act of applying lipstick in her dressing room while gazing at her own reflection in a hand mirror. His original rendering included the lipstick in her hand; after deciding it wasn't necessary he removed it with a saw and "dressed the wound." This portrait is in the streamlined, curvilinear style that Esherick transitioned toward during the 1930s and 1940s.

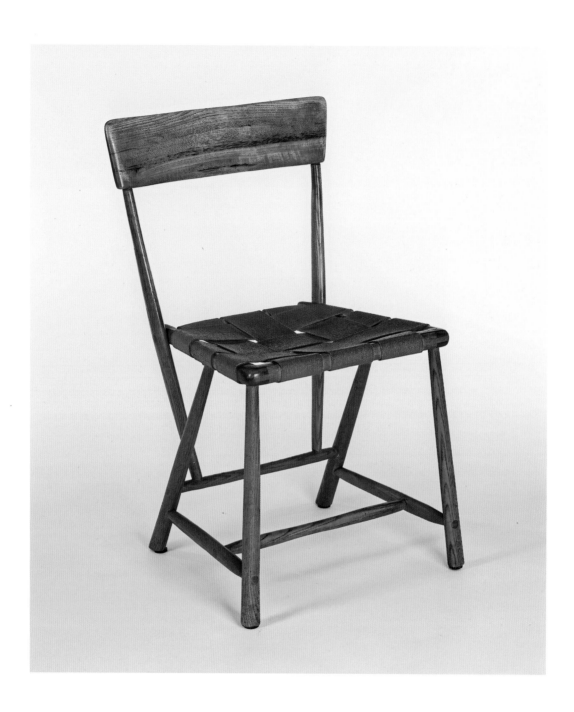

Hammer Handle Chair, 1938
Hickory and oak,
laced canvas belting
32¼ × 17¾ × 16¼ in.

THIS UNCONVENTIONAL CHAIR is one of Esherick's best-known forms. After acquiring two barrels of hammer handles at an auction in a search for inexpensive wood, he repurposed them as legs for a series of forty-five related, but distinct, pieces of seating. Esherick traded thirty-six of the chairs to the Hedgerow Theatre, in exchange for an apprenticeship for his daughter Ruth.

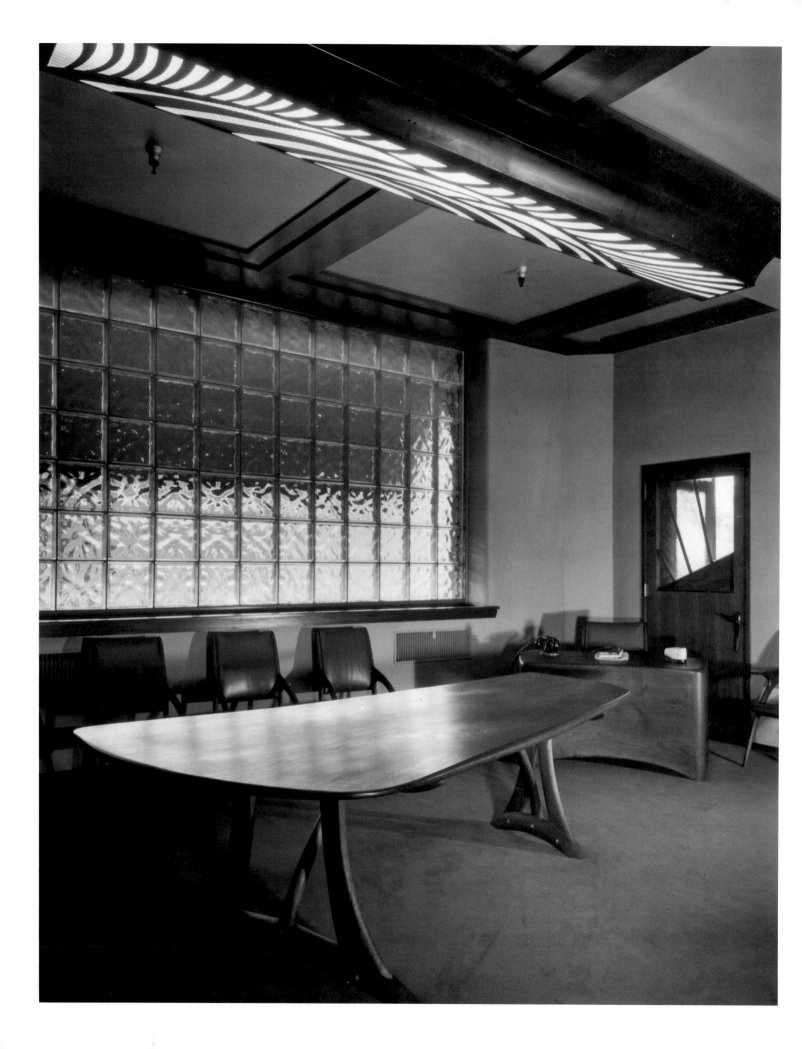

S-K Chair, 1957
Walnut, black Naugahyde
32 × 18½ × 18½ in.

THE *S-K CHAIR* is a static object in perpetual
motion. The curved and elongated line that
continues from the arm into the leg branches
organically from the chair's erect back. The
chair appears to be in mid-stride, as it reflects
the lyrical form of Esherick's sketches of
dancing bodies. It is part of a suite of furniture
Esherick made for his great patron Helene
Koerting Fischer, who, upon her husband's
death, assumed the presidency of Schutte &
Koerting, a Philadelphia-based manufacturer
of precision machine parts. Hoping to convey
the forward-thinking approach of her dynamic
leadership, Fischer commissioned Esherick to
design new office and boardroom furniture for
the company.

This version of the *S-K Chair* was produced
more than a decade after the original
commission; although still constructed from
walnut, it swaps the red leather upholstery
of the original for black Naugahyde. While
the design of the *S-K Chair* is elegant in its
simplicity, it was a substantial departure from
traditional furniture design and was influential
in the development of later iconic furniture
forms, including Art Carpenter's *Wishbone
Chair* in the 1970s. When Fischer sold her
company in 1972, the boardroom furniture was
donated to the Philadelphia Museum of Art,
which put it to use in its own boardroom for
some time.

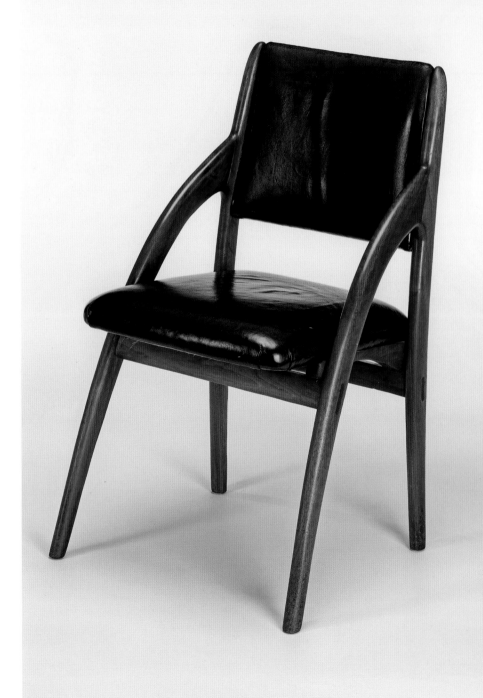

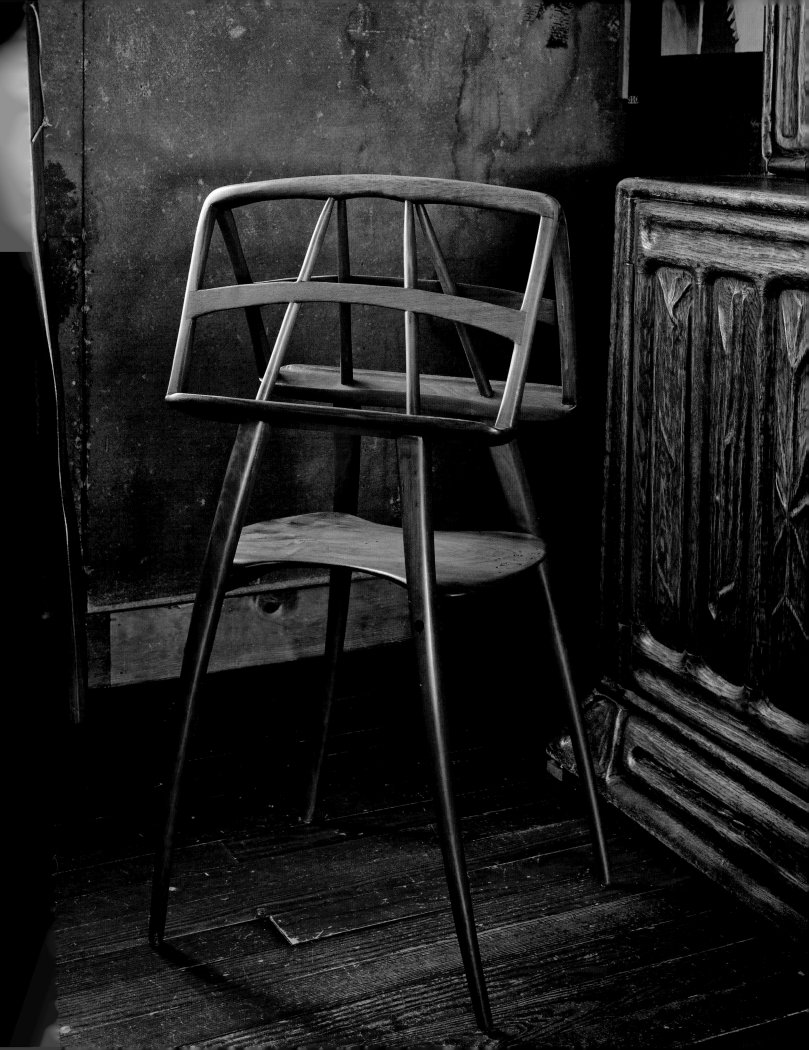

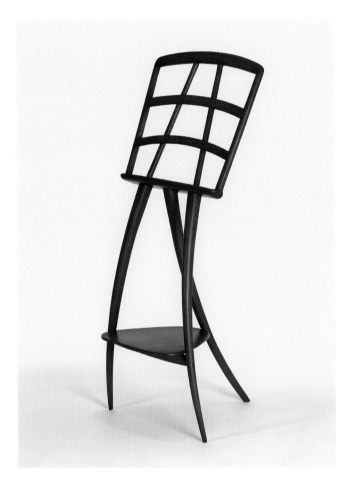

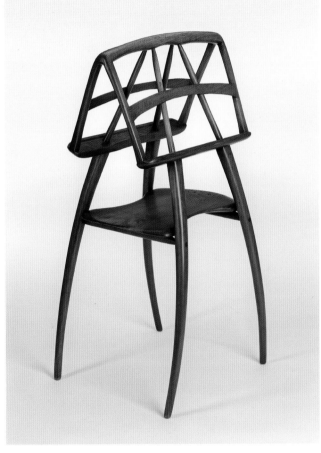

ABOVE LEFT
Music Stand, 1960
Walnut and cherry
44½ × 20 × 20 in.

OPPOSITE, ABOVE RIGHT
Double Music Stand, 1962
Walnut and cherry
39 × 21 × 17½ in.

THE SINGLE *MUSIC STAND* was originally designed for Rose Rubinson, a major Esherick patron who, along with her husband, Nathan, filled their modest home in the Philadelphia suburbs with Esherick's work over eighteen years. Rose was a passionate amateur cellist, and this object was designed to coordinate with her movements while playing. It leans backward in an elegant curve to accommodate the motions of bowing and plucking strings. Esherick braced the three legs of the stand with a triangular shelf, which he told Rose in a notation on a hand-drawn cartoon was "for a little snifter in case you feel faint during a performance."

Esherick followed with the *Double Music Stand*, a commission that allowed his client Herbert Koslow—an insurance industry professional as well as a flutist and classical singer—and his wife, also a flutist, to play duets. The construction of this stand required the musicians to face one another rather than the audience, allowing each to better respond to gestural and sonic cues from their partner.

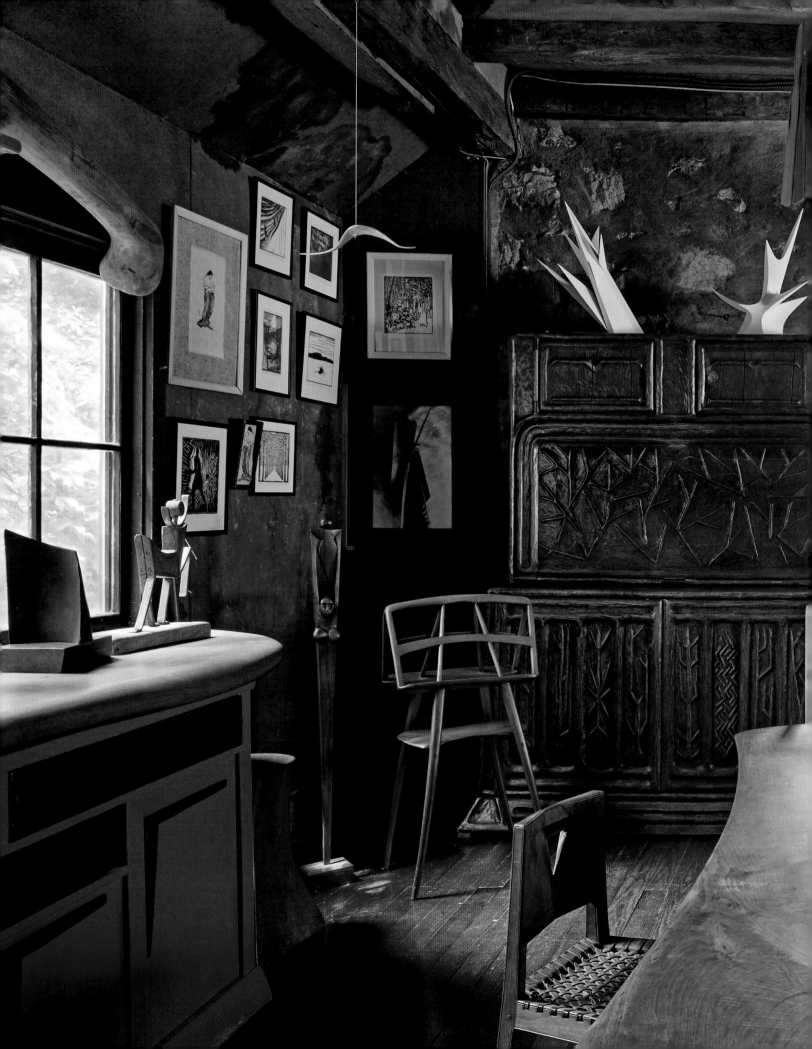

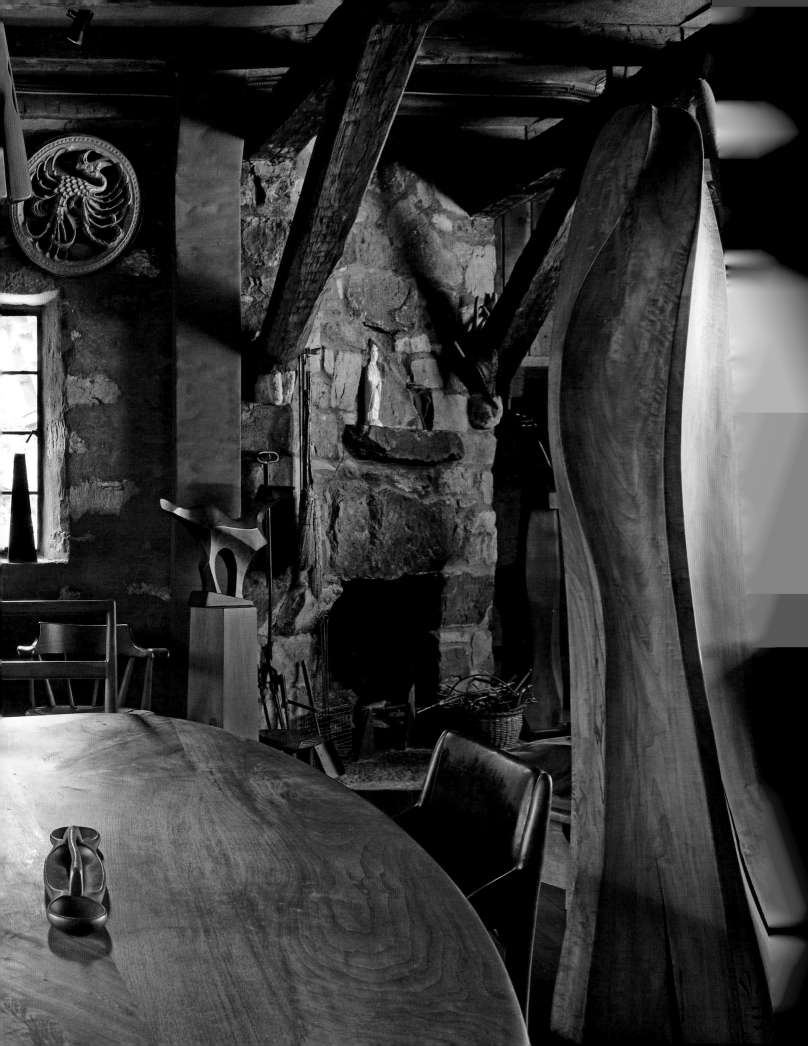

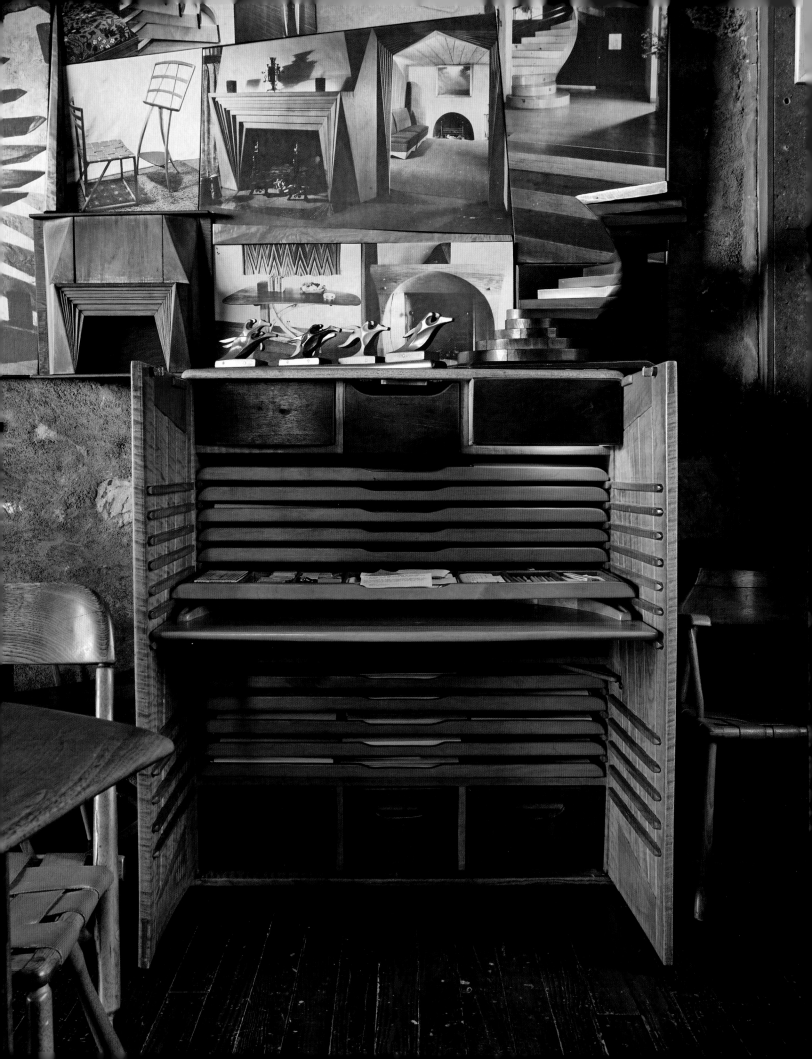

FOR ALL THE WORLD TO SEE

Presenting the Work of Wharton Esherick

ANN GLASSCOCK

► AFTER *THE FURNITURE AND SCULPTURE OF WHARTON ESHERICK*—the first museum retrospective of his work—opened on December 12, 1958, at the Museum of Contemporary Crafts (MCC) in New York City, a journalist reviewing the exhibition commented that Esherick "was almost unknown nationwide, previously."[1] Perhaps the reviewer was trying to create an air of mystique around Esherick—the lone craftsman in the Pennsylvania wilderness—while also applauding the MCC for promoting the work of craftspeople in the United States. Although he was not a household name, Esherick was known in certain artistic circles, and he had presented his work often. In fact, his creations had been included in some fifty exhibitions at museums and galleries before his 1958 solo show. Examining several of the most important exhibitions in which he participated, from Esherick's installation at the New York World's Fair in 1940 through his involvement with *Objects: USA* in 1969—the last important show during his lifetime, and a milestone for contemporary craft—can provide insight into his journey toward becoming one of the country's leading artists working in wood.

In the 1920s and 1930s, Esherick mostly exhibited paintings, prints, and sculpture. He also received commissions for full-scale interiors, like the Curtis Bok House, as well as for several pieces of furniture. Yet he had not shown a substantial amount of three-dimensional work until 1940, when the Philadelphia architect George Howe recommended him as a partner in designing an interior for the America at Home building for the second season of the 1939–40 New York World's Fair.[2] Esherick eagerly accepted.

Thousands of enthusiastic consumers and curious spectators flocked to the America at Home pavilion to admire the newly installed showrooms by architects and designers, which included interiors ranging from urban apartments to country retreats. According to the pavilion organizers, these spaces were intended to represent "the wide variety of interest and living habits in a democracy such as ours."[3] Additionally, the models showed

OPPOSITE View of the *Cabinet Desk* (1958) with doors open

visitors what domestic life looked like from coast to coast. In a letter to Esherick, the director of America at Home, Louise Bonney Leicester, stated, "Through these rooms the living needs and creative impulses in different parts of our country will be dramatized for a large public and for the manufacturing world which must turn, more and more, to America for inspiration, design and materials."[4] She also stressed the importance of regional identity and the use of native materials, which accorded with Esherick's creative program, as he preferred to use wood from his own backyard. He later said, "If you can't make something from a stick out of the woodpile, then you might as well quit."[5]

Esherick and Howe's interior, called the Pennsylvania Hill House, was loosely based on the design of Esherick's home, but at the fair it was marketed as a "comfortable camp, rather than a year-round dwelling."[6] For their so-called cabin in the woods—what one reporter alluded to as "rustic" and "modern" in design—Esherick assembled about a dozen pieces of furniture (fig. 1).[7] Visitors to the 17-by-18-foot room found an efficiently arranged and dramatically decorated space filled with handcrafted works of art. Organizers hoped visitors would come away knowing that "living in Democratic America is increasingly more comfortable, more attractive, more individual—more American."[8]

Esherick's now iconic *Spiral Stair* from 1930 (see p. 113) stood near the center of the room.[9] The staircase, along with a curved sofa (later integrated into Esherick's own Studio bedroom), helped create a division between the bedroom and the living and dining space.[10] Esherick also staged seating areas, one of which included an upholstered leather armchair with a whimsical dog-shaped footstool. Nearby, a five-sided hickory table and chairs could

FIG. 1. ABOVE LEFT George Howe and Wharton Esherick, Pennsylvania Hill House interior, 1940, from America at Home pavilion, New York World's Fair

FIGS. 2–4. ABOVE RIGHT, OPPOSITE Installation views, *The Furniture and Sculpture of Wharton Esherick*, Museum of Contemporary Crafts, New York City, Dec. 12, 1958–Feb. 15, 1959

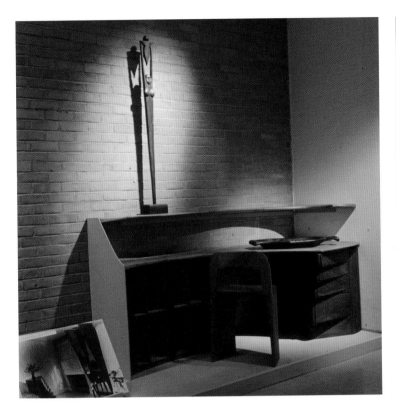

be used for dining, as a coffee table, or as a desk. For both practical and aesthetic reasons, Esherick inset a layer of durable phenolic material into the tabletop. Mansfield (Bob) Bascom, Esherick's son-in-law and a cofounder of the Wharton Esherick Museum, later observed that the surrounding wooden edges appeared to be "almost growing around that sharp, black, smooth surface."[11] Esherick's decision to use different types of wood in the room also created visual interest. Planks of cherry rose behind the sofa, while a walnut lamp with a dramatic arc hung on the opposite wall.[12] An article in the *New York Times* noted the room's "odd, sculpturesque quality"—no doubt due to the fact that Esherick was a sculptor—but went on to assert, "Those who wish to hark back to the handicraft age and still be modern will find their ideal in the 'Pennsylvania hill house.'"[13]

To further showcase the crafts of the region, Esherick enlivened the space with handmade ceramics by Frances Serber, Harold Reigger, and Lisa Langley; woven fabrics by Priscilla Buntin and Mildred Wentworth; a carved ivory serving spoon and fork by Hannah Weil Fischer; a brightly colored rug designed by Kathryn Wellman; and a fiber art panel titled *Bull over Spain* by June Groff.[14] These additions by local craftspeople made the Pennsylvania Hill House look and feel like a home. Another journalist observed that the room "reminds us that the Quaker State has a pioneer tradition" that "translates pleasantly into a modern idiom."[15] Perhaps it also encouraged fairgoers to look closer to home for their decorating needs.

The America at Home pavilion, and especially Esherick and Howe's Pennsylvania Hill House, was featured in numerous newspapers and magazines. In a letter to Esherick,

the fair's publicity director Louise Sloane reported that his and Howe's interior was very popular with visitors, specifically noting the staircase, which continuously brought forth "exclamations, questions and comments" from those who went through the building.[16] As Esherick's first large-scale public-facing installation, the Pennsylvania Hill House was a success; the America at Home project not only showed visitors what living looked like in different parts of the United States, but also brought attention to some of the country's most talented architects, designers, and craftspeople, one of whom was Esherick.

During the 1940s and 1950s, Esherick continued to receive commissions and lend works to exhibitions, including *Artists for Victory* (1942) at the Metropolitan Museum of Art; *Sculpture of the Twentieth Century* (1952–53), organized by the Philadelphia Museum of Art; and *Designer Craftsmen USA* (1953), held at the Brooklyn Museum.[17] In the late 1950s a number of other opportunities presented themselves. In 1956 Thomas Tibbs, director of the MCC, visited Esherick's Studio and decided to include his work in *Furniture by Craftsmen*, a show that opened in February 1957. During his visit, Tibbs also recognized the need for a major retrospective of Esherick's work, which would open the following year.[18]

In June 1957 the First Annual Conference of American Craftsmen took place in Asilomar, California. Aileen Osborn Webb, founder of what would become the American

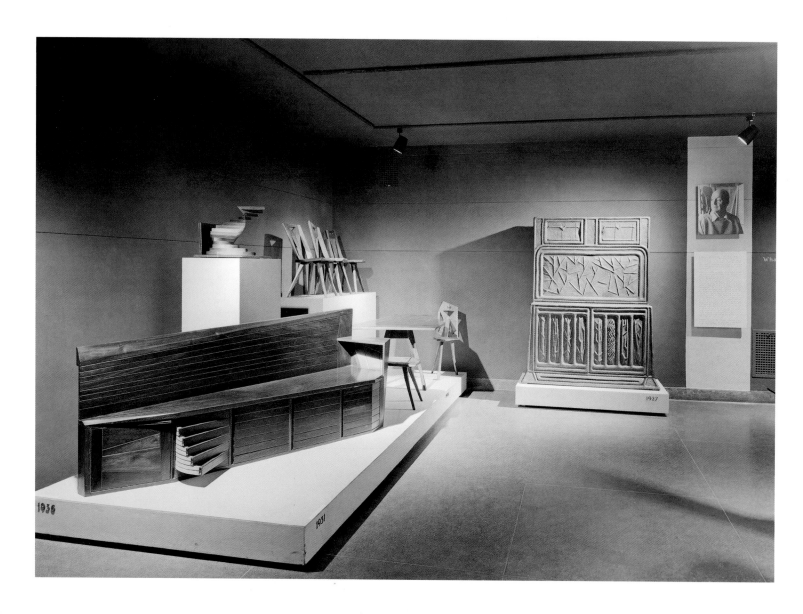

Craft Council (ACC), invited Esherick to be a part of the medium-specific group discussions and demonstrations, writing that she felt certain that Esherick "would make an invaluable addition to our deliberations."[19] She asked Esherick to serve as an adviser to the speakers on the Wood Panel, which included the design and craft luminaries Lee DuSell, Tage Frid, Lawrence Peabody, and Sam Maloof, who later recalled receiving words of advice and encouragement from Esherick. Reflecting after the conference, Esherick admitted that he was rather reserved and hoped he had earned his pay.[20] Despite the minimal role he believed he had played, it was one of the few times that Esherick actively participated in a public conference; the invitation alone was evidence that the ACC championed him as an elder statesman in a field that was rapidly being redefined.

The ACC and Webb were vital in the establishment of the Museum of Contemporary Crafts, thus bringing prestige and recognition to artists and craftspeople like Esherick. In 1958, for his first solo show, the MCC secured loans for approximately one hundred works—ranging in date from 1926 to the very year of the exhibition's opening—from Esherick himself as well as from several museums and numerous private collectors.[21] An article in the *New York Times* with the headline "Families Make Sacrifice to Aid Furniture Exhibit" reported that "Eighteen families are doing without so that the new show at

the Museum of Contemporary Crafts can be as complete as possible." It dramatically continued: "They have parted with salad bowls still gleaming with oil from the dressing." Furthermore, "Mr. Esherick's own home in Paoli, Pa., also has been denuded. 'We tried reaching for something the other day and remembered it was in New York,' he said during an interview."[22] Surely the sacrifice was justifiable, because the works lent helped round out the show and make it a success.

As in the World's Fair installation, Esherick's *Spiral Stair* was one of the highlights of the show (fig. 2). Some members of the fashion industry felt it served as the perfect backdrop for a photoshoot. An article called "Accent on Sleeves" in the *New York Times Magazine* shows a photograph of a model standing in front of the staircase, creating a striking juxtaposition between the exaggerated sleeves of her blouse and Esherick's angular steps. Robert A. Laurer, assistant director of the MCC, also drew attention to this piece in the exhibition catalog: "The famous stairway in the studio incorporates perfectly the duality of Esherick as artist and craftsman. It is daring in concept, functional and thoroughly sculptural. It provides the keystone for the understanding of Esherick, perhaps better than any other single work."[23]

Like many of Esherick's other designs, his staircase plays with movement and light, qualities seen in pieces such as his 1958 desk and bookshelf unit—whose drawers reveal a reverse stairstep-like design when open (figs. 3 and 4). Upon the shelf, a spotlight draws attention to *First Born* (1927), a rosewood, padauk, and snakewood sculpture (p. 176). Texture and the inherent qualities of wood also were important components in Esherick's work. While walking through the exhibition with him, a journalist saw "the dean of American craftsmen" run his hand over the smooth surface of a dictionary stand, observing the beauty of the cottonwood. She went on to declare, "Esherick's work is a major achievement of our time and the museum is to be congratulated for an exhibition which gathers so much of his notable efforts together for all to enjoy."[24]

The journal *Charette*, in a review of the show, hailed Esherick as "one of the most famous creators of contemporary American furniture," while a supplement to the *New York Herald Tribune* asserted that he was "probably the greatest living craftsman making furniture in the United States today."[25] Esherick took pride in his work, which he considered both useful and beautiful; in the catalog, Laurer agreed, saying it had won him "a high and influential place in the field of contemporary design."[26] Esherick asserted, "I have never copied anyone. I dig up what I do out of my own soul."[27] After the show closed, he wrote to Tibbs, "The energy, expense and enthusiasm spent on [the] Esherick [exhibition] to me is amazing. I wonder why it should be, yet inwardly I wanted it." He continued, "You were the cause of it all. It bewildered me, and I wonder if I realize what has happened."[28]

Esherick's reputation as one of the foremost furniture makers of the time was becoming more widespread. In 1961, when the exhibition *Masters of Contemporary American Crafts* opened at the Brooklyn Museum, it included the work of eight exceptional craftspeople: the weavers Lili Blumenau and Marianne Strengell, the ceramicists Frans Wildenhain and Edwin Scheier, the enamelists Kenneth F. Bates and Karl Drerup, the silversmith Hudson Roysher, and, as the sole maker in wood, Wharton Esherick. Marvin

FIGS. 7 AND 8. OPPOSITE, FOLLOWING PAGE Visitors at *Wharton Esherick: Sculpture, Furniture, Paintings, and Graphics*, Peale House Gallery, Pennsylvania Academy of the Fine Arts, Oct. 3–Dec. 8, 1968

Schwartz, curator of decorative arts at the museum, believed these individuals had made an impact on the field of contemporary craft, and he hoped visitors would appreciate and be inspired by the quality, skill, and originality of their work.[29]

Schwartz chose about thirty pieces of furniture that spanned Esherick's career, in a presentation that demonstrated his evolution as a designer-craftsman (figs. 5 and 6). Visitors viewed pieces as early as a desk from 1927 carved with naturalistic motifs and a 1937 model for the Bok House chimney stair (see pp. 105, 114), and as recent as a group of freeform bowls and trays from 1961. A reviewer for the *New York Times* found Esherick's recent work "so avant garde in design that it is impossible to trace any traditional concept in his work," while an article in *Craft Horizons* declared that the exhibition was "vital and a change from the many craft shows based not on an idea but on . . . similarity of media."[30] Schwartz was satisfied with the overall response the show received, deeming it "a great success."[31]

Esherick participated in several other exhibitions during the 1960s, including *The American Craftsman* (1964) and *Acquisitions* (1967), both at the MCC; *Why Is an Object* at the Akron Art Institute (1967); and *Wharton Esherick: Sculpture, Furniture, Paintings, and Graphics*, organized by the Pennsylvania Academy of the Fine Arts, Esherick's alma mater, at the Peale House Gallery in 1968. Although the latter show received little press, it was a noteworthy retrospective of Esherick's work, featuring nearly ninety pieces dating back to as early as 1919, and including a variety of media. Two photographs taken at the opening show visitors caressing his sculptures *Ex-Ex* (1946) and *Ant's Eye View* (1968), illustrating the tactile quality of Esherick's work (figs. 7 and 8).

While Esherick's pieces were on view at Peale House, the gallerist Lee Nordness invited him to participate in *Objects: USA*. Sponsored by the S. C. Johnson Wax Company of Racine, Wisconsin, this exhibition brought together 308 works by 267 leading artists that showcased different craft media—wood, clay, glass, fiber, and metal.[32] The final selection was assembled by Nordness and Paul Smith, director of the MCC. Samuel C. Johnson, Jr., the president and chairman of S. C. Johnson Wax, declared, "The artistic efforts of America's craftsmen have long been overlooked as a vital part of the nation's cultural heritage. We hope that this collection will stimulate widespread interest in this special field of individual creativity."[33] Furthermore, Nordness and Smith believed it would help define and develop the field while bringing recognition to contemporary craftspeople. The show also expanded conversations about what the word "craft" meant—discussions that are still relevant and debated today.

The selection process was arduous, but it was clear to Nordness and Smith that Esherick, as "one of the most important woodworkers in the country," should be represented.[34] Nordness commissioned three of Esherick's signature three-legged stools with hickory legs and coffeetree, walnut, and bird's-eye maple seats (see pp. 76, 77); a cherry and hickory spiral three-step ladder; and a walnut chest-table.[35] As for all of the works in the exhibition, they were purchased by S. C. Johnson Wax, rather than borrowed. At the show's closing, the objects were gifted to a number of museums with the hope that they would receive "lasting exposure."[36]

The exhibition opened in October 1969 at the National Collection of Fine Arts (now the Smithsonian American Art Museum), in Washington, D.C. The *Washington Star*'s art critic wrote, "Cabinet-making in the show has gone off into fantasy, a delight to see and obviously a delight to use everyday." Of special interest were Esherick's *Library Ladder*—one of his latest designs—and chest-table, both of which "expand one's notions of what these humble, useful pieces can do." The reviewer concluded: "The exhibition is all the evidence needed that American crafts have come of age and can take their place as full equals in the house of art."[37] For Nordness, and for many others who believed craft belonged alongside what has traditionally been defined as fine art, this was a turning point for the field.

Objects: USA traveled throughout the United States and Europe. For the American tour, Nordness approached art museums whose audiences were unfamiliar with contemporary craft.[38] One such venue was the Indianapolis Museum of Art. A local reviewer called it "one of the most 'touchable' shows of its history"—a far cry from what might be said about an exhibition of paintings. The objects in wood were declared to be "little short of fantastic" in terms of care and craftsmanship: "One 'hit' of the show, a piece many members of the preview audience considered kidnapping, is a chest-table by Wharton Esherick. To look at it is to want to own it."[39] It must have been gratifying for both craftspeople and patrons to observe such a passionate response to an object. During a time when mass production and planned obsolescence were becoming all too common, Esherick made unique, visually pleasing, sustainable objects, and even though he was older than many of the artists featured in *Objects: USA*, he was still positioned as a vital contributor to the studio craft movement.

Of the thousands of works made by Esherick, many were exhibited during his lifetime, with several significant presentations from 1940 to 1970. His creations were seen by the public in major cities throughout the United States and Europe, including Philadelphia, New York, Chicago, San Francisco, London, and Brussels. Esherick had successfully brought his work to a wide audience. Through his objects, he became a voice for change and possibility in the craft field, although he modestly said, "I don't know if it's art or not—I just make beautiful things."[40] These "things" reveal an appreciation for local materials and for quality over quantity, and they inspired the careers of burgeoning furniture makers, including Wendell Castle—who was greatly influenced by Esherick and who also was represented in *Objects: USA*—as well as future generations of craftspeople working in wood. Esherick additionally helped people to see that a utilitarian object also could be a work of art. The large number of exhibition reviews and articles written during Esherick's lifetime reveal the public's appreciation for his work. They had learned not just about a man but about a maker. ▼

NOTES

1 Hope Johnson, "Glorious Renaissance of Handcraftsmanship," newspaper clipping, Jan. 11, 1959.

2 Oral history interview transcripts, "Bob & Ruth (Phyllis Whitehorn tape)," undated, p. 1, and "Ruth & Bob," 1989, p. 9, Oral History Archive, Wharton Esherick Museum. The America at Home building was called Home Furnishings in 1939. Esherick had shown works at other world's fairs, including the Golden Gate International Exposition in San Francisco 1939 and the 1958 Brussels World's Fair.

3 America at Home informational sheet, "Exhibitions, 1920–85," Wharton Esherick Museum Archives.

4 Louise Bonney Leicester to Esherick, Feb. 29, 1940, "Exhibitions, 1920–85," Wharton Esherick Museum Archives.

5 Marilyn Hoffman, "Individuality Wins," *Christian Science Monitor*, Dec. 31, 1958, p. 6.

6 Mansfield Bascom, *Wharton Esherick: The Journey of a Creative Mind* (New York: Abrams, 2010), 169.

7 James W. Holden, "Progress of Modern is Shown," newspaper clipping, May 25, 1940.

8 America at Home promotional booklet, Wharton Esherick Museum Archives.

9 Most of the works on display were for sale; Esherick priced the staircase at $900 (an estimated $20,000 in today's dollars). "Exhibitions, 1920–85," Wharton Esherick Museum Archives.

10 The sofa, which was previously in the Bok House, and the staircase are now in Esherick's Studio.

11 Oral history interview with Mansfield Bascom, Aug. 1988, "Info for American

Woodworker Article," p. 7, Oral History Archive, Wharton Esherick Museum.

12 Oral history interview with Ruth Bascom, Feb. 1990, transcript, p. 4, Wharton Esherick Museum Archives. Esherick brought the cherry paneling back to Paoli and installed it in what would eventually become his dining room.

13 Walter Rendell Storey, "Decorative Art: Exhibit at Fair," *New York Times*, May 19, 1940, p. 51.

14 Also on display were more than a dozen books with woodcut illustrations by Esherick published by the Centaur Press in Philadelphia.

15 Elizabeth MacRae Boykin, "Pioneer Architecture for Rustic Retreats," *Cincinnati Enquirer*, June 16, 1940, p. 21.

16 Louise V. Sloane to Wharton Esherick, July 27, 1940, Wharton Esherick Museum Archives.

17 *Sculpture of the Twentieth Century* traveled to the Art Institute of Chicago and the Museum of Modern Art in New York. Esherick also was a finalist in 1951 for a public sculpture commission commemorating the "Unknown Political Prisoner." The model he submitted was displayed at the Museum of Modern Art in New York and the Tate Britain in London.

18 Thomas S. Tibbs to Wharton Esherick, Dec. 19, 1956, Wharton Esherick Museum Archives.

19 Mrs. Vanderbilt Webb to Wharton Esherick, Jan. 15, 1957, Bascom Papers, Wharton Esherick Museum Archives.

20 Wharton Esherick to David Campbell, June 25, 1957, Bascom Papers, Wharton Esherick Museum Archives.

21 Institutions that lent objects included the Philadelphia Museum of Art, the Pennsylvania Academy of the Fine Arts, the University of Pennsylvania, and the Whitney Museum of American Art. Also in 1958, Esherick served as a juror for *Young Americans,* a major exhibition spearheaded by the ACC that aimed to recognize new talent in the field for artists 30 and younger.

22 Cynthia Kellogg, "Families Make Sacrifice To Aid Furniture Exhibit," *New York Times*, Dec. 30, 1958.

23 Robert A. Laurer, *The Furniture and Sculpture of Wharton Esherick* (New York: Museum of Contemporary Crafts, 1958), n.p.

24 Harriet Morrison, "Esherick Is Whittling Artist," *New York Herald Tribune*, Dec. 31, 1958.

25 "Furniture as Sculpture," *Charette: Tri-State Journal of Architecture & Building* (1959): 18; Robert Endicott, "Esherick—Sculptor of Furniture," *New York Herald Tribune*, Feb. 1, 1959, p. 2.

26 Laurer, *The Furniture and Sculpture of Wharton Esherick*.

27 Marilyn Hoffman, "Individuality Wins," *Christian Science Monitor*, Dec. 31, 1958, p. 6.

28 Esherick to Thomas S. Tibbs, March 23, 1959, Wharton Esherick Museum Archives.

29 Marvin D. Schwartz, *Masters of Contemporary American Crafts* (New York: Brooklyn Museum, 1961), n.p.

30 Rita Reif, "Ways to Display Crafts Get Spotlight at Exhibit," *New York Times*, Feb. 10, 1961, p. 30; Gloria Finn, "Brooklyn Show," *Craft Horizons* (May–June 1961): 45.

31 Marvin D. Schwartz to Wharton Esherick, May 16, 1961, Wharton Esherick Museum Archives.

32 Robert Hilton Simmons, "Objects: USA, The Johnson Collection of Contemporary Crafts," *Craft Horizons* (Nov.–Dec. 1969): 25.

33 Lee Nordness, *The Johnson Collection of Contemporary Crafts* (1969), 4.

34 Lee Nordness to Esherick, Oct. 26, 1968, Wharton Esherick Museum Archives.

35 Nordness also purchased two bird's-eye maple trays and a walnut cutting board, but it is unclear if these were for the exhibition. See invoice from Dec. 16, 1968, Wharton Esherick Museum Archives.

36 Lee Nordness, *Objects: USA—The Johnson Collection of Contemporary Crafts*, exhibition catalog (1972), 4. See also Lee Nordness, *Objects: USA* (New York: Viking Press, 1970).

37 Frank Getlein, "New Things Are Happening in Some Old Media," *Sunday Star* (Washington, D.C.), Oct. 5, 1969.

38 Interview, Bruce W. Pepich, "A Conversation with Paul J. Smith, Co-Curator of *Objects: USA*," Aug. 20, 2019 (Racine Art Museum), p. 2.

39 Herbert Kenney Jr., "'Objects: USA' Collection Begs to Be Touched," *Indianapolis News*, March 17, 1970, p. 11. Esherick modeled the chest-table after one made from padauk for Marjorie Content in 1932.

40 "Objects: USA, Tomorrow's Heirlooms from Today's Craftsmen," *Women's Day*, Aug. 1969, p. 46.

LIST OF EXHIBITED WORKS

All works are in the Collection of the Wharton Esherick Museum, unless stated otherwise.
Works are listed in chronological order.

p. 36 *Self-Portrait*, 1919
Oil on canvas
31 × 26 in.

p. 61 *Moonlight on Alabama Pines*, 1919–20
Oil on canvas, carved wood frame with
metallic paint
23½ × 17½ in.

p. 168 *Doris*, 1920
Painted plaster casting
11¼ × 6¾ × 5 in.

p. 172 *Rhythms, Opening*, 1922
Woodblock print
8¼ × 8¼ in. (image)

p. 62 *Mary*, 1922
Oil on canvas, carved wood frame with
metallic paint
24½ × 20½ in. (framed)

p. 37 *Woodcarver's Shop*, 1922
Oil on canvas, carved wood frame with
metallic paint
20½ × 24¾ in. (framed)

p. 38 *Diamond Rock Hill*, 1923
Woodblock print
9 × 6½ in. (image)

p. 140 *The Hammersmen*, 1924
Illustration for Walt Whitman,
Song of the Broad-Axe (Centaur Press, 1924)
Woodblock print
10 × 9 in. (image)

p. 140 *Forger at His Forge-Furnace*, 1924
Illustration for Walt Whitman,
Song of the Broad-Axe (Centaur Press, 1924)
Woodblock print
9¼ × 8½ in. (image)

p. 141 *The Solid Forest*, 1924
Illustration for Walt Whitman,
Song of the Broad-Axe (Centaur Press, 1924)
Woodblock print
9⅝ × 8⅞ in. (image)

Walt Whitman, *Song of the Broad-Axe*
(Centaur Press, 1924)
Bound book, illustrated with
woodblock prints
31¾ × 24 in.

p. 173 *Song of Solomon*, 1924
Bound artist's book, woodblock prints
and hand lettering
31¾ × 24 in.

p. 173 *Song of Solomon* sketchbook, ca. 1924
Bound sketchbook, pencil drawings
11½ × 9 in.

p. 64 *The Race*, 1925
Painted wood on walnut base
6¾ × 30¾ × 8½ in.

p. 139 *Coal Wagon*, 1925
Woodblock print
6½ × 8 in. (image)

p. 174 *Swing*, 1925
Woodblock print
10¾ × 9 in. (image)

p. 39 Consuelo Kanaga (1894–1978)
Wharton at His Studio Entrance, ca. 1927
Photograph
4 × 5 in.

p. 102 *Harvesting*, 1927
Illustration for Walt Whitman,
As I Watch'd the Ploughman Ploughing
(Centaur Press, 1927)
Woodblock print
6½ × 7½ in. (image)

p. 103 *Harrowing*, 1927
Illustration for Walt Whitman,
As I Watch'd the Ploughman Ploughing
(Centaur Press, 1927)
Woodblock print
6½ × 7½ in. (image)

p. 178 *Carved Cup*, 1927
Walnut
5 × 5 in.

p. 105 *Drop Leaf Desk*, 1927
Red oak, leather
78 × 55½ × 22 in.

p. 176 *First Born*, 1927
Rosewood, padauk, snakewood
49 × 6¼ × 4¼ in.

p. 142 *Head of Dreiser*
(*Portrait of Theodore Dreiser*), ca. 1927
Pine
17½ × 7½ × 6 in.

p. 144 *Of a Great City*, 1928
Woodblock print
10½ × 6½ in. (image)

p. 60 *Alabama Pine*, from the
Alabama Trees series, 1929
Woodblock print
9¾ × 6⅜ in. (image)

Original woodblock for *Alabama Pine*, 1929
9¾ × 6⅜ in.

p. 108 *Alabama Moss Hung*,
from the *Alabama Trees* series, 1929
Woodblock print
8 × 7½ in. (image)

Original woodblock for
Alabama Moss Hung, 1929
8 × 7½ in.

pp. 180–81 Three *Dance Sketches*, ca. 1929
Ink on paper
Each: 6½ × 8½ in. or 8½ × 6½ in. (sheet)

p. 146 *Flat Top Desk*, 1929 and 1962
Walnut and padauk
28 × 82 × 36 in.

p. 146 *Flat Top Desk Chair*, 1929
Walnut, padauk, laced leather seat
28 × 18 × 18 in.

pp. 146, 149 *Flat Top Desk Figure*, 1929
Bronze cast of cocobolo original
10 × 5 × 4 in.

p. 175 *Light pull*, ca. 1930
Aluminum cast of cocobolo original
4¾ × 1 × 1 in.

p. 68 *Iseult*, 1930
Illustration for Amory Hare,
Tristram and Iseult (Centaur Press, 1930)
Woodblock print
7 × 8 in. (image)

Original woodblock for *Iseult*, 1930
7 × 8 in.

p. 69 *Silence—Death—Shadows*, 1930
Illustration for Amory Hare,
Tristram and Iseult (Centaur Press, 1930)
Woodblock print
6⅛ × 5 in. (image)

p. 70 *Daphne Pier*, 1931
Woodblock print
6½ × 6¼ in. (image)

p. 182 *Angular Dance I*, 1931
Printed reproduction of ink drawing
4½ × 3 in. (image)

p. 183 *Angular Dance II*, 1931
Printed reproduction of ink drawing
6 × 4⅓ in. (image)

p. 110 *Three-Legged Stool*, 1931
Oak
11 × 11½ × 12½ in.

p. 138 *Wagon Wheel Chair*, 1931
Hickory, laced leather seat and back
40 × 20 × 22 in.

p. 71 *The Lane*, 1931
Woodblock print
7¾ × 9¼ in. (images)

p. 151 *Holzhausen*, 1932
Woodblock print
9 × 12 in. (image)

p. 66 *Speed*, 1932
Cast aluminum
6 × 33½ × 12 in.

p. 73 *Table Lamp*, 1932
Padauk
30½ × 5¾ × 5½ in.

p. 150 *Fjord*, 1932
Woodblock print
8 × 9¼ in. (image)

p. 109 *Moonlight and Meadows*, 1932
Woodblock print
7½ × 8 in. (image)

p. 115 *Hedgerow Theatre Lobby
Stair model*, 1934
Walnut
26¼ × 14½ × 12 in.

p. 112 Emil Luks (active 1930s)
Spiral Stair, ca. 1934
Photographic print
6⅜ × 4¾ in. (image)

p. 186 *Oblivion*, 1934
Walnut
77 × 24 × 21½ in.

p. 188 Marjorie Content (1895–1984)
Oblivion, 1934
Photographic print
6⅜ × 4¾ in. (image)

p. 189 Emil Luks (active 1930s)
Wharton Esherick with "Oblivion," ca. 1934
Photographic print
6⅜ × 4¾ in. (image)

p. 145 *The Concert Meister*, 1937
Woodblock print
9¼ × 11¼ in. (image)

p. 114 *Bok House Chimney Stair model*, 1937
Painted wood
12 × 11 × 11 in.

p. 192 *Hammer Handle Chair*, 1938
Hickory and oak, laced canvas belting
32¼ × 17¾ × 16¼ in.

p. 191 *The Actress*, 1939
Cherry
29 × 16 × 10 in.

p. 184 *Five-Sided Bench*, 1947–50
English walnut, chestnut, oak, cherry
15½ × 29¾ × 16 in.

p. 152 *Captain's Chair*, 1951
Walnut, cherry, leather
31 × 24 × 21½ in.

p. 117 *The Pair*, 1951
Ebony and walnut
32 × 12¾ × 9½ in.

p. 74 *Fireplace Wall model*, 1953
Mixed media
11½ × 20 × 3½ in.

p. 75 *Wall Cabinet model*, 1954
Wood and paper
10 × 14¾ × 5¾ in.

p. 118 *Piano Table*, 1956
Walnut
28 × 52½ × 39½ in.

p. 195 *S-K Chair*, 1957
Walnut, black Naugahyde
32 × 18½ × 18½ in.

p. 197 *Music Stand*, 1960
Walnut and cherry
44½ × 20 × 20 in.

p. 197 *Double Music Stand*, 1962
Walnut and cherry
39 × 21 × 17½ in.

pp. 79, *Trays, bowls, and salad servers*, 1962–68
80–81 Various woods
Various dimensions

p. 114 *Spiral Stair model*, 1963
Pine
21¼ × 19 × 16½ in.

pp. 76–77 *Three-legged stools*, 1950s–60s
Various woods
Various dimensions

p. 78 *Curvilinear Tray*, 1968
Cottonwood
5 × 22 in.

p. 170 *Library Ladder*, 1969 (designed 1966)
Cherry
48½ × 25½ × 16½ in.

SELECTED BIBLIOGRAPHY

ARCHIVES

Wharton Esherick Family Papers. Wharton Esherick Museum, Malvern, PA.

Oral History Archive. Wharton Esherick Museum, Malvern, PA.

Theodore Dreiser Papers. Kislak Center for Special Collections, Rare Books and Manuscripts, University of Pennsylvania Archives, Philadelphia.

PUBLICATIONS

Adamson, Glenn. *Craft: An American History.* New York: Bloomsbury, 2021.

Bascom, Mansfield. *Wharton Esherick: The Journey of a Creative Mind.* New York: Abrams, 2010.

Benson, Gertrude. "Wharton Esherick." *Craft Horizons* 19, no. 1 (Jan.-Feb. 1959): 33–37.

Bradbury, Dominic. *The Iconic Interior: Private Spaces of Leading Artists, Architects, and Designers.* New York: Abrams, 2002.

Campbell, Louise. *Studio Lives: Architect, Art, and Artist in 20th-Century Britain.* London: Lund Humphries, 2019.

Cooke, Edward S., Gerald W. R. Ward, Pat Warner, and Kelly H. L'Ecuyer. *The Maker's Hand: American Studio Furniture, 1940–1990.* Boston: MFA Publications, 2003.

Corn, Wanda. *The Great American Thing: Modern Art and National Identity, 1915–1935.* Berkeley: University of California Press, 1999.

Dewey, John. *Experience and Education.* New York: Touchstone Books, 1938.

Dewey, John. *The School and Society.* Chicago: University of Illinois Press, 1899.

Eisenhauer, Paul D., and Lynne Farrington, eds. *Wharton Esherick and the Birth of the American Modern.* Atglen, PA: Schiffer Publishing, 2010.

Ford, Ford Madox. *Great Trade Route.* New York: Oxford University Press, 1937.

Foulkes, Julia L. *Modern Bodies: Dance and American Modernism from Martha Graham to Alvin Ailey.* Chapel Hill: University of North Carolina Press, 2002.

Gore, Holly. "Organic Form in the Functional Woodworks of Wharton Esherick." Master's thesis, Stanford University, 2013.

Howe, George. "New York World's Fair 1940." *Architectural Forum* 73, no. 1 (Jan. 1940): 31–39.

Igoe, Laura Turner, and Mark Sfirri. *Daring Design: The Impact of Three Women on Wharton Esherick's Craft.* Doylestown, PA: James A. Michener Art Museum, 2021.

Kreis, Mateo, and Julia Althaus, eds. *Rudolf Steiner: Alchemy of the Everyday.* Weil-am-Rhein: Vitra Design Museum, 2010.

Laurer, Robert A. *The Furniture and Sculpture of Wharton Esherick.* New York: Museum of Contemporary Crafts of the American Craftsmen's Council, 1958.

Lears, T. J. Jackson. *No Place of Grace: Antimodernism and the Transformation of American Culture, 1880–1920.* Chicago: University of Chicago Press, 1994.

Maloof, Sam, and Wendell Castle. "Wharton Esherick: 1887–1970." *Craft Horizons* 30, no. 4 (Aug. 1970): 10–17.

Mayer, Roberta A., and Mark Sfirri. "Early Expressions of Anthroposophical Design in America: The Influence of Rudolf Steiner and Fritz Westhoff on Wharton Esherick." *Journal of Modern Craft* 2, no. 3 (Nov. 2009): 299–323.

McGoey, Elizabeth. "Staging Modern Domesticity: Art and Constructed Interior Displays in America, 1925–1940." PhD diss., Indiana University, 2013.

Renwick Gallery and Minnesota Museum of Art. *Woodenworks: Furniture Objects by Five Contemporary Craftsmen—George Nakashima, Sam Maloof, Wharton Esherick, Arthur Espenet Carpenter, Wendell Castle.* Washington, DC: National Collection of Fine Arts, Smithsonian Institution, 1972.

Schwartz, Marvin D. *Masters of Contemporary American Crafts.* New York: Brooklyn Museum, 1961.

Whitman, Walt. *Song of the Broad-Axe.* Illustrations by Wharton Esherick. Philadelphia: Centaur Press, 1924. Reprinted: Atglen, PA: Schiffer Publishing, 2010.

Whitsitt, Steven, and Tina Skinner. *Esherick, Maloof, and Nakashima: Homes of the Master Wood Artisans.* Atglen, PA: Schiffer Publishing, 2009.

Williamson, Leslie. *Handcrafted Modern: At Home with Mid-Century Designers.* New York: Rizzoli, 2010.

Wright, Frank Lloyd. "In the Cause of Architecture: The Work of Frank Lloyd Wright." *The Architectural Record* 23 (March 1908): 155–65.

CONTRIBUTORS

SARAH ARCHER is a design writer based in Philadelphia and the author of books including *The Midcentury Kitchen*, *Midcentury Christmas*, and *Catland: The Soft Power of Cat Culture in Japan*. Her articles and reviews have appeared in the *New York Times*, *The Atlantic*, *The Cut*, *Architectural Digest*, *The New Yorker* online, *Hyperallergic*, *ELLE Decor*, *Vox*, *Curbed*, *Metropolis*, *Bloomberg CityLab*, and the *Journal of Modern Craft*, among other outlets. She was the 2017 Jentel Visiting Critic at the Archie Bray Foundation in Helena, Montana. She has contributed essays to exhibition catalogs for the Renwick Gallery of the Smithsonian Institution, Washington, D.C.; the Peabody Essex Museum, Salem, Massachusetts; the Portland Art Museum (Oregon), the Milwaukee Museum of Art, and the Museum of Arts and Design, New York. She was Senior Curator at the Philadelphia Art Alliance at the University of the Arts. A native New Yorker, she was the Director of Greenwich House Pottery in New York City.

COLIN FANNING is Assistant Curator in the department of European Decorative Arts and Sculpture at the Philadelphia Museum of Art, where he primarily focuses on modern and contemporary design. He is also a PhD candidate in design history at Bard Graduate Center, where he is completing a dissertation on the intellectual and technological transformations of design pedagogy in the late twentieth century. His research and curatorial efforts cover a broad range of American and European design, craft, and architecture, with specific interests in the material culture of childhood, intersections of postwar craft and counterculture, and the visual and material cultures of spaceflight. His writing has appeared in the *Journal of Design History*, *The Public Historian*, the *Encyclopedia of Greater Philadelphia*, and various edited volumes and exhibition catalogs. Since 2021, he has co-convened (with Antonia Behan of Queen's University, Ontario) the Craft History Workshop, a virtual works-in-progress seminar for interdisciplinary histories of making.

ANN GLASSCOCK serves as Associate Curator at the Taft Museum of Art in Cincinnati, Ohio. Specializing in decorative arts and furniture, she contributes to various aspects of the museum's operation, including curating exhibitions and conducting research on the permanent collection. Prior to joining the Taft, she worked for the Chazen Museum of Art in Madison, Wisconsin; the Chipstone Foundation in Milwaukee; and the Philadelphia Museum of Art. She also spent several years as a specialist in the Silver & Objets de Vertu and English & Continental Decorative Arts departments at Freeman's auction house in Philadelphia. In 2019 Glasscock received a doctorate from the University of Wisconsin–Madison; her dissertation, "Hudson Roysher: Silversmith, Designer, Craftsman," explored Roysher's participation in the revival of ecclesiastical silver in postwar America. Glasscock earned her bachelor's degree from Indiana University–Bloomington, master of letters from Christie's Education London, and master's degree in art history from Temple University. She also attended the Attingham Summer School and the Dresden International Academy for the Arts.

HOLLY GORE is the Director of Interpretation and Associate Curator of Special Collections at the Wharton Esherick Museum in Malvern, Pennsylvania. Gore is a scholar, curator, and educator whose research investigates the intersections of art, craft, design, and gendered work. She has held curatorial fellowships at the Asheville Art Museum, in North Carolina; and the Art, Design, and Architecture Museum at the University of California, Santa Barbara. Her writing has been published in the *Journal of Modern Craft* and she is a contributor to *Mobilizing Pedagogy: Two Social Practice Projects in the Americas*, by Pablo Helguera and Suzanne Lacy with Pilar Riaño-Alcalá (2018), among other books. She holds a PhD in the history of art and architecture from the University of California, Santa Barbara.

JOSHUA McHUGH is a New York–based photographer who specializes in architecture, interior, and design related projects. He collaborates with many of today's leading architects and interior design firms, and these commissions regularly appear in *Architectural Digest*, *ELLE Decor*, *Galerie*, *Interior Design*, and other national and international publications. His images have been featured in recent monographs from Alyssa Kapito Interiors, Drake/Anderson, Sara Story Design, and Sawyer/Berson. He has pursued a long-term project of chronicling museums and their displays, making his documentation of the Wharton Esherick Museum particularly felicitous. He is the photographer and coauthor of *Murals of New York City: The Best of New York's Public Paintings from Bemelmans to Parrish* (2013).

EMILY ZILBER is a curator, consultant, and educator whose work supports modern and contemporary art, craft, and design. As the Director of Curatorial Affairs and Strategic Partnerships at the Wharton Esherick Museum, she facilitates conversations between contemporary artists and Esherick's legacy. Zilber also maintains an independent artist consulting practice, teaches at Tyler School of Art and Architecture at Temple University, and has served as guest curator for the Renwick Gallery of the Smithsonian American Art Museum in Washington, D.C. For almost a decade, Zilber was the first Ronald C. and Anita L. Wornick Curator of Contemporary Decorative Arts at the Museum of Fine Arts, Boston, where she built an integrated curatorial program for craft and design within the museum's contemporary art department. Before joining the MFA, she held curatorial positions and fellowships at Cranbrook Academy of Art and Art Museum, in Bloomfield Hills, Michigan, and the Museum of Arts and Design and the Metropolitan Museum of Art in New York. Zilber holds a bachelor's degree in art history from the University of Chicago and a master's degree in the history of decorative arts and design from the Bard Graduate Center.

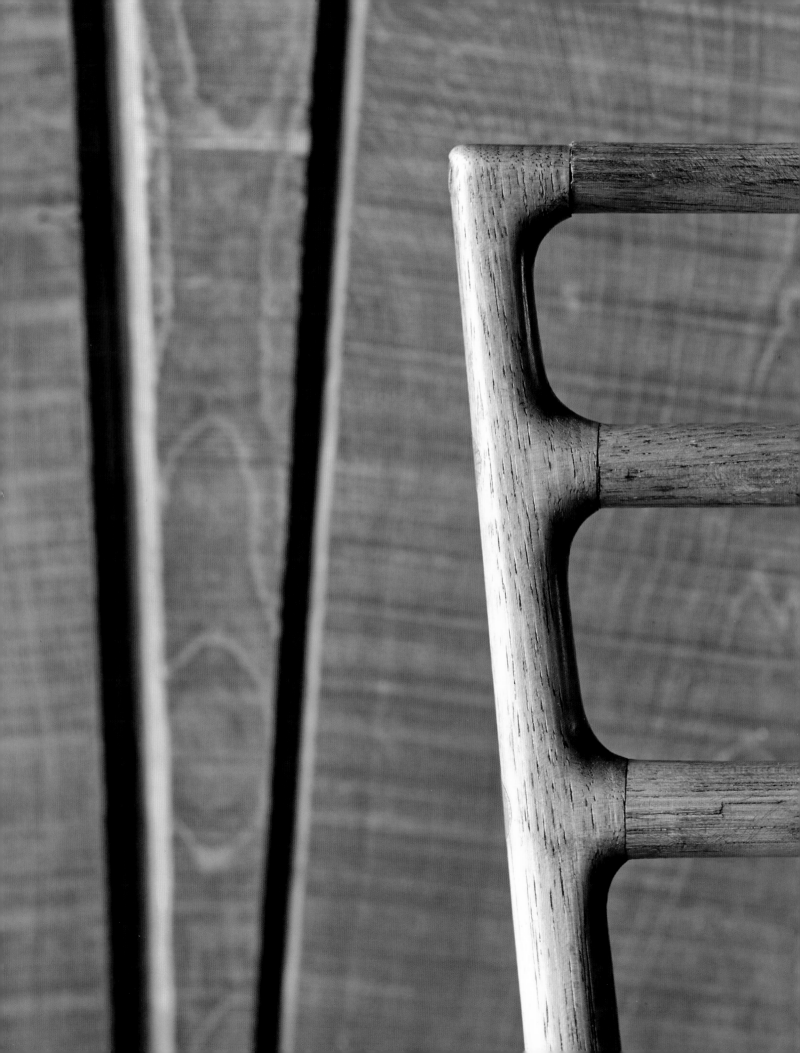

Published on the occasion of the exhibition *The Crafted World of Wharton Esherick*, organized by the Brandywine Museum of Art and the Wharton Esherick Museum

EXHIBITION ITINERARY

Brandywine Museum of Art, Chadds Ford, PA:
October 12, 2024–January 19, 2025

Chazen Museum of Art, Madison, WI:
February 17–May 18, 2025

Taft Museum of Art, Cincinnati, OH:
June 7–September 7, 2025

First published in the United States of America in 2024 by

Rizzoli Electa
A Division of Rizzoli International Publications, Inc.
300 Park Avenue South
New York, NY 10010
www.rizzoliusa.com

in association with

Brandywine Museum of Art
1 Hoffman's Mill Road
Chadds Ford, PA 19317
www.brandywine.org

and

Wharton Esherick Museum
1520 Horseshoe Trail
Malvern, PA 19355
www.whartonesherickmuseum.org

Furthermore: a program of the
J. M. Kaplan Fund

THE DECORATIVE ARTS TRUST
A Dean F. Failey Grant of the Decorative Arts Trust

FOR THE BRANDYWINE
MUSEUM OF ART
Editor: Amanda C. Burdan
Managing Editor: Todd Bradway

FOR THE WHARTON ESHERICK
MUSEUM
Editor: Emily Zilber

FOR RIZZOLI ELECTA
Publisher: Charles Miers
Associate Publisher: Margaret Rennolds Chace
Editors: Sarah Scheffel, Jennifer Snodgrass
Production Manager: Alyn Evans

Design: Sarah Gifford

Copyright © 2024 by the Brandywine Museum of Art and the Wharton Esherick Museum

Photographs by Joshua McHugh copyright © 2024 by Joshua McHugh

2024 2025 2026 2027 2028 / 10 9 8 7 6 5 4 3 2 1

ISBN: 978-0-8478-3638-3

Library of Congress Control Number: 2024934447

Printed in China

FRONT COVER
The Main Gallery of Wharton Esherick's Studio, 2023: see p. 111

BACK COVER
Wharton Esherick, *Flat Top Desk*, 1929 and 1962 (detail): see pp. 146, 148